KLIMT

GERBERT FRODL

KLIMT

Translated by Alexandra Campbell

1866-1991

125th

ANNIVERSARY

HENRY HOLT AND COMPANY

NEW YORK

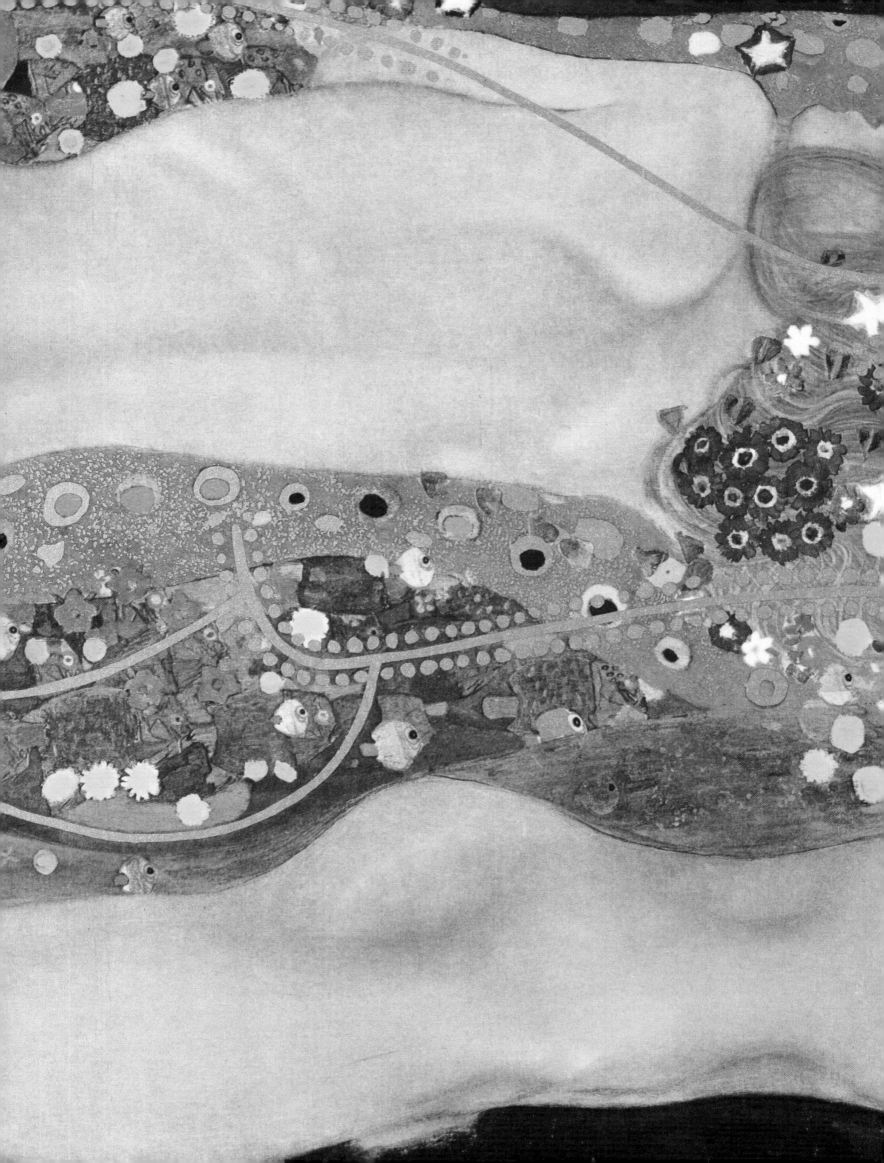

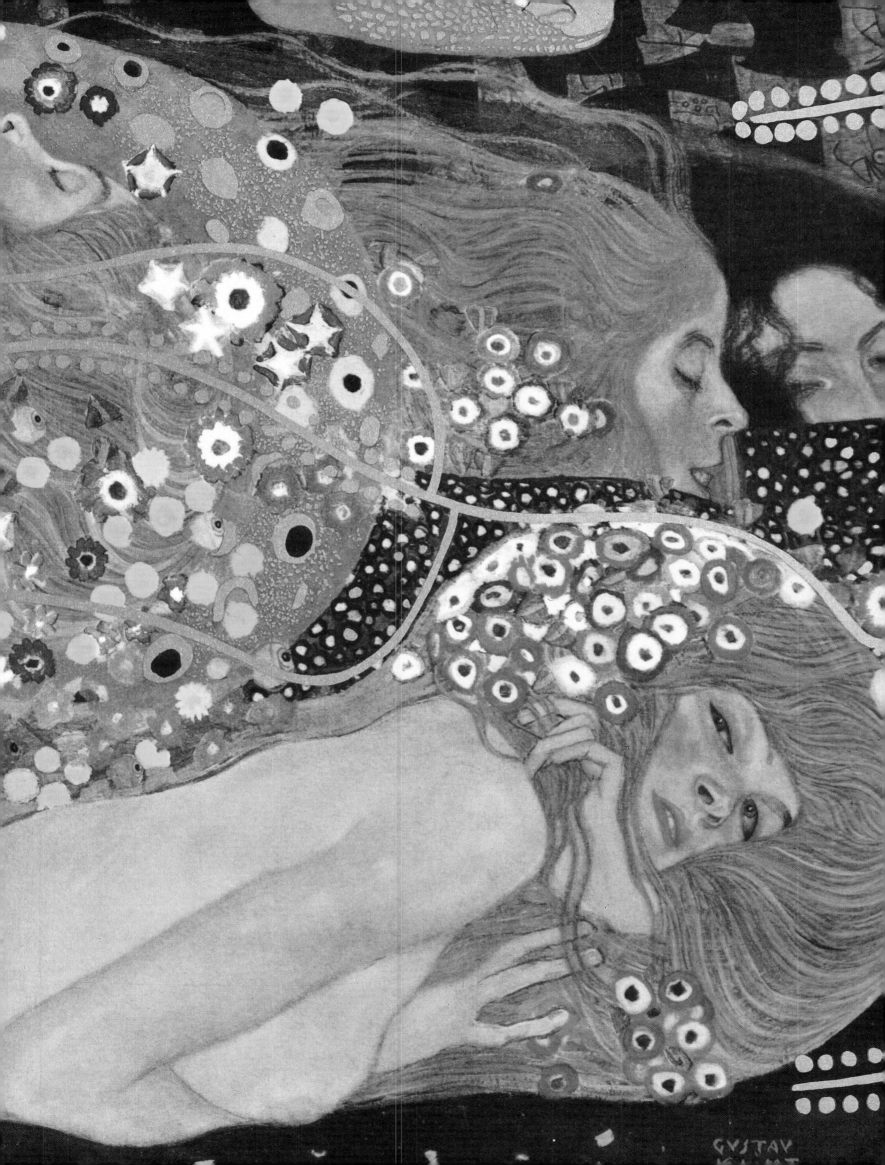

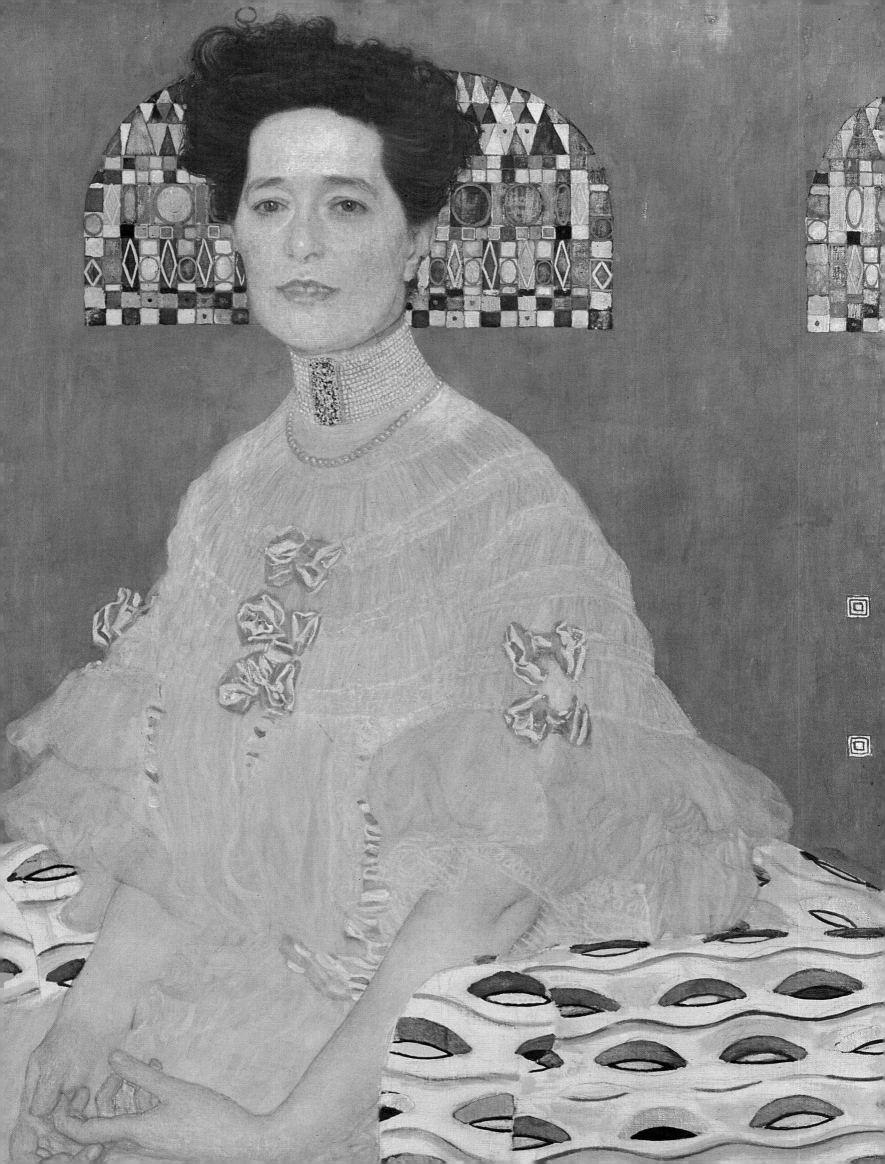

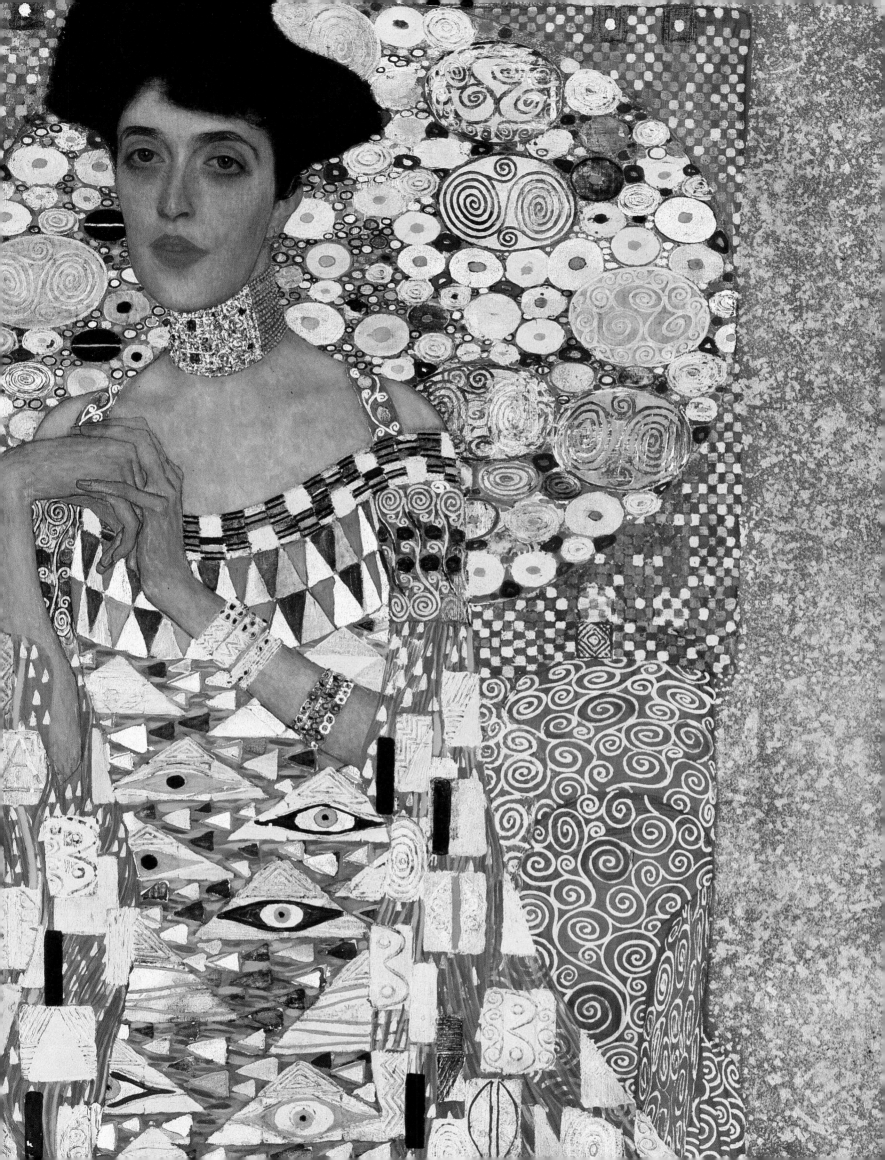

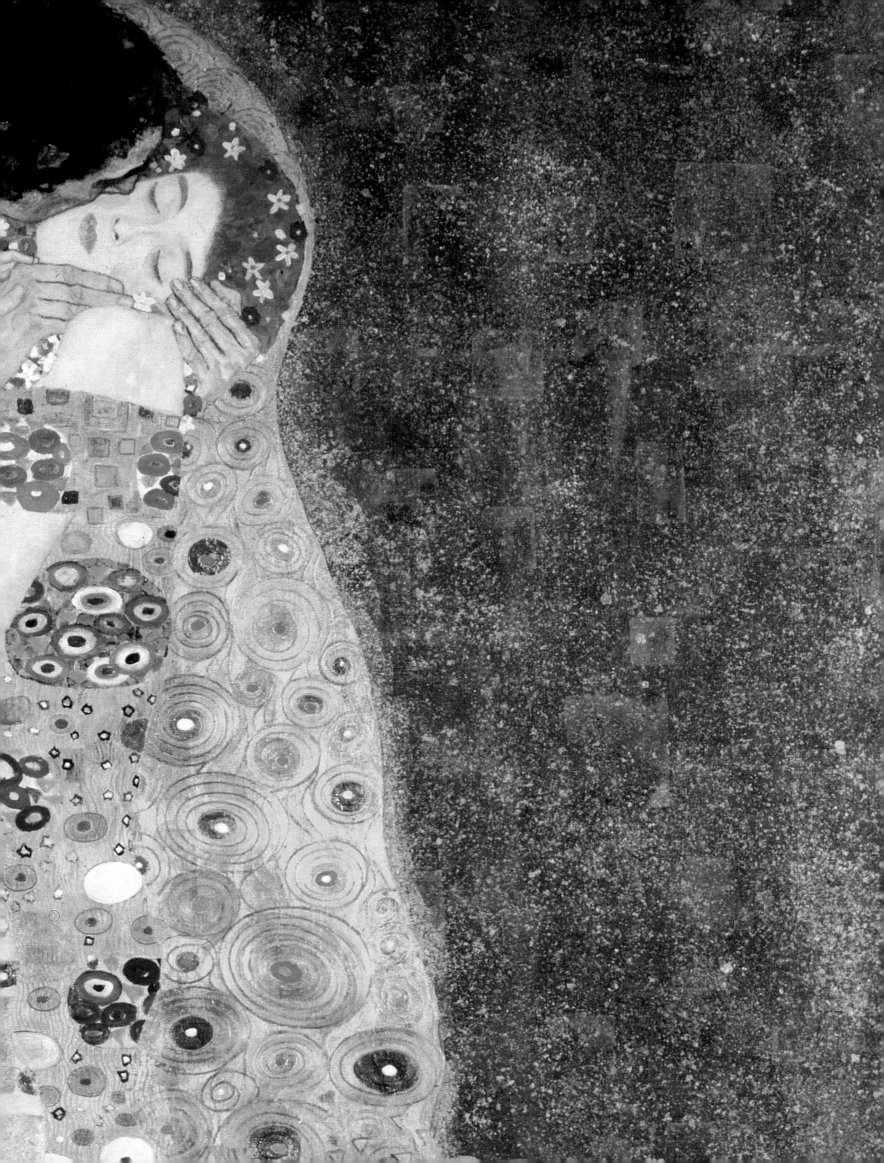

1 *Water Snakes II*
(& detail pp.4-5)
1904, repainted 1907
Oil on canvas, 80 × 145 cm
Private collection

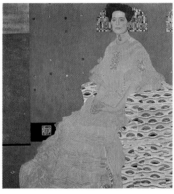

2 *Portrait of Fritza Riedler*
(& detail pp.6-7), 1906
Oil on canvas, 153 × 133 cm
Österreichische Galerie, Vienna

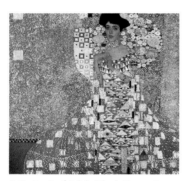

3 *Portrait of Adele Bloch-Bauer I*
(& detail pp.8-9), 1907
Oil on canvas, 138 × 138 cm
Österreichische Galerie, Vienna

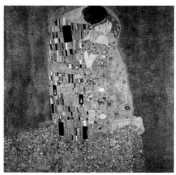

4 *The Kiss*
(& detail pp.10-11), 1907-9
Oil on canvas, 108 × 180 cm
Österreichische Galerie, Vienna

Commentary on a non-existent self-portrait

*'I can paint and I can draw. I think so,
and others also say they think so.
But I am not sure that it is true.
Only two things are sure to me:*

*1. No self-portrait of me is in existence.
I am not interested in myself
as the "subject of a painting", I am interested
rather in other people, women in particular,
and even more in other subjects.
I am convinced that as a human being
I am not particularly interesting.
There is nothing extraordinary to be seen in me.
I am a painter and I paint every day from morning
to evening. Human figures, landscapes,
more rarely portraits.*

*2. I am not at ease with the spoken word or
the written word, even when it comes to expressing
something about my work or myself.
When I have to write even the simplest
of letters, I feel a sense of fear
that is like seasickness. This is why
there can be no self-portrait in my case
either artistic or literary.
Which there is no reason to regret.
If anyone wants to know anything about me
as a painter – and that is the only question
worthy of consideration –
let him carefully study my works
and try to read in them
what I am and what I wish for.'*

Klimt

'T oday the Secession entertains its friends. Those involved are the guests of Gustav Klimt, as the association is opening the new season with an exhibition of this artist's works. It is probably the most interesting thing to be seen at the moment in Viennese painting: an overall view of Klimt's development since the founding of the Secession, the association to which Klimt and a number of others owe their very distinct artistic identity.'

These are the opening lines of a series of three articles written in November 1903 by Ludwig Hevesi, the Secession's loyal spokesman and chronicler, who worked hard to promote the young artists and their cause. The articles, written in a militant and high-flown style, nonetheless touched the root of the matter. They were published on an occasion of great significance to the artistic world of Vienna: the first exhibition devoted solely to the work of Gustav Klimt – co-founder of the Secession and one of its most active members, a painter admired and celebrated by some, attacked and criticised by others. It was to take place, what is more, in the building of *his* association of artists. Several interrelated factors had predisposed Viennese art-lovers to the event: the activities of the Secession, founded six years previously, had proved unprecedentedly successful. It was this association that had opened the eyes of the Viennese, particularly the city's painters, to the world of international contemporary art. Klimt's own role in achieving and communicating the new artistic awareness was by no means negligible, as will be seen later. The works and aims of the Secession's members proved controversial from

the outset, provoking those for and against to publish a stream of articles in the press. The public was thus kept abreast of the Secession's minutest doings by a regular issue of reports. Gustav Klimt played a leading role here, as the recognised founder and driving force of the movement, as well as its figurehead. Within a few years he was well known as a forthright and determined fighter in the cause of art. This was largely the result of events related to the 'Fakultätsbilder' (the paintings for the University). For all these reasons, it was not surprising that Klimt's first major exhibition attracted so much attention; nor that it effectively established his talent, perhaps less in his own eyes than in those of his friends and admirers, who were able to trace there the unwavering development of his genius. The exhibition also amounted to a stand against those opponents of modern art in general who identified Klimt as their prime target. Bertha Zuckerkandl, joining the battle for the recognition of art nouveau, wrote: 'Klimt experiences through colours and lines what Schubert experienced through music.' (These words of praise are incidentally an apt illustration of the typical Viennese view of art: music had always been closer to the Viennese heart than the visual arts.) At the time of his exhibition then, Klimt was undoubtedly the dominant figure in the artistic world of Vienna and the arguments that raged for and against him served only to confirm this fact.

W hen, in October 1876, Klimt entered the Wiener Kunstgewerbeschule

(Vienna School of Arts & Crafts), Hans Makart (1840-84) was the incontestable (but not uncontested) 'prince-painter' of the Imperial city. He was not only an accomplished artist, but also the darling of the bourgeoisie. His studio was a fascinating place, and the setting for celebrated parties. Makart had brought a new impetus to art both in Vienna and throughout central Europe by giving prominence to colour and its effects rather than to a picture's subject-matter. This innovation was

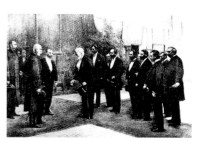

Opening of First Exhibition of Secession (R.Bacher)

welcomed enthusiastically, and the 'picturesque' came to the fore in paintings, great murals and gigantic scenes for theatres. The public was saturated with history painting, and the dry, figurative manner in which it was practised by the Academy professors. An artist who introduced spectacular and unusual effects into both his history paintings and his portraits was therefore not slow to gain public favour. The young Gustav Klimt could not escape the spell of Makart, this 'genius of colours', nor could his brother Ernst (1864-92) and his colleague Franz Matsch (1861-1942). Their first direct contact with Makart was brought about by their professor, Ferdinand Laufberger (1829-81), in the spring of 1879 when they helped prepare the famous

pageant held in celebration of the silver wedding of the Imperial couple, Franz-Josef I and Elisabeth. Makart had designed the costumes. In the years that followed Laufberger, a painter of a sterile eclecticism, proved even more helpful to his pupils: he put them in touch with a firm of architects who specialised in the design of theatres; and he also offered them the chance to collaborate in *Allegories and Emblems*, a part-work produced by a Viennese publisher. This launched the careers of the three young men, providing them with work for some time ahead. Klimt's first contributions to the above collection, *The Four Seasons* (1881) and *Youth* (1882), are imbued with Laufberger's graphic style, not surprising given that in 1880 Klimt had helped work on Laufberger's *Grafiti* for the courtyard of the Kunsthistorisches Hofmuseum. These early works, like the ones that followed, *In the Kingdom of Nature* (1882) and *Idyll* (1884), are striking for their architectural quality, which is equally apparent in Klimt's painting and drawing. This can be explained by the specific terms of the commission to prepare designs for cycles of decorative murals. It was, however, their collaboration with the architects Ferdinand Fellner and Hermann Helmer that played the greatest part in shaping the future of Klimt and his colleagues' future. Fellner and Helmer handed over the theatres they designed in a completed state, decorative painting included. Through their work for the theatre, the young artists became increasingly familiar with the picturesque and colourful style of Hans Makart, who was the obvious source of inspiration here. Gustav and Ernst Klimt and Franz Matsch then set themselves a further challenge: they founded a 'Maler-Compagnie' together, working from 1883 in a communal studio.

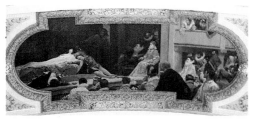

Globe Theatre in London

Between 1882 and 1885 this 'company' painted frescos on ceilings and produced curtains for the theatres of Liberec (Reichenberg), Karlovy Vary (Carlsbad), Rijeka (Fiume, Yugoslavia) and Bucharest. We know that Matsch, perhaps because he was the eldest, fulfilled the roles of secretary, treasurer and general administrator, and that he negotiated the terms of the commissions. Each of the three artists produced a full set of designs for a project. When the master of works had studied them all, they drew lots to determine who should carry out which section. Thus Matsch might end up working from a design of Gustav Klimt's, and vice versa. Their work was done diligently and efficiently and their growing reputation in Vienna brought in fresh commissions. They were asked to execute paintings for the ceilings

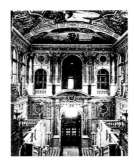

Ceiling of the stairwell in the Burgtheater

above the two main staircases in the Burgtheater. The architectural structure determined the size and shape of the paintings, which were to feature the history of theatre from antiquity to the baroque (the subject being determined by the director of the theatre, Adolf Wilbrandt). The eldest of the three artists was then just twenty-five, and the commission was regarded as a great honour. Gustav Klimt was responsible for four of the ten paintings produced between 1886 and 1888 (their allocation again being determined by lots): *The Thespian Cart, The Globe Theatre, The Theatre of Taormina, The Altar of Dionysus*. While Makart's influence is clearly apparent in *Romeo and Juliet* (Globe Theatre), signs of new development in Klimt's art emerge in *The Theatre of Taormina*. This painting moves away from the neo-baroque found in Makart's work and betrays the influence of Sir Lawrence Alma-Tadema (1836-1912), a painter very much in vogue in the Victorian period.

When Klimt came to portray the theatre in antiquity, he must have remembered the English artist's 'narrative' painting on the same subject, which had made a strong impression on him. The allegory of *Sculpture*, which he produced in 1889, shows Klimt working along the same lines in a variety of projects, while at the same time developing a more personal style. This emerges in the flatness of his design, the use of decorative elements, and the novel way the dominant lines in his painting determine the interrelation of its component parts. A few years later this manner had become the general 'style' of Vienna around 1900, a style whose existence and characteristics were largely attributable to Gustav Klimt. Its roots lay buried in Viennese tradition while it simultaneously reached out to inspiration from the world beyond. At first glance it might appear that Gustav Klimt's art as it developed after the dissolution of the 'Künstler-Compagnie', and the premature death of Ernst Klimt, amounted to no more than a combination of influences from various European countries. These can be readily identified and differentiated within his work. However, what is impressive later is the way Klimt steeped himself in these influences by systematic study and blended them with Viennese traditions to make them his own, thus giving birth to a new Viennese style.

When they received the commission for the stairwell of the Kunsthistorisches Museum, which had remained unfinished after Makart's death (with the exception of the vast ceiling decorated by Mihaly Munkaczy, a Hungarian painter living in Paris), the Klimt brothers and their colleague Matsch had made their mark while still in their twenties, and seemed destined to have highly successful careers. They accomplished their task with brio; the forty paintings in the spandrels and spaces between the columns were completed in 1891, the year the theatre opened. The theme of these works was 'the development of different styles with reference to the subjects of museum collections'. Klimt produced thirteen paintings featuring Egyptian art, Greek antiquity, and the Quattrocento and Cinquecento in Italy. Some of

these (*The Girl from Tanagra* and *Pallas Athene*) showed signs of progression towards the new 'style'. The areas to be painted were unusually shaped, which affected the disposition of the personae: where the structural composition of a work was best adapted to the available area, the artists were most successful in breaking away from the didactic and decorative style. The frescos in the stairwell of the museum earned the three painters 'the highest Imperial recognition'. They also marked the end of an era in Klimt's life. In December 1892 his brother died, tragically ringing down the final curtain on the Maler-Compagnie after over ten years of harmonious collaboration. Gustav was clearly the strongest artistic personality of a group in which individual differences had emerged. It had become apparent that sooner or later Klimt would inevitably go his own way.

When the company was dissolved, Klimt was established as an artist. His painting corresponded to the fashion for historicism which had taken over the sumptuous buildings running the length of the Ringstrasse in Vienna. The plans for these buildings were embarked on in 1857 at the instigation of the Emperor Franz-Josef I. A great boulevard with adjoining streets replaced the old glacis and the remnants of the city walls. Some 800 luxurious buildings, private and public, sprang up, linking the historic centre of the city to the expanding suburbs. The planning and execution of this vast urban project was both politically and culturally significant, bound up with the city's role as an Imperial residence and the centre of a multi-racial state. Neither the defeat in the war against Prussia in 1866 nor the stock market crash of 1873, following the financial failure of the World Exhibition, impinged on the euphoria reigning in and around the boulevard. All the buildings were to be decorated and there was a crying demand for painters, sculptors and decorative artists, not to mention architects and masters of works. This brought Hans Makart to Vienna in 1869, at the Emperor's summons. A generation later the Klimt brothers and Franz Matsch were the accepted painters of the

Ringstrasse, devotees of the style bearing its name.

Little is known of Klimt's life between the death of his brother and the founding of the Secession. There are few works from this period in which both his family life and his painting suffered upheavals: only six months before his brother's death, Klimt had lost his father. No longer tied to com-

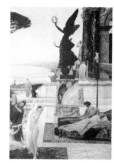

The Theatre in Taormina

munal work, he seemed to become open to the influences of contemporary European art. The dissolution of the Maler-Compagnie undoubtedly released him from constraints and exposed him to new ideas. He came across these ideas in art magazines, reproductions and photographs, and also in the international exhibitions of the Vienna Künstlerhaus. Some of the figurative and narrative art on view seemed at times more inspired by the work of decorators than of painters; and they were far removed from the luminous and suggestive pictures of the Impressionists and their successors. Alma-Tadema, already mentioned, was one of these artists, as were Frederick Lord Leighton, John Everett Millais, the Belgian Symbolist Félicien Rops, with his 'pleasing eroticism', his fellow countryman, Fernand Khnopff, and the German Max Klinger.

Although it did not pass unnoticed in Vienna, the move to reform art that was under way in Britain, France, Holland, Belgium and Germany had made no great impression on the city. Recently established periodicals, *The Studio* (London, since 1893), or *Die Jugend* (Munich, since 1896), helped to foster the growing awareness of Viennese artists and encourage them to take new directions. The founding of the Secession in Munich tempted thoughts of a similar move in Vienna, but it was five years before this became a reality.

It needs to be stressed that Gustav Klimt in 1892 did not immediately turn to modern artistic movements heralding the future. A sudden and outright break with the past to ally himself to foreign trends would have been surprising in a painter who had produced a good number of monumental works in the pure spirit of Makart, and to the taste of Viennese society as represented by the Ringstrasse. He was, indeed, regarded at the time as Makart's successor, a view there seems no ground to dispute.

In these years of transition, Klimt produced a few small paintings which one can fairly take to be illustrations of contemporary taste, such as *The Actor in the Hofburg Theatre, Joseph Lewinsky in Carlos* and *Love*, both in 1895. *Love* was the model for its namesake in the new series of *Allegories* (original works by well-known modern artists, with explanatory text; published by Martin Gerlach, Vienna), part-works starting in spring 1896. The subject-matter of the painting was clearly symbolic: the heads floating above the couple represent age and death, the roses in the frame of 'love' betoken beauty and illusion. Naturalism and stylisation play against each other in the two pictures, accentuating the aesthetic effect and creating the impression of a 'picture within a picture'. Other artists also used the same methods to emphasise

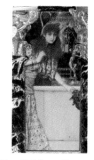

The Girl from Tanagra

the illustrative element in their works: Georges Rochgrosse (1859-1938), French salon painter in his *Méditation*, or Max Klinger (1857-1920) in his aquatints of *Death*, 1885. The parallel use of stylisation and naturalism in the work of the young Klimt became one of his dominant characteristics and took many different forms.

The first, small, version of *Music* was a preparatory study for the music room in the villa belonging to Nikolaus Dumba in Vienna. This work, like *Love*, clearly displays Jugendstil, or art nouveau, motifs. The composition of the motifs is, however, somewhat forced and uneasy. Klimt was clearly at this point in his life trying to establish his own individual style, which begins to emerge in his drawings at the time, particularly his portraits. The works of the Belgian Symbolist Fernand Khnopff (1858-1921) show similarities to Klimt's drawings; the figures are invested with a quality at the same time inaccessible and erotic, an effect accentuated by the unreal light.

Artists in Vienna took longer than elsewhere to break away from the artistic establishment. The official artistic body in the city was the Genossenschaft bildender Kunstler Wiens (Co-operative of Viennese Painters) in the Künstlerhaus (House of Artists); it had been in existence since 1861, dominating artistic life. Virtually every Viennese artist – painter, sculptor or architect – belonged to the association, which

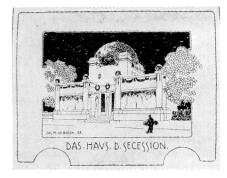

Postcard of the Secession Building

was the sole and unchallenged representative of the artistic community *vis-à-vis* the public and the authorities. The eventual split was preceded by internal conflicts, arising from arbitrary decisions by the jury, controversy about participation in exhibitions, disagreements between conservatives and progressives, and between authoritarian and democratic personalities. On 3 April 1887 a new association was formed within the Künstlergenossenschaft (Artists' Co-operative), initially intending to operate within the existing organisation. But in May the venerable gentlemen of the jury refused to allow the exhibition of Josef Engelhart's *Cherry Picker* on the grounds that 'society ladies' might be shocked by the nudity of the young girl. This proved the last straw. A group of artists left the association to found a new Vereinigung bildender

Künstler Österreichs (Austrian Association of Visual Artists). It came to be known simply as the Secession and the first president was Gustav Klimt. Rudolf von Alt (1812-1905), landscape painter and at eighty-five the doyen of Viennese artists, was honorary life president.

In spring 1897 Klimt was far from being considered a rebel. Indeed, he had been the first winner of the Kaiserpreis (Emperor's Prize), awarded to him in 1890. His reputation as Makart's successor was based both on his own works and those of the Künstler-Compagnie, on view in a variety of theatres and museums. One might wonder if he was not freeing himself from his own past by breaking away from an ossified artistic association that was hostile to change, inflexible and complacent. Did the founding of the Secession not provide an impetus necessary to Klimt himself? He was appointed its first president primarily because of his qualities as a human being, but also because of his reputation as an artist.

The ensuing eight years of the Secession brought a 'sacred spring' to Viennese art, flowering after too long a winter. The works born of this sudden liberation amazed more than one member of the association itself. Klimt continued as president until 1899. The resolution 'to promote purely artistic interests' and 'to raise the level of artistic awareness throughout Austria' was written into the statutes. This end was to be attained by 'direct contact with great foreign artists' and by a system of exhibitions 'free of all mercenary considerations'. There was as strong a desire to exhibit Austrian art abroad as to 'make general developments in the arts and the important masterpieces of other countries known to the Austrian public'.

Unfortunately we have little information about Klimt's dealings with his friends

Theseus and the Minotaur

and colleagues, and few established facts about his work for the Secession. He undoubtedly exercised a strong influence on the exhibition programme. But the organisation was essentially handed over to 'managers', Carl Moll (1861-1945) and Josef Engelhart, who both had excellent foreign contacts. A year after the new association was founded the first stone of a new exhibition centre was laid. On 10 November 1898 the building was completed, according to the plans of the architect Joseph Maria Olbrich (1867-1908), a member of the Secession. In gold letters on the façade were inscribed the battle-cry of Hevesi: Der Zeit ihre Kunst, der Kunst ihre Freiheit (To Each Age its Art, to Art its Freedom). The gigantic sphere composed of thousands of gilded laurel leaves and suspended over the entrance became the emblem of the new building; it was as much an object of mockery as of admiration, winning the nickname 'gilded cabbage'. A couple of little sketches of the façade show that Gustav Klimt had turned his thoughts to the structure of the projected building: there is a definite correlation between his drawings and Olbrich's final version. The Secession held its second exhibition in the new building. After extensive restoration work, it continued to be used for the association's exhibitions, although the very first shows took place in rented premises. Klimt was responsible for the design of the posters. The interior design was by the architects Olbrich and Josef Hoffmann (1870-1956). At this period the concept of an exhibition as a 'total work of art' had not wholly developed. There was still a tendency to overcrowd the displays. Twenty-three exhibitions were held before 1905, the year Klimt left the association, taking with him a number of other well-known artists together forming the 'Klimt-Gruppe'. It is no exaggeration to say that some of these shows made exhibition history, not only in the quality and range of the works displayed,

but also in their subjects, organisation, and novel approach to an 'exhibition'. An organiser and a 'designer' – architect, painter or sculptor – were put in charge of each exhibition. This resulted in accomplished productions, in some cases photographically recorded, which furthered the reputation of the designers involved. Koloman Moser (1868-1918), painter and 'designer', and Hoffmann particularly distinguished themselves; it is to them, among others, that we are especially indebted for displays that were avant-garde.

The eight flourishing years of the Secession did not, however, prove unclouded for Klimt. His endurance was sorely tested, particularly by the conflicts and arguments over the 'Fakultätsbilder', three gigantic paintings for the ceiling of the University of Vienna. It must not be forgotten that the start of the artist's mature period coincided with the start of the Secession. None of his great works was produced before 1898, only studies and preparatory paintings, such as those intended to go over the doors in the Dumba Villa. Fritz Novotny, a Viennese art historian, saw them as a key to understanding Klimt's evolution: 'in the sense that they allow one an insight into what the artist intended and achieved as well as into what remained to be accomplished'. These observations on Klimt, made in 1967, remain valid today. Nikolaus Dumba (1830-1900), an industrialist and patron of the arts, commissioned Klimt not only to produce paintings to go above the doors in the Music Room but also to decorate the room in its entirety. A water-colour survives to show us how Klimt envisaged the paintings in relation to the decoration of the rest of the room. It was his second brother, Georg Klimt, the goldsmith, who carried out the figurative metalwork and bronze decorations. A good number of years earlier Dumba, already playing a significant part in Viennese artistic life, had ordered the entire decoration of a room in his mansion by one of the foremost Viennese artists: Hans Makart was responsible for the decoration of the Library, which went down in local art history as 'Dumbazimmer'. His allegorical scenes represented the highpoint of the neo-baroque variant of the Ringstrasse style. These flamboyantly coloured paint-

ings were still much admired in Klimt's time and Ludwig Hevesi in 1900 saw such works as a foretaste of *fin-de-siècle* style. Klimt's paintings for the spaces above the doors, *Music* and *Schubert at the Piano*, were destroyed at the end of the Second World War with others of his works. The poet and journalist Hermann Bahr (1863-1934) described these pictures in unstinting terms as 'the most beautiful paintings an Austrian has ever produced'. Klimt must have captured in these works something of Schubert's spirit, an atmosphere that evoked the subject. The divergence between naturalist and non-naturalist elements doubtless also played a part: it was to characterise his painting in later years. And the Impressionist manner in which the light was rendered added a mysterious

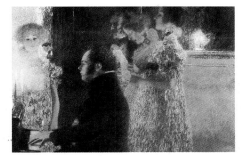
Schubert at the Piano

charm. It does not seem excessive to draw a comparison with such Nabis as Vuillard or Bonnard. The same light, with its naturalist effects, occurs in Klimt's portraits of that time. Meanwhile the narrative element in Klimt's works was fading; it had in any case been of little personal importance to him. The second of the pictures for the spaces above the doors (*Allegory of Music*) was completed a little beforehand; it belongs with Klimt's earlier works and bears little resemblance to *Schubert*. *Music* is an allegory, a visual rendering of ideas, and as such harks back to the spandrels in the Kunsthistorisches Museum or the 'Vorlagewerk' (sketch) pictures, while also sharing elements with subsequent works such as *Pallas Athene* or the poster Klimt designed for the Secession's first exhibition. The latter shows Theseus killing the Minotaur, an aggressive symbol of the Secession's stance against hostile forces. The individual character of these works derives from the use of contrasting pictorial techniques and forms of composition: Klimt makes simultaneous use of realistic and graphic forms, of 'real' painting and abstract decorative elements. In conclu-

sion, the group of works dating about 1900 shows an influence by the Munich painter Franz von Stuck (1863-1928). The latter was a co-founder of the Munich Secession (1892), the activities of which were well known in Vienna. A good number of Stuck's paintings are a mixture of the erotic and the demonic, charged with an acute tension that unfailingly communicates itself to the viewer. Klimt used some of Stuck's ideas in his compositions (for example, treating the frame as part of a work of art), and also a number of motifs of antique inspiration (*Pallas Athene*). But he skilfully moved away from the heavy immobility of Stuck's pictures, and their too obvious symbolism, to produce paintings only loosely evocative of their models, the culmination of this development being *Judith I* (1901). In so doing Klimt established a 'prototype' which set the standard for portraits of ladies in Viennese society.

To this day *Judith* remains an undisputed success. In his account of the exhibition of 29 March 1901, Hevesi speaks of 'Judith the dangerous', a creature of fatal powers, invested with an unearthly quality that removes her from the present moment. 'The future is painted,' he wrote, with absolute confidence that his verdict would stand the test of time. *Judith* was the first of a series of female portraits offering

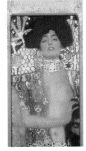
Judith and Holofernes I

an insight into Viennese society of the period, an exciting confusion of mood and atmosphere which combined a sense that the world was ending with expectations of new beginnings. There was a strangeness and contradiction in the air which must have made itself felt in Klimt's studio and found expression in *Judith*, a painting which itself harks directly back to *Schubert*. Klimt rejected all 'Symbolist' works of the kind displayed then and afterwards in Viennese exhibitions: superficial while

seeming to be profound, they were also difficult to render without heavy-handedness. *Judith* reveals a spiritual affinity with Oscar Wilde's *Salome* and Aubrey Beardsley's drawings for this work. For all the dearth of convincing productions of Richard Strauss's *Salome*, any opera-goer or art-lover would have appreciated the close relationship between the opera and Klimt's painting and in this context have accepted the idea of *Zeitgeist*.

Philosophy

The 'magic' years around 1900 in Vienna were also notable for great works in other fields, ranging from science to literature and music. Some of these were of world significance and wide-ranging in their influence. Vienna was at this period the cultural hub of central Europe. Sigmund Freud (1856-1939) published his *Traumdeutungen* (Interpretation of Dreams) in 1900, a deeply significant work which offered 'new access to the inner depths of psychological life by applying the technique of free association to dreams' (Freud). The important literary figures around the turn of the century were the poets known as 'Jung-Wien': Hermann Bahr (1863-1934), Hugo von Hofmannsthal (1874-1929), and, above all, Arthur Schnitzler (1861-1913). Theirs were the voices that questioned bourgeois morality and standards of behaviour. Hermann Broch later gave their writings the paradoxical nickname 'happy Viennese apocalypse'. Karl Kraus (1874-1936) was the most biting critic of the time; he saw language as an 'unfailing force' and in his paper *Die Fackel* (first issued 1899) he waged a vehement campaign against journalism, against the majority of poets of his period, against artists. The architect Adolf Loos (1870-1933) was another who did not share the prevailing euphoria about the Secession's activities; on the contrary he criticised the excessive taste for ornament and in his building on the Michaelerplatz (the 'Loos-Haus') he found an answer to it that lasted for decades. It was in 1897 that Gustav Mahler (1860-1911) became conductor and director at the Wiener Hofoper. As well as composing his own music, which had formed only part of the repertoire of the major orchestras for twenty years, he made Vienna into the centre of the musical world, and earned himself a reputation which survives to the present day. It is based on the first pieces of modern music and on interpretations and productions of Wagner that marked an epoch. For Mahler, to produce an opera was to create a total work of art; and his relationship with the graphic artist Alfred Roller (1864-1935) proved a happy chance for the history of theatre. Though Roller had never worked in theatre before meeting Mahler, the settings he created for the latter's productions were verging on genius. In 1902 the composer married Alma Schindler, daughter of the well-known Viennese landscape painter and step-daughter of Carl Moll, co-founder of the Secession and one of its most active members. Through Alma and Moll, Mahler made the acquaintance of Klimt and then in turn of Roller. The year 1906 brought not only the publication of a first novel by Robert Musil (1880-1942) *Die Verwirrungen des jungen Zögling Törless* (The Distress of the Student Törless), but also a revolutionary work in the musical world: Chamber Symphony op. 9 by Arnold Schoenberg (1874-1951) represented a major step towards the 'emancipation of dissonance', achieved by renouncing tonality, something to which audiences at the period were scarcely accustomed. The consequences were remarkable, and hard to envisage at the time. The 'Wiener Schule' of music (Anton von Webern,

Medicine

Alban Berg) was still producing important avant-garde works before the First World War.

The Secession's seventh exhibition was held from March to May 1900. Displayed was a painting by Klimt entitled *Philosophy* which released a wave of indignant protest. Many opponents of the Secession and the Modern Movement in Vienna seemed to have found here the ideal target for their hostility and a chance to air long-established opinions and prejudices. This may partly explain the violence of their reaction. For why should so many have protested against the picture, those steeped in the arts as strongly as the uninformed? The negative, even damning, response to Klimt's picture was so extensive that one of the Secession's supporters, the poet Hermann Bahr, went as far as to produce a book on the subject: *Gegen Klimt* (Against Klimt), published in 1903.

Briefly, to return to 1894: this was the year that Gustav Klimt and Franz Matsch were commissioned by the Ministry of Cultural Affairs to decorate the ceiling of the Great Hall in the University of Vienna. (The previous year the scheme designed by Matsch alone had been turned down.) The project was prescribed on wholly historicist lines: *Der Sieg des Lichtes über die Finsternis* (Triumph of Light over Darkness) was to be represented in the centre, while allegories of the four Faculties were to occupy the smaller areas of the ceiling. Klimt was assigned the three secular Faculties, *Philosophy*, *Medicine* and *Jurisprudence*, while Matsch was to be responsible for the centre, *Theology*. The plans were submitted to the Ministry in May 1898 and, after approval by the latter, Matsch and Klimt declared themselves 'ready to introduce modifications subject to preservation of artistic freedom'. As we have already seen, however, when Klimt's *Philosophy* was first shown at the Secession's exhibition in March 1900 it provoked a scandal. The University professors rose up in protest, among other reasons because they thought the painting was not in harmony with the Renaissance style of the building and because they thought the sacrosanct Hohe Schule (University College) was threatened. One of the professors claimed to be opposed not to nudity or freedom in the arts but to ugliness. Franz von Wickhoff, who held the Chair of History of Art, gave a lecture to mark the occasion called

'What is Ugly?', coming out strongly in Klimt's defence. And that same year, 1900, the painting won a prize at the Exposition Universelle in Paris.

The seeds of conflict dated back to the commissioning stage of the project. The work of the two artists had for some time been heading in different directions and Klimt's style had changed radically between his acceptance of the commission and the presentation of the first painting, *Philosophy*. This was not the case of Matsch, who respected the formal dictates of historicism up to the beginning of the twentieth century and was very successful as a 'society painter' thanks to the popularity of this style; he paid no heed to prevailing signs of change.

The second of the 'Fakultätsbilder', *Medicine*, was shown at the Secession's tenth exhibition (15 March – 12 May 1901). It drew the same response as the first painting. Again there was hostile criticism of an unfamiliar form of allegory which shunned neither ugliness nor nudity and was anything but idealised. Incomprehension and hostility were provoked by Klimt's divergence from the simple beauty of the classical forms of allegory. Once again Klimt's friends and supporters rose to his defence and that of the Secession. On 21 March a question was even raised in Parliament, so great were the repercussions of the affair. At Klimt's major exhibition at the Secession in 1903 the three 'Fakultätsbilder' provided an obvious focus of attention. *Jurisprudence* was there exhibited for the first time and Klimt's detractors once again foregathered. There was talk of 'pornography', of 'the excess of one depraved'. Klimt had accepted such attacks in previous years with equanimity; he had not let them disrupt his work and had made a half-humorous, half-mischievous riposte in his painting *An meine Kritiker* (To My Detractors). Though he changed its name to *Goldfish* for the exhibition, following the advice of his friends, the picture nonetheless made its point. And the entire press again resounded with cries of protest: the beautiful

smiling naiad is undeniably turning her bottom towards the viewer. But when *Jurisprudence*, too, came to be vilified, the artist lost patience. He wrote to the Ministry, which had treated him benevolently, but had not come sufficiently to his defence. Klimt asked to be allowed to keep his paintings, in exchange for which he undertook to refund his fees to date. The Ministry initially refused, urging him to complete and deliver the paintings. A few days later, on 12 April 1905, the Viennese journalist Bertha Zuckerkandl interviewed Klimt who firmly set out his point of view:

Jurisprudence

'The main reasons that have led me to want to take back my ceiling paintings . . . are not attributable to a fit of bad temper provoked by the various attacks. All that barely affected me at the time and would not have detracted from the pleasure the commission has given me. I am not very vulnerable to criticism in general, but I become more vulnerable when I feel that those who have given me a commission are not satisfied with my work. And this is precisely what is happening in the case of the ceiling.' Klimt made a further, and spirited, demand that art and the artist should in future remain free of all state interference. He concluded the interview somewhat petulantly: 'I shall not hand over my pictures unless driven to it by force.' Two weeks later the Ministry declared its willingness to give up any claim to these controversial paintings and Klimt repaid the money due with the help of the industrialist August Lederer. The latter became the owner of *Philosophy* in exchange and in 1907 Koloman Moser bought *Medicine* and *Jurisprudence*. After Moser's death in 1918, Lederer acquired the latter work. *Medicine* went to the Österreichische Gallery. On 5 May 1945 the sad and eventful tale of the three pictures was brought to a catastrophic end: they were destroyed in a fire at Schloss Immendorf in southern Austria, where they had been taken with other works of art to remove them from risk of war damage in

Vienna. Franz Matsch's painting, to which no one had paid any attention for a long time, was left in Vienna and survived the war intact – a particularly ironic twist of fate.

The story of the 'Fakultätsbilder' has been covered here at some length because if offers particular insight into the circumstances and mood prevailing over Viennese artistic life around 1900. Neither Klimt nor the other artists in the Secession allowed their work to be influenced by the affair; it nonetheless exposed them to the élitist thinking that they had themselves advocated and enshrined in their new statutes. It became clear that the new Viennese art was practised and accepted only by a relatively small number of artists and a minority of the public.

We can today form a rough idea of the coloration of the 'Fakultätsbilder': first thanks to a good colour reproduction of *Hygeia* from the allegory of *Medicine*; and then from Ludwig Hevesi's description of the three paintings, which appeared in 1903 in one of his publications. He sums up

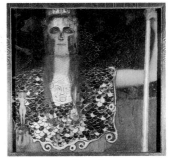

Pallas Athene

as follows: 'Let us look at the two side-sections *Philosophy* and *Medicine*. A mystic symphony in green and a sumptuous overture in red, each a purely decorative play of colour. Black and gold predominate in *Jurisprudence*. These are not true colours, a fact which lays the emphasis on lines and forms instead, investing the picture with a quality one can fittingly describe as monumental.' Nowadays one is driven to wonder if the rejection and the acclaim that accompanied the 'Fakultätsbilder' did not result from a double misunderstanding. The enthusiasm was perhaps generated not so much by approval of the artistic forms employed as by the way the artist managed

to free allegory from hardened old traditions without compromising its basic principle. Klimt wins admiration for his skill in giving new life to artistic forms that had seemed doomed. And the rejection of his work sprang from this same attempt to regenerate art. *Ver Sacrum*, a bibliophilic periodical of the Secession, published a well-founded reply to the professors' criticisms. Putting forward a global defence of art, the article tried to establish reasons for the rejection of the paintings and arrived at the following plausible explanation: 'He [a professor] makes no real demand of Art, what he seeks is that the Fine Arts, by all the techniques of deception at their disposal, evoke illusions of a purely literary nature. A force like Klimt's is far too valuable for this type of exercise, a good painter of words can perfectly meet such wants.'

The paintings *Philosophy* and *Medicine* were executed at the same time. The idea of setting a block of human figures opposite an empty space was already a feature of the preliminary drawings. *Jurisprudence* came after the first two paintings; it differs from them in its composition which moves away from a 'picturesque indefiniteness' towards a certainty 'achieved

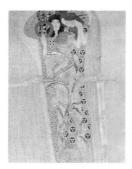

The Golden Knight

by means of the increasing force of the lines. And it is this force that imposes order on the picture as a whole' (Novotny). In *Jurisprudence* Klimt abandoned contrast as a means of figurative expression in favour of a new sense of unity. A few days before the private view at the Secession, he was still working on the picture and Hevesi came to take a look at it. The journalist had only a few days earlier returned from Sicily and, as if by inspiration, perceived a link between Klimt's monumental work and the gilded Byzantine mosaics found on the island. But what he noticed above all was a

sense of solemnity and hierarchy inspired by the room in which the picture was hanging.

It is interesting to observe here that neither 'friends' nor 'enemies' pointed out that the three paintings were displayed vertically on the wall and not, as had been envisaged originally, on the ceiling. Klimt himself seemed to have forgotten his original brief: the pictures had been painted not to be viewed from below, but

The Gorgons and the giant Typhoeus

as if intended to hang on a wall, and conceived independently of any particular architectural setting. The fourteenth exhibition of the Secession, lasting from 16 April to 27 June 1902, was one of the association's greatest successes. It stands out among all the notable exhibitions held in its eight-year existence. The plan was to organise the exhibition around a 'spiritual' centre represented in tangible form so as to create a form of 'spatial art' in the proper sense of the term. This centre was to be a monumental statue of Beethoven in bronze and coloured stones, evocative of the statues of the deities of antiquity. It was the work of Max Klinger, an artist from Leipzig who was well known at the time. Today the statue stands in the Leipzig Art Museum.

The exhibition was conceived as a tribute to a famous contemporary as much as to the genius of Beethoven. The catalogue refers to the aim 'to create a setting worthy of the sincere and magnificent tribute Klinger pays to Beethoven in his monument. This setting, although it was made to last for only a short period, in full awareness of its ephemerality, is intended to convey the individual's unceasing surrender of himself to his work.' In addition to the 'burning desire for a great task', another idea had

been influential: 'to attempt something which our age denies in the creative force of the artist: the well-designed arrangement of an interior'. The overall artistic direction was in the hands of Alfred Roller. Gustav Klimt and nineteen other Secessionists also provided contributions to this virtually 'sacred' exhibition devoted to Klinger's *Beethoven* and featuring murals, reliefs and sculptures. It was for this occasion that Klimt painted a frieze more than 30 metres long, executed on plaster mounted on straw. The work took months to complete and involved numerous drawings of details (over 100 survive, among them some of the finest examples of Klimt's early style, by this stage well established). The original intention had been to destroy the frieze immediately after the exhibition, but it was cut into eight sections in the winter 1903-4, on the initiative of Klimt's friends and collectors. August Lederer bought it, together with all the drawings. After an eventful history, the frieze was purchased by the Austrian State in 1973. It was completely restored and has been on display in the Secession building since 1986. So a work of art intended to last a few months has, after considerable efforts, been preserved, while the 'Fakultätsbilder', which were to decorate an official building 'for ever', have perished.

Josef Hoffman was responsible for the area's layout in which the frieze was displayed. Thanks to his well-conceived plan, the overall effect managed to be both theatrical and 'sacred', the architecture discreetly setting off the painting. The rough surface of the walls, in which the shallow alcoves were placed, formed an aesthetically pleasing background. A muted light fell from the ceiling. Below the frieze, the right wall gave on to an intermediate room leading the way to the focal point of the exhibition, the great statue of Beethoven. The section of the frieze lying above this passage was left starkly unpainted: a deliberate detail. The frieze itself featured Beethoven's Ninth Symphony; the catalogue explained the contents of the painting, from left to right following the successive groups of figures which were arranged in the form of a U: ' . . . first long wall . . . The burning desire for happiness. The suffer-

ings of feeble mankind. The two driving forces which appeal, externally on the one hand, to the strong and well-armed individual, and, internally on the other, to compassion and pity, both incitements to engage in the struggle for happiness. Short wall: the hostile powers. The giant Typhoeus, against whom the gods themselves fought in vain; his daughters the three Gorgons; sickness, madness, death, lust, lasciviousness, excess, gnawing grief. The cravings and desires of mankind float above. Second long wall: the desire for happiness finds fulfilment in poetry. The arts lead us to an ideal kingdom in which we can find joy, happiness, pure love. The heavenly choirs of angels: "Freude schöner Gotterfunken. Diesen Kuss der ganzen Welt." These last phrases are a direct quotation from Friedrich von Schiller of the choirs' final lines in the symphony.'

It has been shown that Klimt was referring in the frieze to an interpretation of Beethoven's symphony by Wagner. Performed in 1846, it laid emphasis on the struggle 'of the soul seeking for joy against the hostile powers that cut us off from earthly happiness and cast us into darkness with the wings of night'. Confronted by the enemy, we come to understand the noble resolution and virile energy of the resistance, which intensifies in open combat. Wagner then speaks of the 'ephemeral nature of happiness . . . until such time as the soul, tormented by the quest for joy, is freed by the universal love of mankind' (Bisanz-Prakken). In view of his ideas, in particular on collaboration in the arts, Wagner had always been the idol of the Secessionists. They perpetuated a tradition of Viennese historicism in their constant efforts to realise 'a total work of art'. It is in this context that one can best understand the enthusiasm and admiration Hevesi felt for the great Viennese historicist painter Hans Makart. We do not know who brought Wagner's interpretation of Beethoven's music to Klimt's notice, nor who drew up the complicated exhibition programme. But one can hazard a few guesses: Gustav Mahler numbered among Klimt's acquaintances and he may have put forward ideas. There are also facts pointing to

the painter and draughtsman Ernst Stohr (1860-1917), a musician by training, as the actual author of the programme. The preface to the exhibition catalogue and the comments quoted above were both by him. Klimt may also have had his personal situation in mind when he conceived the project: the struggle between the 'strong' in gilded armour and the 'hostile powers' can easily be read as a metaphor of the artist's own dilemma in a tense period of his life.

The *Beethoven Frieze* represents the undoubted culmination of 'stylistic' art and is notable for the strong emphasis given to surface effects. It is significant that Klimt

Poetry playing the Lute

moves radically away here from the picturesque and illusory character of the two first 'Fakultätsbilder'. The manner in which he superimposes human figures is directly inspired by Auguste Rodin's *Porte de l'Enfer*, greatly admired and praised by the Secessionists. (Rodin, in Vienna in June 1902, had met Klimt and his colleagues and visited the *Beethoven* exhibition.) The composition of the frieze on the other hand, like that of *Jurisprudence*, has its sources elsewhere. The extent to which Klimt assimilated the influences he came into contact with and interpreted them in his own manner was commented on even in his lifetime, and more than once. Artistic styles and techniques developed by others provided him with different means of expressing himself. In the *Beethoven Frieze* he drew inspiration from the figures of the Belgian sculptor Georges Minne who was well known in Vienna, and even more markedly from the painting of the Dutch artist Jan Toorop (1858-1928). Exhibitions of Toorop and Minne's work were held in 1899 in the Künstlerhaus in Vienna and in

1900, 1901 and 1902 at the Secession. All drew an enthusiastic response from Viennese artists. One cannot fail to see the influence that these compositions, as linear and angular as they were curvaceous and flowing, exercised over Klimt's Symbolist works. In 1893 Toorop had painted *The*

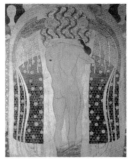

A Kiss for the Whole World

Three Brides, a monumental work of a wholly new kind. It revealed the undiscovered possibilities of art to Viennese painters, who proved their commitment to contemporary artistic developments by founding the Secession. It is not, of course, possible or appropriate to track down every single influence on an artist. Beyond Toorop one would need to go back to the English Pre-Raphaelites or the Belgian Fernand Khnopff. The Dutch artist did nonetheless play a significant part in Klimt's work at this stage. The *Beethoven Frieze* represents the culmination of modern monumental painting. The dissonances of form – naturalistic effects on the one hand, stylised composition with a profusion of decorative elements on the other – can be regarded as a deliberate extension of pictorial vocabulary. The message of the last scene (*The Heavenly Angels* and *A Kiss for the Whole World*) could probably not have been conveyed in naturalistic terms. Thus the forceful use of line that is characteristic of Toorop's art provides Klimt with a means of expressing the abstract message of the concluding section of the frieze: change for the Good.

A few years later, Klimt undertook for the last time the decoration of a room. The commission was a frieze for the dining room of the young Belgian industrialist Adolphe Stoclet, a familiar figure in Viennese artistic circles. The architect of the Palais Stoclet was Josef Hoffmann. Klimt spent some years designing the frieze

which diverged in many respects from its predecessor. The first difference was technical: the work was to be executed not by Klimt but by other artists following his designs; and different materials were to be used. The three sections of the frieze featured only one single figure and one pair: *Fulfilment*, represented by a couple embracing, is set opposite *Expectation*, symbolised by a woman alone. The figures do not stand out against a 'resounding emptiness' (Novotny), as was the case before, but are incorporated in an abstract

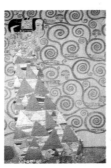

Expectation

and richly ornamental rendering of the Tree of Life. The narrow rectangular section of the frieze on the end wall of the room features an entirely abstract composition unique in Klimt's work. It is probably best understood as a decorative representation of Hoffmann's spatial ideas. The Stoclets, Adolphe and his wife Suzanne, owned a notable collection of works of art, which included a number of excellent oriental pieces, some of them Japanese. We can only guess at the direct influence this art-loving couple may have had on Klimt's work, but their collection, which was situated not far from the dining room, may well have acted as a stimulus to him. Unfortunately, no details have been left to posterity. The setting of the frieze and the style of Hoffmann's architecture obliged Klimt to 'create a unique work which would stand comparison with the masterpieces of past millenniums and those of the present day: a fountain by Georges Minne was placed in the great hall. The techniques applied – inlay of marble and pearl, mosaic, metal, ceramic and enamel – were without precedent' (A. Strobl). Klimt produced many drawings of details as well as models on a larger scale in colour and gold-leaf. It was from these models that the Wiener Werkstätte executed the frieze in a year and a half, under the direction of Josef Forstner. The work was

deliberately not shown to the public before being sent to Brussels in 1911, to avoid exposing Klimt to further attack. Hostility to his work was still current. The *Stoclet Frieze*, an important commission, is yet another illustration of Klimt's talent in adapting his work to a specific architectural setting. There was, of course, collaboration between him and the architect; this was in the spirit of a Gesamtkunstwerk (total work of art), much favoured at the period, and put into practice earlier in the *Beethoven* exhibition. The *Stoclet Frieze* also exemplifies another – and not the least – of Klimt's talents: his skill in responding to the stimulus of each new situation (in this case the Stoclet collection), as well as in drawing on sources 'in reserve'. Hence the female head in profile in *Expectation* is clearly inspired by Egyptian bas-reliefs, while the position of the arms and hands corresponds not only to gestures seen in the art of the Ancient Egyptians, but also to the movements of a dance popular at the time. A few years later Egon Schiele used the same gestures as a central feature in his portraits. *Fulfilment* is a reworking of a subject from the final scene of the *Beethoven Frieze*. This time Klimt's ornamentation is more futuristic, moving closer to that of his best-known work, *The Kiss*, produced in 1908. The harmonious play of gilded tones, pale marble and multicoloured inlay forms a background that is simultaneously ceremonious and bright. The same tones characterise some of his

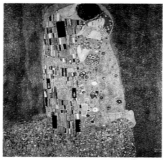

The Kiss

oil paintings of the period (*Friends, Adele Bloch-Bauer I*). This use of ornamentation as an almost integral part of a painting can be explained only in terms of a synergy with architecture. It represents, at any rate in Klimt's case, the final stage of a development the origins of which date back to his training at the Kunstgewerbeschule. Removed – or freed – from conventional spatial constraints, the pictures acquire something of the quality of richly decora-

tive icons, almost inviting adoration. From henceforth different elements come to the fore in Klimt's work: above all, colour, and in close association with it a new approach to naturalism.

There is little autobiographical documentation of Klimt's life: a brief handwritten curriculum vitae listing a few dates (perhaps linked to his unsuccessful candidature for a Chair at the Wiener Akademie), and the revealing interview by Bertha Zuckerkandl. Also extant are a good number of accounts and recollections by others which give a reasonably coherent view of Klimt's personality; and many photographs which reinforce the impression gained. A handful of references and quotations will tell us what we wish to know about Klimt's character and daily life.

Adolf Lichtwark described Klimt as 'stocky, rather stout, athletic ... curious and somewhat rough in manner, like a great strapping woodsman, with the tanned skin of a sailor, prominent cheekbones and keen eyes. When he speaks, his voice carries far, he has a strong accent. He loves to laugh often and hard at things.' A great beard and an unruly coronet of hair at times lent him the air of a faun.

An impression of Klimt's daily life and work has been left to us by Emil Pirchan: 'His ordinary working day was that of a respectable citizen, healthy and regular. Before six o'clock in the morning, he made a pilgrimage on foot to Tivoli near Schönbrunn; his friend the photographer Max Nahr accompanied him in his "morning prayers" for thirty years. Once arrived, they ate a substantial breakfast at the farm. Then he took a coach back to his studio in Josefstädterstrasse, impatient to start work. The studio was very simple, its only decoration being pictures resting on their easels. But in front of this simple house giving on to a courtyard there was a little garden in which Klimt planted his favourite flowers for use as models. Six, eight, and more cats lived there and as he could not part with any of his beloved animals, from time to time they had secretly to be disposed of because the pack increased at such a rapid rate and had damaged more than one picture. Klimt worked all day until dark; he spent most of his evenings in the company of friends. He

was very generous with money and willingly gave to those who asked for help.'

Carl Moll's memoirs (published in *Neue Wiener Tageblatt*, 24 Jan. 1943) are a valuable source of information. A loyal colleague of Klimt's at the Secession, from its foundation to its end, he confirms that Klimt was blessed with great physical strength, and that he sometimes engaged in sport, such as fencing or wrestling. Moll also observed that Klimt read much more extensively than other Viennese artists of the period and wherever he went he took his favourite work of Dante.

In 1912, on the artist's fiftieth birthday, Franz Servaes wrote a description of Klimt's studio (published in *Der Merker*). The studio was then at Heitzing, a suburb west of Vienna, at that time very countrified. Up to 1912, Klimt had worked in a studio on the ground floor of 21 Josefstädterstrasse, which in the very heart of the city, must have been charming with its neglected garden. This was the same

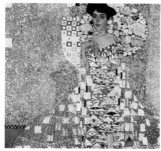

Portrait of Adele Bloch-Bauer I

studio he had established in 1892 with the Maler-Compagnie, and which Franz Matsch had left in 1893. The Heitzing studio was grander. In the ante-room was furniture designed by Josef Hoffmann and a collection of Japanese woodcuts and clothes from East Asia. Klimt himself always wore a plain blue tunic when he was working, which became his trademark.

Klimt's friends often crop up in the story of his life and art, speaking on his behalf and defending him when necessary. This was also true of those who admired and collected his work, such as August Lederer who came to the rescue at an opportune moment. Bertha Zuckerkandl and her husband, a well-known anatomist, kept open house for Klimt; their drawing room was a meeting place for artists,

writers and scientists. Bertha's sister Sophie was the wife of Paul Clemenceau, younger brother of Georges, the French statesman. Klimt and the Zuckerkandls seem to have been on easy social terms, but there was no talk of actual friendship. This is how Bertha later described the artist: 'An isolated figure, a loner, surfaced from the ancestral depths of a tribe, a people. Primitive and discerning, simple and complicated, but always full of soul.' Who, then, were his true friends? There is one unequivocal answer: Emilie Flöge. With her sisters Pauline and Helene she ran a well-known fashion salon, Schwestern Flöge, in Vienna. Ernst Klimt married Helene in 1891. After his death, Gustav took on responsibility as guardian of his young niece Helene. His relationship with Emilie, whom he never married, deeply influenced both his life and his work. He painted a life-size portrait of her (which she did not greatly like) and they used to spend the summer months together by the Attersee in northern Austria. Klimt's life thus fell into two parts, according to the time of year; he nonetheless continued working in the summer, as is shown by many landscapes featuring the lake and its surroundings. Many photographs survive of Klimt with Emilie, his family, friends and fellow artists by or on the water, in cheerful groups, on relaxed outings. Emilie kept nearly 400 postcards, letters and telegrams from Klimt. They confirm one's impression of him as a man of few words who nonetheless used them precisely. Most of his communications and greetings were brief and unemotional, but indicative of a

Emilie Flöge dressed for a concert

deep unspoken understanding. The art magazine *Deutsche Kunste und Dekoration* (1906-7) published photographs of Emilie taken by Klimt on the shores of the Attersee. The story goes that he himself designed some of the dresses Emilie is wearing in the photographs, but this has never been proved. The first words he uttered

after suffering an attack on 11 January 1918 testify to his strong attachment to her: 'I want Emilie to come.'

It requires no piercing insight to realise that Klimt was attracted by the opposite sex. His models played a significant part in his life, as is evidenced by a number of oil paintings and an abundance of drawings. Notwithstanding, these relationships did not exclusively or fundamentally dominate his figurative painting. Although much of his work may be erotic, it is in a sense that speaks of reverence and admiration for womanhood in general. 'He had . . . to safeguard his personal freedom to be able to create, and this is probably the very simple answer to the question: why did Klimt not marry Emilie Flöge?' (Nebehay 1969)

The *Stoclet Frieze* was Klimt's last massive work connected to an architectural setting and he left something of himself behind when it was finished. After this he concentrated on oil painting and drawing, which he practised constantly. His favourite subject continued to be female portraits, while Symbolist and allegorical works and, from 1898, landscapes, came to figure increasingly in his oeuvre. Klimt's portraits of women of the period are charged with undeniable artistic conviction, both in their intrinsic selves and as parts of a wider scene.

His allegorical compositions, some on a grand scale, continued on the lines he had long been pursuing: the inspiration of some of his paintings and a few of his large portraits is clearly derived from murals. Landscapes, on the other hand, represented a new departure. He painted them during the summer months spent with Emilie Flöge on the shores of the Attersee and they helped him to relax after the stressful controversies of life in Vienna. The year 1908 proved a watershed for Klimt. The reasons were various, but above all he seemed at this point to recognise the pervasive influences that were making themselves felt in Vienna, specifically in the work of young artists such as Oskar Kokoschka and Egon Schiele. More will be said of this in relation to the 'Kunstschau'. In autumn 1909 Klimt embarked on a journey to Paris and Madrid with his friend and colleague Carl Moll. In a joint postcard

addressed to Josef Hoffmann in Vienna, Moll wrote: 'Little squares are out, naturalism prevails,' and Klimt added teasingly: 'Spain and Moll wholly unsuited to *nocturnes*.' (Nebehay 1969.) Behind its happy holiday tone, the card was artistically significant. On the one hand it was alluding to Hoffmann's personal style; on the other it is worth remembering that the previous year Klimt had exhibited his great painting *The Kiss*, which is now a key work for all devotees of Jugendstil as well as the best

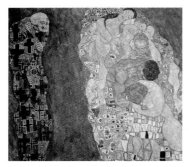

Death and Life

example of what is known as Klimt's 'Golden Period'. He ceased afterwards to use gold in his pictures, which is explained by the humorous remark 'naturalism prevails'. He also abandoned the, at times, extreme ornamentation of his figures, and consequently the deliberate contrast between naturalist and supernaturalist elements (Inkarnat).

Klimt must himself have sensed that he was in a cul-de-sac. He decided to turn his back on aestheticism with its emphasis on gilded decoration, perhaps reinforced in his resolve by the writings of the great Viennese architect Adolf Loos: *Ornament and Crime* (1908), a harsh critique of his Viennese fellow artists in which he argues that 'ornament is no longer an intrinsic part of our culture. It is no longer capable of evolution, it represents a regression or a pathological occurrence.'

Colour now assumed an increasing importance in Klimt's work, to the extent that it became an actual element of composition. On the journey mentioned above, Klimt studied the great works of

other artists and seemed most of all to have been impressed by El Greco. This experience perhaps reinforced his decision to seek a new direction. It is likely that in Paris he saw the work of the Fauves, the group centred on Henri Matisse and exhibited for the first time at the Salon d'Automne in 1905. Moll, who accompanied Klimt, was well abreast of the latest artistic developments. The new way of using colour had in any case already been seen in the Expressionist works of Die Brücke (The Bridge) in Dresden and Der Blaue Reiter (The Blue Rider) in Munich, before re-emerging in the highly coloured pictures Klimt produced after 1912 (*Adele Bloch-Bauer II*). Klimt continued to choose his subjects according to his own lights and his pictures were, both in their content and composition, effectively the 'descendants' of the 'Fakultätsbilder'. According to Novotny, 'Much of Klimt's work was dominated by the same problem: the acquisition of a pictorial method, a new method, and the rendering of a subject in terms that transcended it. A stronger, direct, connection between an idea and the form used to convey it constituted the novelty, the modern principle, more-or-less consciously applied.' The significance of this is that feelings, such as joy or unease, can be communicated by the lines of a painting. A perceptible contrast between the personae, either isolated or grouped, and a flat and indeterminate background contributes to the expression of feeling. Later, in Klimt's Symbolist and allegorical

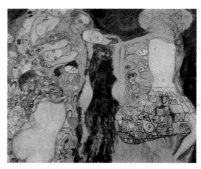

The Bride

compositions, *Death and Life*, *The Virgin*, *The Bride*, colour becomes increasingly important, until it is used as a means of communication in itself, a function once assigned to lines. The meaning of Klimt's allegorical paintings was, it would seem, intensely personal, although coded. There is no reason to doubt that Klimt's subjects here were of his own choosing, since he

was not restricted by the terms of a commission or a prescribed overall plan. This is in contrast to the *Beethoven Frieze*, which leaves one wondering who was the originator behind this complicated production. As far as subject-matter is concerned, *Hope* (1905) is a paraphrase of the upper part of *Medicine*, while *The Three Ages of Woman* (1905) can be linked to *Jurisprudence*. To the great consternation of his contemporaries, Klimt did various drawings in his studio of a pregnant woman which culminated in the painting *Hope*. On the advice of the Ministry of Education this picture was not included in the collective exhibition of 1903. A later version of the same subject, *Hope II*, was painted at the same time as *The Kiss* and the two pictures are closely related in composition, colouring and mood. If the subject of these works can be readily grasped and interpreted, the same is not true of later Symbolist works such as *The Virgin* and *The Bride*. The latter seem to be statements of Klimt's personal philosophy of life. According to his friends Klimt was acquainted with Nietzsche, some of whose ideas seem to have a bearing on the two pictures concerned.

The Kiss is not hard to interpret if one starts from the premise that it is directly related to the artist's own life and love: a couple kissing, kneeling on a ground of multi-coloured flowers, floating over an abyss, threatened, but beyond reach. The artist in Klimt could not, it is true, allow him to marry Emilie Flöge, but it enabled him to portray the real love he bore her. Klimt's subsequent Symbolist pictures never matched the emotional conviction seen here. Soon after finishing *The Kiss*, he embarked on a new work, *Death and Life*. An old colour photograph shows that he altered the original picture years afterwards. The changes provide an interesting clue to developments in his artistic thinking. They were made in 1907-8 and had the effect of diminishing the importance of line in the painting, while emphasising colour as a means of expression in its place; the use of gold was abandoned as being a 'non-colour'. In 1916 the artist changed the background of the picture from its original gold to blue and removed the halo, like a saint's, encircling the head of the figure of Death. The message initially conveyed by this symbol was expressed instead by blue, the colour of death. As in *The Kiss*, everything in the picture is unmis-

takable: the opposition of two figures or groups of figures in front of an empty space is a compositional motif already used by Klimt on a number of occasions: Death on the left, clad in a dark robe decorated with crosses; on the right a tangle of human figures, living, mingling, stout-limbed, full of colour. The humans smile beatifically: they feel safe in their island world, with no glance, no gesture in the direction of Death. They are caught up in the cycle of birth, life and death that is a central theme of Klimt's paintings, not in the pessimistic and depressed spirit of, say, Munch, but in a manner that is calm and almost light-hearted.

Some of Klimt's massive portraits of women, comparable to wall-paintings, seem to derive directly from his great cycles and friezes even if there is no link in subject matter. In this category are the portraits of Fritza Riedler (1906) and Adele Bloch-Bauer (1907). The portrait of Adele, the wife of a Viennese industrialist, is striking in its ornamentation which overruns the figure of Adele and the background and sets off the precisely rendered tints of her flesh. However, the absence of particular meaning stands out in comparison with *The Kiss*, equally skilful in technique, but produced at a later date. All this pompous 'Imperial' gold for a Viennese society lady? One could argue that Klimt had a purpose in decking out this lady and surrounding her in gold. One of his contemporaries termed the painting 'Idol in a Shower of Gold', showing himself to be an acute observer: the work is a glorification of femininity in the style of an Imperial painting. After visiting the mosaics in Ravenna in 1903, this genre of artistic vocabulary was added to Klimt's repertoire and it is likely that he had in mind the Empress Theodora de San Vitale when he decided to portray Adele Bloch-Bauer in this way. Perhaps he realised here the danger an excess of ornamentation presented to his art. This picture, rather than *The Kiss*, was to prove the culminating point of historicism: form and content attain a visible unity, virtually excluding colour, but incorporating a knowledge of history.

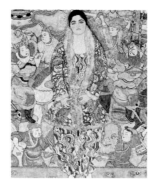

Portrait of Friedericke Maria Beer

Klimt is often credited with having produced the finest examples of female portraiture in the 1900s. His sensibility as an artist enabled him both to perceive and portray the duality of a woman's life at the period, caught between conservative traditions on the one hand and the stirrings of female emancipation on the other. He admired, even adulated women. This admiration made itself felt in his life as in his work. His female portraits present women on the threshold of 'their' century. The first portraits of Sonja Knips (1898) and Serena Lederer (1899) show an influence by the Europeanised American James McNeill Whistler (1834-1903), as well as by the thriving, home-based tradition of Hans Makart. Whistler was one of the first artists to draw inspiration from the art of the Far East, which makes him particularly interesting here. The oriental element is most apparent in his portraits of women in the 1860s; indeed it is hard to conceive of these being carried out independently of Japanese woodcuts (*Symphony in White II*, for example). The same influence is clearly to be seen in operation in Klimt's work at a later date: I shall refer to it simply as 'Japan', a source of inspiration that reached Klimt through the painting of Whistler.

In paintings such as *Judith I* or the portrait of a *Woman with a Hat and Feather Boa*, Klimt incarnated the dangerous and seductive *femmes fatales* of Vienna who now seem to typify the spirit of the 1900s. His portraits of the ladies Riedler and Bloch-Bauer in regal pose, represent, like *The Kiss*, an interim stage. They gave place

to what one can call the 'emancipation of the model'. The association of the traditional and the modern becomes perceptible in Klimt's painting after 1912. It is apparent both in the attitudes of the personae and the manner in which they are painted. The superimposition or mingling of figures identifies his works as true creations of the period. This is true even of his later painting, and despite the changes and developments that marked his career. His art now no longer looked to the future; tradition – even that established by Klimt's own work – was stronger than the influences from Paris, Munich or Dresden. Klimt's great artistic achievement, encompassed also in his later work, was to produce paintings of an age that was dying yet nonetheless trusted in the future, delightful fantasies innocent of social and political concerns. Of course, there are portraits that amount to more than the reflection of an age, such as those of Mäda Primavesi

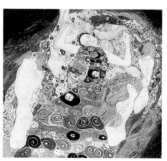

The Virgin

(1913-14), Elisabeth Bachofen-Ech (*c.* 1914) or Maria Beer-Monti (1916), to name but a few. They are set at the turn of the century, but do not foreshadow what is to come. (After 1896 Klimt painted no more male portraits.) The relationship of Klimt's painting to that of van Gogh, although much discussed, has little to add to our understanding. The two men shared a fascination with Japanese woodcuts, but this had long been current, and was common to other artists. After seeing van Gogh's work, in 1906 in the Miethke Gallery in Vienna, Klimt often expressed admiration for his work. But this is not sufficient grounds to assume an influence in the proper sense. The flat background against which van Gogh set his figures featured in Klimt's paintings from the outset. However, the use of multi-coloured decorative backgrounds, partially incorporating Japanese motifs (based on his collection of Japanese scrolls) could perhaps have been inspired by van Gogh.

At this same period, Henri Matisse (1869-1954) had caused controversy in the art world with his 'emotional conception of space' as a forceful means of expression (*Le Châle de Manille*, 1911). Was Klimt acquainted with this new theory? The Japanese exhibition organised by the Secession in 1900 had featured not only purely Japanese works, but also European ones of Japanese inspiration. Klimt, at least at this point, must have become acquainted with woodcuts and Noh masks (afterwards he owned one himself). The fixed expression of these masks inspired him on a number of occasions in his rendering of simple beatitude (as in *Death and Life* or *The Bride*).

To Klimt, landscape was an inner world, a source both of sadness and joy. The art historian Johannes Dobei offers this definition and it does indeed seem that landscape became for Klimt a way of being himself.

Even in his lifetime his landscapes were overshadowed by his figurative compositions and the reason is clear: his subjects lack the obvious appeal of his figurative paintings and are devoid of the slightest breath of eroticism. In his landscapes he captures the variations of atmosphere seen in nature, often achieving a successful marriage of form and content. This was the ultimate object of his struggle as an artist, both here and in his great figurative works. Landscape represents a sizeable proportion of his oeuvre, even although it is not

Tall Poplars II

the source of his fame. Indeed, roughly a quarter of the 222 oils, wall and ceiling paintings enumerated by Novotny and Dobai are landscapes. None of them was produced in his historicist period and even once he was a Secessionist he did not

embark on landscape until he first visited the shores of the Attersee. His paintings after 1900 were square and remained so for the rest of his life. This geometric shape 'suggests calm' and, regardless of variations of style, makes one appreciate landscape as an object of contemplation (Dobai). This theory is better understood if one remembers the extent to which Klimt was in need of calm and relaxation by the Attersee. Atmosphere plays a strong part in the first landscapes dating around 1900; it is

Field of Poppies

significant that the dominant motif is the tranquil surface of the water. There were two distinct sources of inspiration at work here: first, the Viennese tradition generally termed 'Stimmungsimpressionismus' (Impressionism of atmosphere); second, from abroad, the work of the Belgian Symbolist Fernand Khnopff and of James McNeill Whistler, whose paintings were exhibited in Vienna. The catalogue of Klimt's drawings (Strobl), numbering over 4000 works, includes not a single landscape. Klimt did produce drawings of nature but his sketchbooks, which became the property of Emilie Flöge, have unfortunately been lost. He once, in 1903, used gold in a landscape: *The Golden Apple Tree*, destroyed in the fire at Schloss Immendorf in 1945. This motif is a variation of the Tree of Life which figures predominantly in the *Stoclet Frieze*. Klimt represented the tree here in abstract and symbolic terms, as a tree of life or the tree of the temptation. At this period Klimt's landscapes became noticeably more individual, in the sense that his subjects lose their anonymity and acquire a character of their own. The titles of the works point to this tendency: *The Tall Poplar* (1903), *The Sunflower* (1906-7). If one pursues this idea one enters the realm of portraits. *The Sunflower* is a flower painting, but in practice a detail of a landscape. No one would ever categorise such a painting as a still life, even where the object concerned is meticulously rendered. This is because Klimt's

trees and flowers are treated as details from a natural setting, whereas a still life portrays objects uprooted from their normal context. The freshness of Klimt's vision is that he makes his details from nature play the part of a still life, of a motif in a work of art. The difference is apparent if one compares Klimt's *Sunflower* with van Gogh's *Sunflowers*.

Klimt's way of seeing details from nature, not as still lifes but as parts of a landscape, was rooted in a Viennese tradition that dates back to the Biedermeier period. It was the artist Olga Wisinger-Florian (1844-1926) who made these consciously restricted, thus very detailed, landscapes a feature of the painting of the end of the century. Over the years Klimt produced a range of different types of landscape: paintings dominated by treetops, others offering glimpses of gardens or fields, yet others featuring architectural motifs, for the most part houses. No human figures were included. The similarities and repetitions of subject-matter are explained by the frequency of his visits to the Attersee. There is a parallel with Monet's series. But it is a parallel limited to the repetition of subject: the tendency to compare Klimt's work to that of the Impressionists or Pointillists has a no more than superficial basis. If, for example, one considers a field by Klimt next to a work by Paul Signac, it is immediately apparent that Klimt's dots represent elements observable in nature, such as whole flowers or leaves, while in Pointillism the dots combine with almost scientific precision to create surfaces and bodies. Klimt thus took the Pointillists' method of working and immediately diverted its original purpose. To draw a parallel between Klimt's landscapes and Claude Monet's fields or luminous water effects requires clairvoyance. For example, in Monet's paintings of hay barns, light (the sun) is the dominant element, both in the composition of the work and as a source of colour. Besides the similarity of subject, Klimt's *Field of Poppies* (one example among others) is penetrated by the same bright and evenly spread – but not radiant – luminosity, a light that passes through each object and both background and foreground. The driving force of Klimt's paint-

ing is not, however, the light itself, but his composition, the choice of detail represented. This comes back to my earlier point about Klimt's landscapes as objects of contemplation.

They were all summer scenes, his paintings from his months by the shore of the lake. He never produced autumn or winter landscapes, or painted the delights of the country around Vienna, attractive though these proved to many other artists of his generation. Curiously he did one painting only of the park of the Schloss Schönbrunn, which he dearly loved and visited daily when in Vienna. He painted a view of Badgastein in 1917, on one of his three visits to this picturesque and fashionable town; and two landscapes resulted from his visit to Lake Garda. These two scenes of the lake introduce a last stage in his conception of landscape. Structural composition plays a more prominent part, at the expense of more indefinable attributes such as atmosphere. It is precisely these indefinable elements in his early landscapes that constitute their appeal.

The principal innovations of van Gogh and Cézanne's art, innovations also in relation to the Impressionists, formed the basis of these paintings. The precedent they set served an entire future generation of artists. While the Impressionists concentrated their attention on the everyday wonders of light and atmosphere, the founders of modern art sought rather to represent the inner life of their subjects. Klimt was a contributory force in the way he married the decorative in his landscapes to the Viennese conception of 'atmosphere'. This marriage gave birth to works of art of a rare intensity of feeling.

T he year 1908 marked a change of direction in Klimt's artistic development. In brief, he shifted from using line to using colour as the dominant means of expression in his painting and in consequence abandoned the use of gold for decorative effects. This change did not happen from one day to the next, nor without inner struggle. It could be said that as the nineteenth century yielded to the twentieth, line yielded to colour in Klimt's work.

It was from one day to the next, however, that a break of a different kind had taken place some three years previously: in spring 1905 Gustav Klimt and eighteen of the best-known members of the Secession left the association (among them were the architects Otto Wagner and Josef Hoffmann, the painters and decorators Carl Moll, Koloman Moser and Alfred Roller). So what can have driven them suddenly to leave this flourishing organisation? From the outset the Secession had comprised two artistic groups: those known as the 'stylists', and the 'naturalists', who were less modern in their approach, impervious to Jugendstil and loyal to the tradition of 'atmosphere' painting. Initially the two groups successfully complemented each other; but as time passed the fundamental differences between them became a source of tension. The 'naturalists' felt excluded from the successes of the Secession, which were achieved basically by the 'stylists'. Jealousy even spawned the idea of separate exhibitions, with 'pure' painting on the one hand, and 'stylistic' art on the other. Resentment was compounded by the fact that Carl Moll's activities were unpopular with his fellow artists: for some time he had acted as consultant to the famous Viennese art gallery run by H.O. Miethke. When the owner died, Moll was pressed to take over the direction and

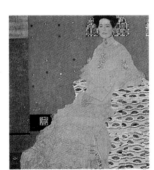

Portrait of Fritza Riedler

run it as a commercial gallery associated to the Secession. Many Secessionists objected to this idea, rightly believing that it was against their founding principles: the association had indeed originally resolved to spurn financial considerations. Furthermore, in 1903 Koloman Moser and Josef Hoffmann, both professors in the Fine Arts, had founded the Wiener Werkstätte with the financial backing of the banker Fritz Waerndorfer. Not surprisingly, this enterprise was obliged to be operated on a com-

mercial basis. Its purpose was to promote 'the economic interests of members by producing all kinds of objects within the scope of arts and crafts, and these to be designed by members of the co-operative. The business was to operate from workshops and the production was to be sold.' The Guild of Handicraft, directed by Charles Robert Ashbee (initially in London and from 1902 in Chipping Campden) in accordance with the ideas of John Ruskin and William Morris, had served as a model. The principle was that art should lie within

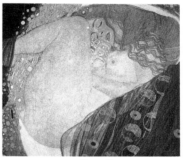

Danaë

everyone's means, moreover it should be both beautiful and functional. Success came quickly. New designs were produced in Viennese glass, ceramics, metalwork and furniture and the resulting objects ranked among the finest of the period. But those who saw themselves as custodians of artistic purity could not tolerate the close association between reputed Secessionists and a thriving business of this kind. There was open conflict and a vote took place over Moll's proposed involvement in art dealing. The 'group of painters' marginally outnumbered the 'Klimt group', who reacted by deciding to leave the association, and Ludwig Hevesi produced a 'posthumous tribute': a year after the event, he published *Acht Jahre Sezession* (Eight Years of Secession), a collection of the majority of articles which had appeared between 1897 and 1905 about the Secession, its activities, and various painters. This book is a prime source of information and is recognised, now more than ever, as an important period document. (Hevesi dedicated it to 'our friends and our enemies'.) After the departure of the 'Klimt group', the Secession faded into insignificance. Some of its functions were taken over by other artistic organisations, one of them being the moderately modern Hagenbund.

How much did all this controversy matter to Klimt? Once again he was in the front line: it was no coincidence that the name 'Klimt-gruppe' figured in the dispute. Yet possibly he was not dismayed by the turn of events. Since the Secession began, he had constantly been in the line of fire (not always from choice) and the chance to remove himself from controversy could have proved welcome. For all his strength of character, he must sometimes have needed calm for his painting, and not only during the summer months. The repeated scandals and attacks targeted at the Secession itself must also have taken their toll, and affected his relationship with more traditionalist colleagues. The outcome was that he retired into private life, but this did not exclude future projects. In 1906 the 'Klimt-gruppe' established itself as the Österreichischer Künstlerbund (Austrian Artists' Association), despite their lack of exhibition premises. Klimt exhibited his finally completed 'Fakultätsbilder' at the Miethke Galerie. This was also where the Moderns and a number of their forerunners showed their work at the instigation of Moll. Had it not been for the breaking away of the Klimt group, these exhibitions would have been undertaken by the Secession.

In 1908 Austria celebrated the sixtieth anniversary of the Emperor Franz-Josef I's accession to the throne. A great pageant was staged in Vienna, recalling that held in 1879 to celebrate the Imperial couple's

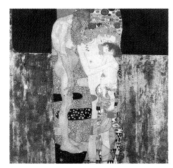

The Three Ages of Woman

golden wedding, which Makart had designed. The progressive artists joined in the jubilee celebrations by organising a tremendous exhibition. Klimt, Moll and the Wiener Werkstätte run by Hoffmann

and Moser staged the 'Kunstschau' (Art Show) on a piece of land earmarked for a new concert hall. This was the most important exhibition of art, arts & crafts, and architecture ever to take place in Vienna. The 'Kunstschau', symbol of the new Viennese art, became a focus of attention, as the Secession's first exhibition had done in 1898. Der Zeit ihre Kunst, der Kunst ihre Freiheit (To Each Age its Art, to Art its Freedom), the Secession motto, was even

Klimt on his Death-bed (E. Schiele)

painted on the façade of the temporary building Hoffmann erected for the occasion. The 'Kunstschau' was held two years running, in 1908 and 1909. The two exhibitions were intended as parts of a combined whole: the first featured Austrian art only (one room was given over to Klimt's work: *The Kiss, Adele Bloch-Bauer I, Fritza Riedler, Danaë*); the second also included international contemporary art. Both exhibitions showed the work of the young Austrian Expressionists for the first time. It is to the credit of Klimt, Moll and Hoffmann that they helped bring the up-and-coming generation to the notice of the public. In 1908 Oskar Kokoschka (1886-1980) was assigned a room in the exhibition entirely for his work; the 'Wilde Kabinette' (Wild Beasts' Room) provoked a scandal, while the 'Kunstschau' as a whole was enthusiastically acclaimed. Klimt, as the most famous of the principals, made a brief introductory speech in which he referred to the exhibition as the 'crucible of Austrian artistic endeavour' and the 'truest review of the present state of the arts in our Empire'.

In the second year of the 'Kunstschau' Egon Schiele (1890-1918) exhibited paintings, as did other young artists. His portraits of nudes at the period betray a distinct influence by Klimt, whose work he

greatly admired. Already, however, his art showed signs of the Expressionism that coincided with his departure from the 'Akademie' and was far removed from the pleasing lines of Klimt's work. It is beyond the scope of this essay to discuss the young Viennese Expressionists in detail. I shall discuss only briefly how the paintings they exhibited in each 'Kunstschau' held the seeds of their extraordinary future development. The highly nervous quality of Oskar Kokoschka's painting and graphic art was most visible in the portraits he produced under the initial influence of Adolf Loos: his use of line was the dominant expressive force, but without any tendency to stylisation. Kokoschka enjoyed the role of *enfant terrible* at this point. Moser and Hoffmann had arranged that he work for the Wiener Werkstätte, which brought him into contact with Klimt and his group of Secessionists; this was apparently how he also came to be involved in the 'Kunstschau'. While Kokoschka bared the soul in his portraits, Egon Schiele, once he had broken away from Klimt's influence, was dominantly preoccupied with existentialist questions, which he interpreted in terms of the duality of life and death (Werkner). Klimt's contacts with these young artists and their new art were not without influence on his own work. (As soon as Schiele left the 'Akademie', he founded a fairly informal artistic association known as the 'Neukunst-gruppe', many of whose members had a determining influence on Austrian art of the 1920s and 1930s.) Klimt seemed fairly impressed by Schiele himself: in *The Family*, painted in 1909, he appears to have observed the melancholy spirit in which Schiele handled birth and death and even adopts Schiele's form of composition. This is another possible explanation for his abandonment of gold and ornamentation.

In addition to his work for the 'Kunstschau', Klimt's post-Secessionist period brought definite advantages: first and foremost, he was no longer constantly in the public eye. After the storm about the 'Fakultätsbilder', no more official commissions were forthcoming, which left Klimt correspondingly free from the stresses of executing them. As he no longer had exhibition premises at his disposal, he ex-

hibited abroad more frequently and won a degree of recognition, although not to the point of international acclaim. He travelled more often, without becoming an inveterate traveller; for example, in 1905 he attended an exhibition of his own work in Berlin. In 1906 he spent some time in Brussels, probably in connection with the *Stoclet Frieze*. Then he went to London in the company of his friend Fritz Waerndorfer. There he probably met Charles Rennie Mackintosh and his wife Margaret, whose work he liked and valued. This couple had been responsible for the decoration of the Waerndorfer's music room.

In 1909 Klimt went on a journey to Spain and Paris, as has already been mentioned; and in 1911 he attended the great international exhibition in Rome (on that occasion the Galleria Nazionale d'Arte Moderna, Rome, bought his *The Three Ages of Woman*). On 11 January 1918 Klimt had a stroke which left him hemiplegic. Just as there was hope of an improvement, an attack of pneumonia brought further complications. On 6 February 1918 Klimt died. In the morgue Egon Schiele, who had been both Klimt's protégé and his friend, drew his death-mask: 'I found Klimt very changed,' were his words, 'he had been shaved. I hardly recognised him, stretched out on his death-bed.' The year 1918 witnessed not only the fall of the monarchy

Signature and Monogram

reigning over the Danube, but the end of an artistic epoch. An entire generation of Viennese artists, the practitioners of the new art of the Secession, perished, among them the most illustrious: Otto Wagner, Koloman Moser and the precocious Egon Schiele, died that same year. There was no successor to Klimt, setting aside a few superficial candidates. The Secession had long faded into insignificance. And the post-Klimtian art of Austria was developed from the seeds he had sown by encouraging the next generation.

Gustav Klimt can ultimately be described as an artist of transition. When one considers his work as a whole, stretching over nearly four decades (distributed equally between the old century and the new), what is initially most striking is how his first works clearly belong to the historicist tradition. This is true as much of his monumental works as of his designs and models for individual projects. Klimt's move away from the 'official and baroque' in his interior decoration coincided with the break-up of the Maler-Compagnie and followed a deliberate study of artistic models. On the international scene there was art nouveau, Jugendstil, Stile Liberty on the one hand, and the work of the Belgian and Munich Symbolists, particularly Franz von Stuck, on the other. Between 1897 and 1918 Klimt was the most prominent artistic figure in Vienna, above all on account of his painting, but also because of his active role in founding the Secession, defending artistic freedom, and encouraging the new generation of artists.

His painting, initially rooted in the established historicist tradition of Vienna, had by the end of the century absorbed other influences, themselves not exactly harbingers of the future. He assimilated the severe linear designs of Mackintosh, the spare and flowing compositions of Toorop, in such a way that line did not tyrannise his work but achieved a harmonious association of painting, dynamic and highly coloured decorative effects, and empty space. The great cycles on which he collaborated with Hoffmann were realisations of an idea current among artists of the time: 'a total work of art'. One can see them as the final productions of a dying era. Klimt's discovery of the artistic innovations of the Parisian art scene between 1905 and 1910 did not alter the course of his own work: such a change would not have been consonant either with his own artistic evolution or the situation in Vienna; nor with

his age, no longer youthful. As we have seen, through his life he drew on a number of artistic models, usually several years after the first contact, always transforming them in a very personal way. Klimt's late work was characterised by the importance assigned to colour. This was not a move towards a new style, or the introduction of a new idea, but a modification inspired by a new way of seeing things, a shift of values. The innovatory elements of his late painting were not sufficient ground to lead the way towards a 'post-Klimt' phase. So what is it that makes Klimt such a highly fascinating artist? He was neither a rebel, nor an innovator, nor one of the avant-garde; his painting was not a formative influence on the art of the twentieth century. His secret lies rather in his interweaving of traditional and modern art, placed as he was between the old and the new, between two epochs. It lies also in the quality of his drawings and painting, the beauty of his decorative effects, the mystery underlying his multiplicity of forms. It derives from the beauty of his feminine figures; fragile and gentle, they seem to float before the viewer's eyes, charged with bewitching powers of seduction, or the enigmatic aloofness of the ladies of Vienna Society.

Klimt's work was the expression of an age, an epoch in the history of Vienna, of Austria, which in a few years, in a confined space, and an atmosphere often charged with tension, witnessed a surge of tremendous creativity. The music of Gustav Mahler, the discoveries of Sigmund Freud, seem to have a place in Klimt's work. The elegance, the beauty of his art, moved by a deep sensibility, renders for us a humanity that is unconscious of the abyss. *The Kiss* provides us with a final, fitting metaphor of Klimt's art: the image of a kneeling couple, embracing on a bed of flowers, self-enclosed, oblivious to the world around them.

GERBERT FRODL

1862

Gustav Klimt was born on 14 July 1862 in Baumgarten, then a rural suburb of Vienna. His father, Ernst Klimt, was a goldsmith and engraver and set the boy Gustav on the path that later took him to the School of Arts & Crafts. His mother Anna is said in her youth to have wanted to make a career as a singer. There was some suggestion that she suffered from mental illness, but the truth of this is now in question. What we do know is that Gustav Klimt read extensively about the subject and about heredity. He himself was timid, full of complexes, and suffered from bouts of depression. His ostensibly middle-class upbringing harboured its secrets and he jealously defended his privacy. A hatred of appearing in public led him to refuse to be interviewed, even when he found himself in the forefront of artistic events and controversies in Vienna. Gustav was the second of seven children, three of whom pursued careers in the arts. His brother Ernst worked with Gustav in the same workshop until his death (the same year as their father, 1892). Georg was a sculptor and engraver, later becoming a professor at the Vienna Art School for Women. He made many metal frames for Gustav's canvases. The four sisters, Klara, Hermine, Anna and Johanna, and also the Klimt parents, all sat as models for Gustav and Ernst's early work, most notably for their paintings for the Burgtheater and the Kunsthistorisches Museum. The family was bitterly affected by the economic crisis in Vienna at that time and suffered serious financial difficulties. In 1876, when he was fourteen, Gustav was given a bursary to attend the School of Arts & Crafts attached to the Austrian Museum of Art (now the Austrian Museum of Applied Arts).

1

2

1
The house in which Gustav Klimt was born: Linzerstrasse 247, Vienna 14. On the right of the front door are the rooms occupied by the Klimt family.

2
A card send by Gustav Klimt to his mother in 1904. The picture is of himself.

3
Gustav Klimt's mother is wearing a cameo made by her son Georg in this drawing. It represents Aurora's chariot and is today in the Rudolf Zimpel Collection in Vienna.

3 *The Artist's Mother, Anna Klimt*, 1879
Drawing, 22.5 x 16.5 cm
Rudolf Zimpel Collection, Vienna

4 *Portrait of the Artist's Father in Dutch Dress*, Ernst Klimt
Study for a decorative painting in the Kunsthistorisches Museum
Rudolf Zimpel Collection, Vienna

3

4

1876

'In October 1876 I was admitted as a pupil at the School of Applied Arts of the Austrian Museum for Art & Industry and for two years I attended the preparatory class run by Professors Riesre, Minnigerode and Hrachownina, and carried on my training at the School of Professional Painting run by Professor Ferdinand Laufberger: I stayed there until his death in 1881. I continued my studies at the same school under Professor Berger for a further two years. In all that makes seven years . . . ,' explains Klimt's curriculum vitae, as recorded by Emil Pirchan in 1916. The school records confirm that Klimt attended classes in technical drawing in 1876-7, and drawing and painting classes in 1878-9. His brother Ernst joined him a year later, in 1877. In their free time, the two brothers drew portraits from photographs, which they sold for six guilders apiece. The technical training they received was complemented by a thorough study of history of art from its earliest beginnings, a subject on which Klimt drew throughout his career. He found source material in the Museum, which he visited regularly. A document in the archives records that he executed a copy of Titian's *Portrait of Isabella d'Este*; and a water-colour after a picture by Moretto da Brescia is now in the Rudolf Zimpel Collection. His academic training was of the most traditional kind and his first works were strongly influenced by the style of Professor Laufberger. The Klimt brothers and Franz Matsch, whom they met at the School, collaborated with him from 1879 onwards. They worked on Laufberger's scheme for the decoration of the courtyard of the Vienna History of Art Museum and similarly contributed to the pageant staged in honour of the Imperial couple's golden wedding. The designs for this occasion were by Hans Makart, the Viennese painter of historicist and allegorical works. The spectacle, which the whole of Vienna was bidden to attend, featured numerous horse-drawn floats and a procession of thousands of people. Hans Makart's baroque and allegorical style was an important influence on Klimt's early work.

1

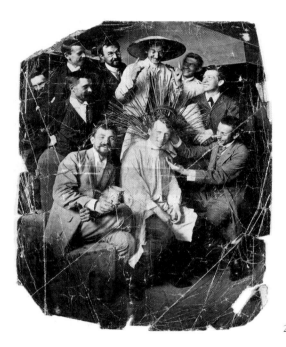

1
The Vienna School of Arts & Crafts, which Klimt and his brother Ernst attended between 1876 and 1883.

2
Class photograph: front row, holding the cup: Ernst Klimt; second row: Franz Matsch; at the back with a lorgnette: Gustav Klimt.

3
Photograph of Laufberger's class of 1880: front row, right: Gustav and Ernst; back row in dark suit: Franz Matsch.

2

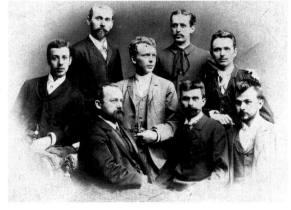

3

1 *Museum of Applied Arts and School of Arts & Crafts*, 1891
J. Varone U.L. Petrovits
Drawing & water-colour
Historisches Museum der Stadt, Vienna

4 *Head of a Young Girl, turned to the right*, study for *Juliet* in The Globe Theatre, c. 1886
Pencil, black chalk, highlighted in white, 27.6 x 42.4 cm
Albertina, Vienna

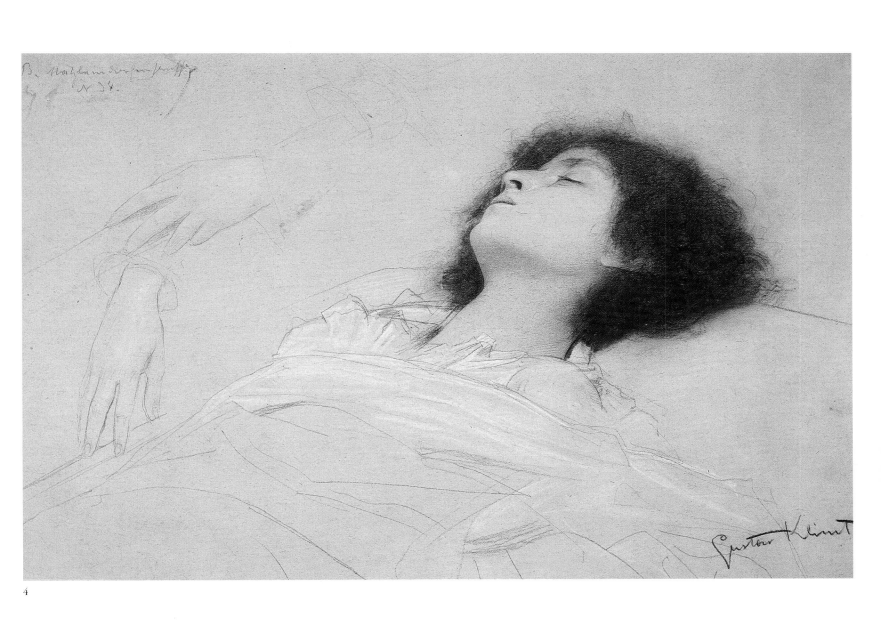

4

In his last two years at the School of Applied Arts, Gustav Klimt was already busy with commissions. In 1880 Gustav and Franz Matsch worked on their first job together: the painting of four medallions in the corners of a ceiling in a house belonging to the architect Sturany.

1880

1
The first studio: 1883-6. The studio was on the now renovated fourth floor of Sandwirtgasse 8, Vienna.

1

These paintings were allegories of poetry, music, dance and theatre, wholly conventional, and in the pure baroque tradition favoured by their professor, Laufberger. While it is impossible to tell which artist did which painting, what is clear is that by their fourth year at the School they had acquired a sound knowlege of the history of art. Laufberger recommended them to a firm of architects specialising in the design of theatres, Fellner & Helmer. As a result Klimt worked on the decoration of a thermal establishment in Karlovy Vary (Carlsbad, 1880-2) and the municipal theatre of Liberec (Reichenberg, 1882-3). In addition to the decoration of various theatres and private houses, Klimt was asked in 1881 by the publisher Martin Gerlach to contribute to a lavish publication on the subject of *Allegories and Emblems*. This involved the figurative representation of allegories of real or idealised life as much as the personification of abstract ideas, indeed of virtually any aspect of human existence. Thus Love is found side by side with Economy, Death or Immortality. While some of Klimt's compositions did not go further than the drawing stage, as, for instance, *The Fairy-Tale* (1884) and *Sculpture* (1896), *Fable* and *Idyll* were produced in oil. These works drew their inspiration from the old masters.

2
These four allegories return to classical iconographic tradition. The neo-baroque style corresponds to the teaching Klimt received at the School of Arts & Crafts.

2

34

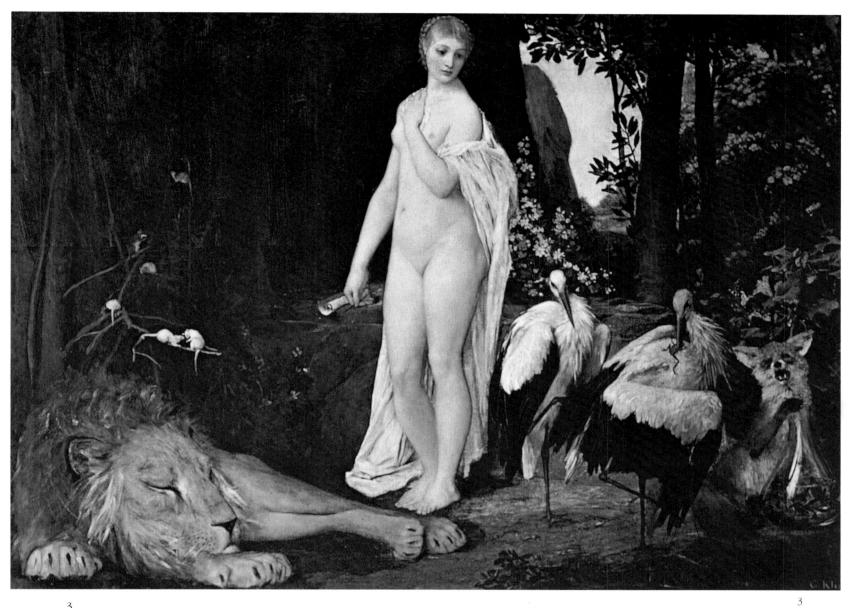

3
Fable, represented by a female
nude in a wood populated by
animals, is modelled on
seventeenth-century Nordic
paintings. The academically
rendered nude holds no hint of
Klimt's later 'Golden Period'.

3

2 *Poetry, Music, Dance, Theatre*, 1880
Oil on cavas. Medallions in ceiling corners
House of the architect Sturany, Schohenring 21, Vienna

3 *Fable*, 1883
Oil on canvas, 84.5 x 117 cm
Historisches Museum der Stadt, Vienna

At the end of the nineteenth and beginning of the twentieth centuries, Vienna, capital of the Austro-Hungarian Empire since 1867, was humming with artistic activity. This high seat of culture, however, was not free from tensions. First, there was ethnic conflict in the Empire, particularly concerning the Serbians; second, there was terrible poverty in Vienna itself resulting from a considerable growth in population. The city and its surrounding areas numbered some two million inhabitants. To deal with housing problems, the Emperor drew up a plan to destroy the city fortifications and build in their place.

In 1887 Klimt was commissioned to paint a picture of the auditorium of the Burgtheater on the Michaelerplatz, prior to its scheduled demolition. A final performance was staged there on 12 October 1888. The theatre had been an important centre for the musical world, as well as providing a gathering place for the Court, the old aristocracy and the new bourgeoisie. Klimt did many studies for his large group painting, in which celebrities are mixed with people from his own immediate circle. His brother Ernst, for example, is to be seen in the second row on the left. Altogether Klimt produced over a hundred individual portraits, featured among them the Emperor's mistress, Katherina Schratt, and the future Mayor of Vienna, the Christian Social Democrat Karl Lueger. The painting earned Klimt the 'Emperor's Prize' in 1890. Its matching piece, which presents the stage seen from the auditorium, was painted at the same time by Franz Matsch.

1

1
Elisabeth, having married Franz-Josef in 1854, was a timorous and unhappy Empress. Her lack of interest in Court life and etiquette led her to neglect her double role of Empress and Emperor's wife in favour of extensive travel. She was assassinated in Geneva by the anarchist Luigi Luccheni while on the point of boarding a steamer on Lake Geneva. She was sixty-one at the time.

2
The Emperor Franz-Josef and Archduke Franz-Ferdinand, heir to the throne, were assassinated with the latter's wife at Sarajevo on 28 June 1914. Franz-Josef's reign began in 1848, the year of the French Revolution. He ruled over Austria for over sixty-eight years, until his death in 1916.

3
The Opera was inaugurated in 1869, the first public building in the Ringstrasse to be completed. It is an example of the historicist style that is characteristic of the buildings of the Ringstrasse.

2

3

1 The Empress Elisabeth
Historisches Museum der Stadt, Vienna

2 The Emperor Franz-Josef and the Archduke Franz-Ferdinand
Historisches Museum der Stadt, Vienna

3 The square in front of the Opera in 1900
Historisches Museum der Stadt, Vienna

4 *Auditorium of the old Burgtheater*, 1888
Gouache on paper, 82 x 92 cm
Historisches Museum der Stadt, Vienna

Vienna

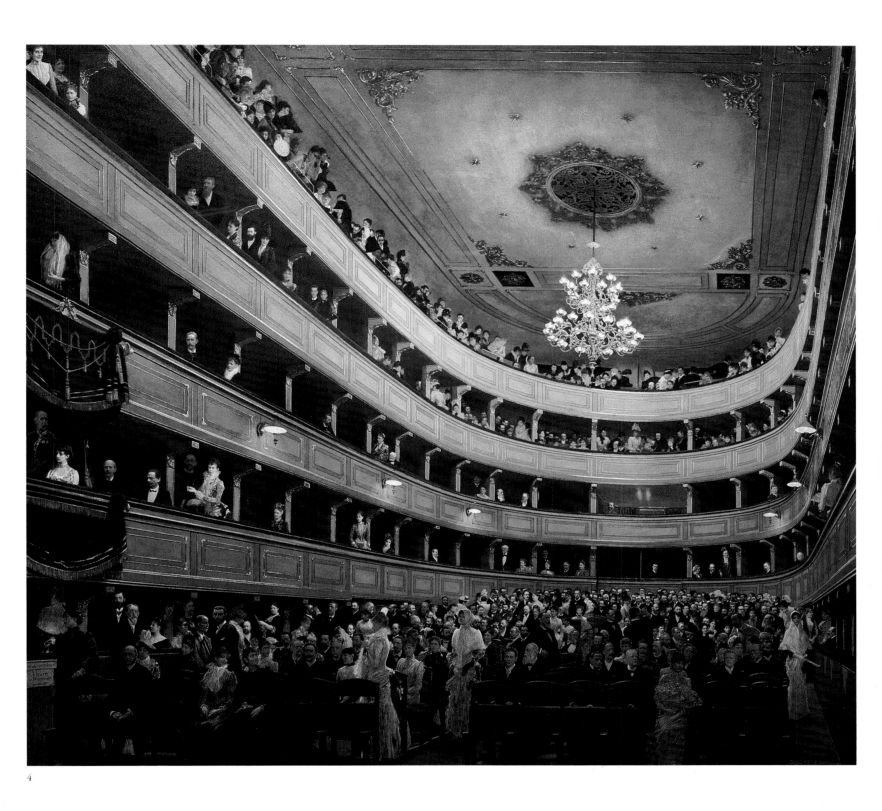

'When I stroll down the Ring, I always feel as if a modern Potemkin has wanted to create the impression one is entering the kingdom of the nobility . . .' (Adolf Loos)

Klimt left his school with a diploma as an architectural decorator and it was as such that he became successful. He worked with his brother and Franz Matsch on the decoration of the last two great buildings in the Ringstrasse: the Burgtheater and the Kunsthistorisches Museum. The Ringstrasse occupied the site of the old city fortifications, destroyed by the Emperor's decree in 1857. The new buildings, both public and private, separated the old city from the suburbs. The Burgtheater, built between 1874 and 1888 by Gottfried Semper and Carl Hasenauer, was designed in the baroque style, looking back to an age when the theatre was first the means of bringing together men of the Church, courtiers and ordinary citizens.

Between 1886 and 1888 Klimt worked with his brother Ernst and his colleague Franz Matsch on lunettes and panels on the ceiling above the great staircase in the Burgtheater. The general theme of the paintings had been prescribed: they were to illustrate the history of theatre by means of contemporary, allegorical or mythological scenes. *The Globe Theatre* and *The Auditorium of the old Burgtheater* are magnificent both as period pieces and illustrations of Klimt's art. For *The Globe Theatre*, he used himself and members of his family as models. There are many photographs to prove that Georg posed for Romeo, while Hermine Klimt, one of his sisters, regularly sat for him in different costumes, representing a variety of ladies in the audience. The group of three men on the right consists of Ernst, Franz Matsch, and Klimt himself, wearing a large ruff. This is the only self-portrait produced by Klimt, in the manner of the old masters. The example that springs to mind is Raphael, and his contemporary Sodoma, in the assembly of philosophers and scientists in *The School of Athens* (see p. 46).

2

3

1
Dionysus, god of wine and inspiration, was fêted with tumultuous processions, giving birth to theatre, comedy, tragedy and satire. The companion to this picture is *The Altar of Apollo*, the god of poetic inspiration, a role shared with Dionysus.

2
Klimt showed commendable skill in adapting this theatrical scene to the unusually shaped frame imposed on him. He produced some brilliant touches to deal with the intrinsic problems, an example being the theatre box featured in the top right indentation of the frame.

3
The ceiling of the stairwell of the Burgtheater. The paintings are set into the elaborate stucco decoration.

1 *The Altar of Dionysus*, 1886-8
Oil on canvas, 160 x 1200 cm
Lunette on stairwell ceiling,
Burgtheater, Vienna

2 *The Globe Theatre*, 1886-8
Oil on canvas, 240 x 400 cm
Panel on stairwell ceiling,
Burgtheater, Vienna

4 *The Theatre in Taormina*, 1886-8
Oil on canvas, 240 x 400 cm
Central panel of stairwell
ceiling, Burgtheater, Vienna

Hodler and Klimt were on friendly personal terms. The work of the Swiss Symbolist was held in high esteem by the Viennese and in 1904 he exhibited thirty-four paintings at one of the Secession's exhibitions in Vienna.

2
Jeune Fille Thrace Portant la Tête d'Orphée is dated 1865, the same year as *Alice in Wonderland*. The painting is praised for 'its grandiose scenery, fairy-tale sky and the beauty of the heads of Orpheus and the young girl'. It became an important point of reference for the Symbolists.

W hat has been termed Symbolism in painting is the visual expression of emotions, dreams, ideas and the myths of literature. The quest for the secret, the unravelling of the mystery, is an imporant part, and the sphinx an apt example. Khnopff's painting *The Sphinx* 'is a dream made flesh that invites the thoughts on a journey towards the mystery,' writes Emile Verhaeren. An iconographic motif much explored by painters, the sphinx becomes in Klimt's work an expression of the mystery of the universe. It appears in *Music*, for the Dumba Villa, and in *Philosophy*, one of his University paintings. The Belgian painter Khnopff was invited to Vienna in 1898 to take part in the inaugural exhibition of the Secession. He showed some twenty paintings there, among them *The Sphinx* (also entitled *Art* or *Caresses*). It is an ambiguous image, apparently inspired by Péladan's praises of androgyny. The Swiss artist Ferdinand Hodler, who was much influenced by Puvis de Chavannes, became a member of the Vienna Secession in 1900. His painting *The Chosen One* was a model for Klimt's *Choir of Angels* which precedes *The Kiss* in the *Beethoven Frieze*. The Dutch painter Jan Toorop was similarly invited on a number of occasions to exhibit at the Secession and a special issue of *Ver Sacrum* was devoted to his work. He was a considerable source of inspiration to Klimt, particularly his floating human figures, echoes of which are present in the *Beethoven Frieze*.

3
Khnopff's painting reveals a close kinship to the work of the Pre-Raphaelites, Burne-Jones in particular.

'Art is moving away from naturalism; it is looking for something new ... one's desire is to flee from visible reality at any price, to take refuge in the shadows, in the unknown, in what is secret.'
(Hermann Bahr, 1894)

1 *The Chosen One*, 1893-4. Ferdinand Hodler
Distemper & oil on canvas, 219 x 296 cm
Kunstmuseum (G. Keller Foundation), Berne

2 *Jeune Fille Thrace Portant la Tête d'Orphée*, 1865. Gustave Moreau
Oil on wood, 154 x 99.5 cm
Musée d'Orsay, Paris

3 *The Sphinx* (or *Art* or *Caresses*), 1896. Ferdinand Khnopff
Oil on canvas, 50.5 x 150 cm
Musées Royaux des Beaux-Arts, Brussels

4 *Sappho*, 1888-90
Oil on canvas, 39 x 31.6 cm
Historisches Museum der Stadt, Vienna

4
Sappho, Greek poetess of the seventh-sixth centuries BC, a married woman with a daughter, caused scandal by voicing her attraction to some of her pupils in her verses. A writer of an erotic lyricism, she celebrated love, beauty and feminine grace, and was understandably a source of inspiration to Klimt, painter of women par excellence.

Following in the footsteps of the Pre-Raphaelites, Whistler, or such French artists as Puvis de Chavannes, Gustav Klimt designed his own frames. They were far removed aesthetically from the white frame advocated by Pissarro and his Impressionist friends. Doing away with the traditional heavy gold frame, Klimt substituted one with a wide, flat, ornamented edge. The most extravagant example is the frame of Klimt's virtually photographic portrait of the pianist Joseph Pembauer. It is decorated with a symbolic musical motif, representing the lyre, in clear reference to the subject of the painting. Klimt adds other details to achieve an 'antique' decorative effect, for instance the tripod on the left, or the fantastical column to the right on which stands a Greek figure (Apollo?) playing the lyre. Other unusual elements appear on the upper and lower edges of the frame: the strangest is the set of initials G.S. accompanying a spatula which was the trademark of a well-known Munich brasserie. They all contribute to the overall sense of a music-inspired dream in which the frame, like the painting, has a message to convey. For all his innovatory elements, Klimt never wholly abandoned the gilded patina of the traditional frame, which continues to feature to a greater or lesser extent, sometimes only on two borders, as in the case of *Love* (Historisches Museum der Stadt, Vienna) or *Judith II* (Galleria d'Arte Moderna, Venice). The ornamentation can at times be very restrained, as, for example, the abstract design chased in the metal frame of *Pallas Athene*. Klimt's use of the frame was one of the most various and original of his period.

1

The frame of *Pallas Athene*, emblem of the Secession, was produced by the brothers Gustav and Georg Klimt in collaboration. The latter, a sculptor also skilled in metalwork, made the frame in embossed copper.

2

Puvis de Chavannes painted the decorative frame of his painting himself. He did this for a number of his oil paintings. On the bottom edge of the frame is inscribed: 'Having escaped the claws of the enemy, the awaited message lifts the hearts of the proud city.'

3

Klimt transposed on to this frame motifs he had observed on Greek vases. The modern style beginning to emerge in his work coexists with archaic decorative effects.

2

1 *Pallas Athene*, 1898
Oil on canvas with inlay, 75 x 75 cm
Historisches Museum der Stadt, Vienna

2 *The Pigeon*, 1871. Puvis de Chavannes
Oil on canvas, painted frame, 136.5 x 84 cm
Musée d'Orsay, Paris

3 *Portrait of the Pianist Joseph Pembauer*, 1890
Oil on canvas, 69 x 55 cm
Tiroler Landesmuseum Ferdinandeum, Innsbruck

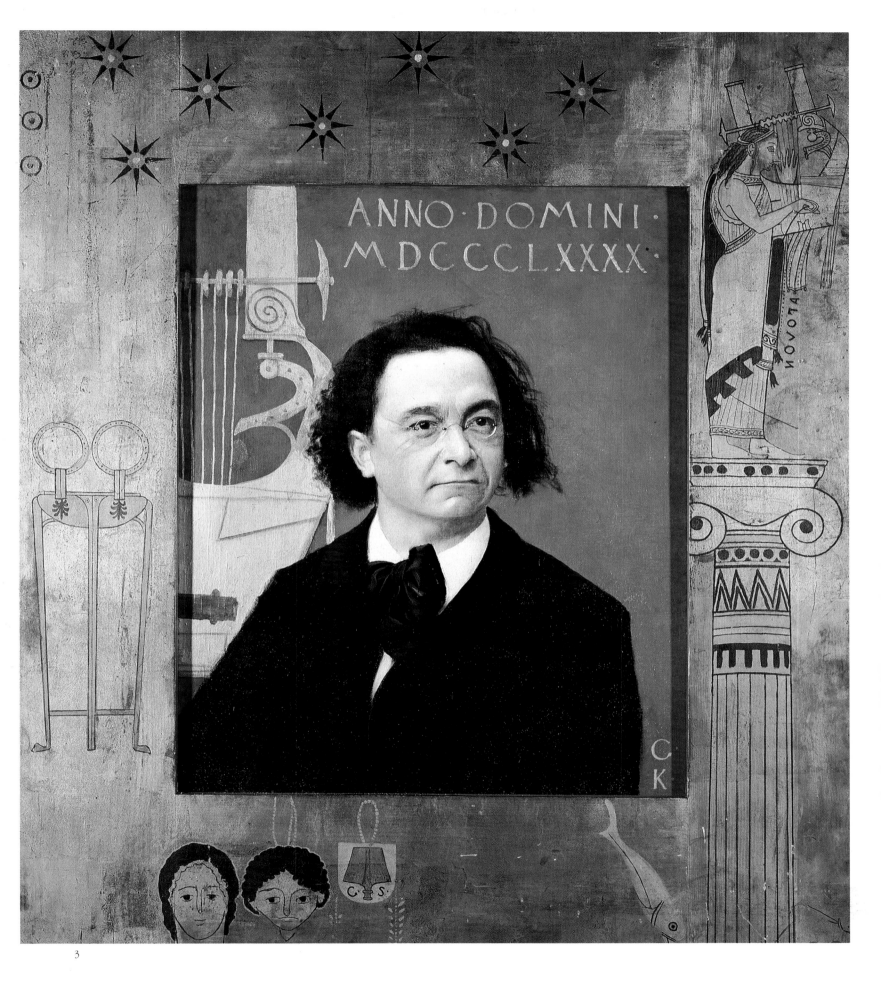

ANNO · DOMINI
MDCCCLXXXX ·

1890

Work for the Ringstrasse

In 1890 Klimt, his brother Ernst and Franz Matsch were given a substantial commission in the Ringstrasse: the decoration of the spandrels and intercolumniations of the entrance hall of the new Museum of Art History. The great Viennese painter of the preceding generation, Hans Makart, had completed twelve lunettes a year before his death in 1884. The central panel had been produced by Michaël Munkáscy after Makart's death. Klimt was responsible for a total of eleven works: eight spandrels and three intercolumniations. Each artist worked on his own account: Ernst decorated thirteen and Franz Matsch fifteen sections. Their brief was to represent a series of allegorical characters each symbolising a great artistic age. Klimt once again demonstrated with panache his wide knowledge of the history of the art of antiquity, mingling the different civilisations, and of the modern age: the allegories spanned the art of Egypt, Ancient Greece, and the Italian Renaissance in Florence, Rome and Venice. Klimt was now well acquainted with the processes of allegorical painting, thanks to his early works in collaboration with Hans Makart, the four allegories for the house of the architect Sturany. His representation of each period showed singular powers of assimilation and characterisation. For the first time here we see the motif of Athena, the warrior goddess of wisdom, who rules over the arts and literature. Klimt drew on the stylistic formulas of the past in producing his figures: what better way to evoke the Italian Renaissance than this young woman next to the head of a putto, the pair of them haloed in gold?

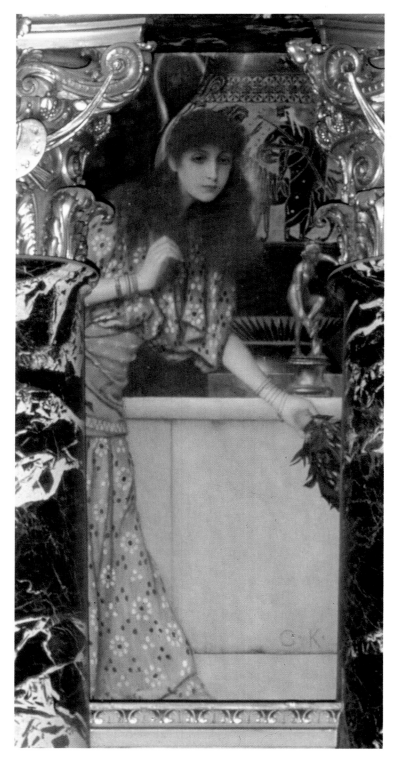

1

1
The Girl from Tanagra evokes an old Greek city to the east of Thebes where the Spartans and the Boeotians defied the Athenians *c.* 457 BC. The layout of the picture is used again later in an illustration for *Ver Sacrum*.

2
Decorative detail of stairwell of Kunsthistorisches Museum in Vienna.

2

1 *Ancient Greece (The Girl from Tanagra)*, 1890-1
Oil on canvas, 230 x 80 cm
Second intercolumniation on left of south wall of stairwell of Kunsthistorisches Museum, Vienna

2 *The Italian Renaissance*, 1890-1
Oil on canvas, 230 x 230 cm
Spandrel of south wall of stairwell of Kunsthistorisches Museum, Vienna

3 *The Quattrocento in Rome*, 1890-1
Oil on canvas, 230 x 230 cm
Spandrel of south wall of stairwell of Kunsthistorisches Museum, Vienna

3

In 1894 the Ministry of Education commissioned Klimt and Franz Matsch to decorate the ceiling of the Great Hall of the University of Vienna with allegorical paintings. Klimt worked on this project until 1907 when, after a recurrence of the vehement criticisms fired at him in April 1905 by his contemporaries, he returned his fees and recovered possession of his pictures. 'I want to free myself! Enough of condemnation! From now on I shall trust only to my own efforts,' he announced in a rare interview. From the moment *Philosophy* was shown in 1900, a violent argument broke out between Klimt's enemies and supporters. The University professors signed a petition protesting that *Philosophy* seemed to represent 'nebulous ideas in a nebulous form' and in any case the allegory seemed a poor illustration of the triumph of light over darkness. The affair spread from the University to the Press. Karl Kraus, a satirist and editor of the review *Die Fackel* (The Torch), joined in the debate in the March 1900 issue: 'An artist who is not a philosopher has every right to paint Philosophy, but his allegory should portray what is painted in the minds of the philosophers of his time.' The next year it was the nudes in *Medicine* that caused scandal and the paintings themselves were described as 'ugly'. The Minister of Education, Wilhelm von Hartel, had to defend the commission in Parliament. Klimt paid the price for the traditionalism of his contemporaries: the Ministry failed to confirm his appointment as Professor of the Academy of Fine Arts. Cold-shouldered by the establishment, ill-defended by his client, Klimt gave free reign to his anger when he embarked on *Jurisprudence* in 1903. To start with he abandoned his initial idea of representing *Justice* in an idealised manner as a symbol of the liberal Austria of the period. He devised instead a composition on two levels. The upper section featured 'Truth, Justice and the Law', presiding over, in the lower part, a condemned man, up against the wall, confronted by the judges (whose heads are glimpsed), and by the furies who symbolise the instincts. It is the latter who administer justice here, drawing the viewer into a strange erotically charged current. *Jurisprudence*, the concluding painting in the cycle, is a pointer to Klimt's personal sufferings and sense of impotence under the yoke of public condemnation.

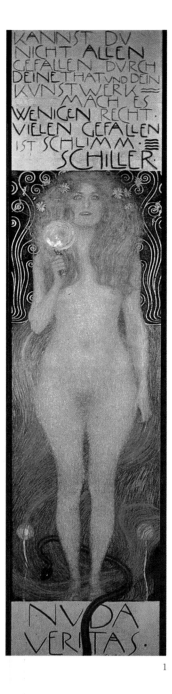

1

1
Nuda Veritas (or Naked Truth) holds out a mirror to modern man. The quotation from Schiller predicts the fate of the University professors.

2
The School of Athens was used as a point of reference by Klimt's detractors. Raphael's work corresponded to their idea of Philosophy. It portrays the assembly of the philosophers and scientists of antiquity, presided over by Plato and Aristotle, discoursing on the nature of things.

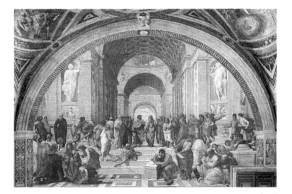

3 2
In 1900 Klimt presented his vision of Philosophy. On the left a sphinx rises up from dark depths in which evanescent bodies seem to be held in suspension. The figure at the bottom of the picture is the only indication that an understanding of things is possible. This historic photograph is all that remains of the painting, which was destroyed in 1945.

1 *Nuda Veritas*, 1899
Oil on canvas, 252 x 55.2 cm
Österreichische Nationalbibliothek,
Theatersammlung, Vienna

2 *The School of Athens*, c. 1510. Raphael
Fresco
Stanza della Segnatura, Vatican

3 *Philosophy*, 1899-1907
Oil on canvas, 430 x 300 cm
Destroyed at Schloss Immendorf in 1945

Following pages:
4 *Medicine*, 1900-7
Oil on canvas, 430 x 300 cm
Destroyed at Schloss Immendorf in 1945

5 *Jurisprudence*, 1903-7
Oil on canvas, 430 x 300 cm
Destroyed at Schloss Immendorf in 1945

4/5 (following pages)
Medicine, exhibited in 1901 in the Secession building, also positions a figure in the lower part of the picture: the priestess Hygeia, who acts as a link between the viewer and a phantasmagoric humanity in which death breeds. The nudes were considered an attack on morality. *Jurisprudence*, started in 1903, was substantially altered in relation to the preliminary sketch, particularly in its two-tier composition. It asserts the primacy of the instincts over a regulated life.

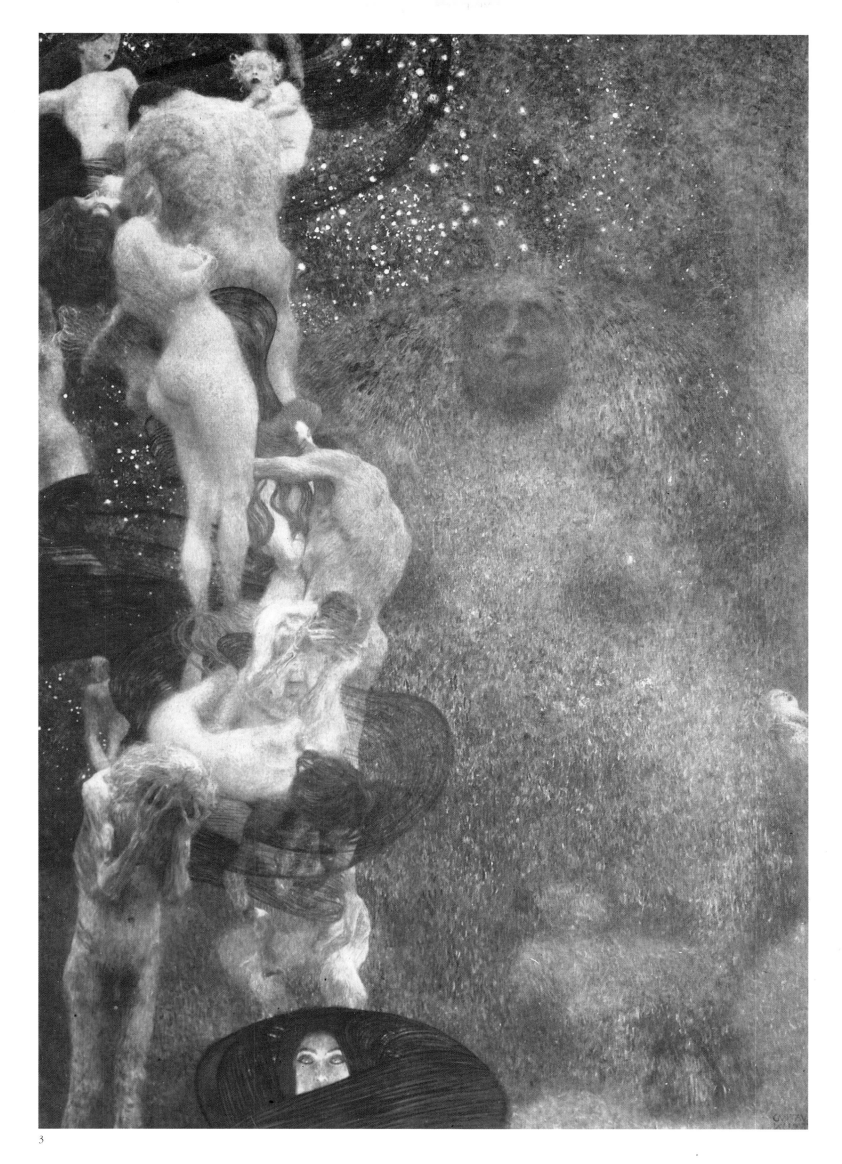

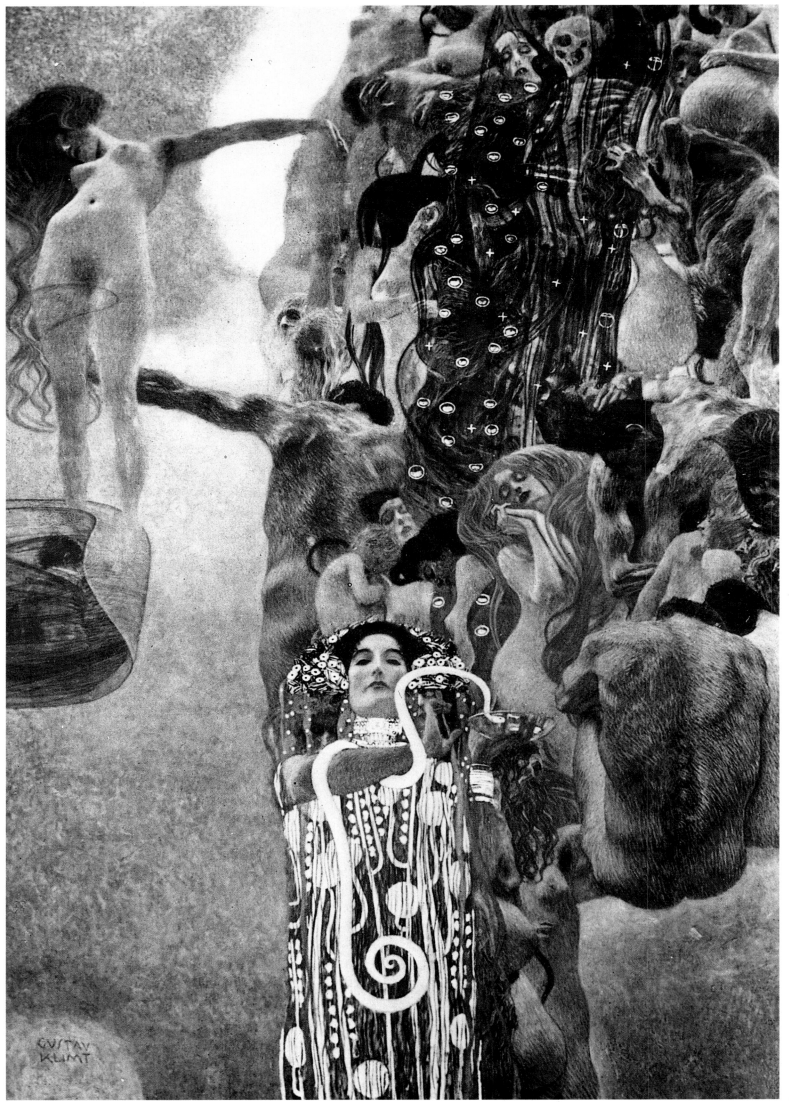

GVSTAV
KLIMT

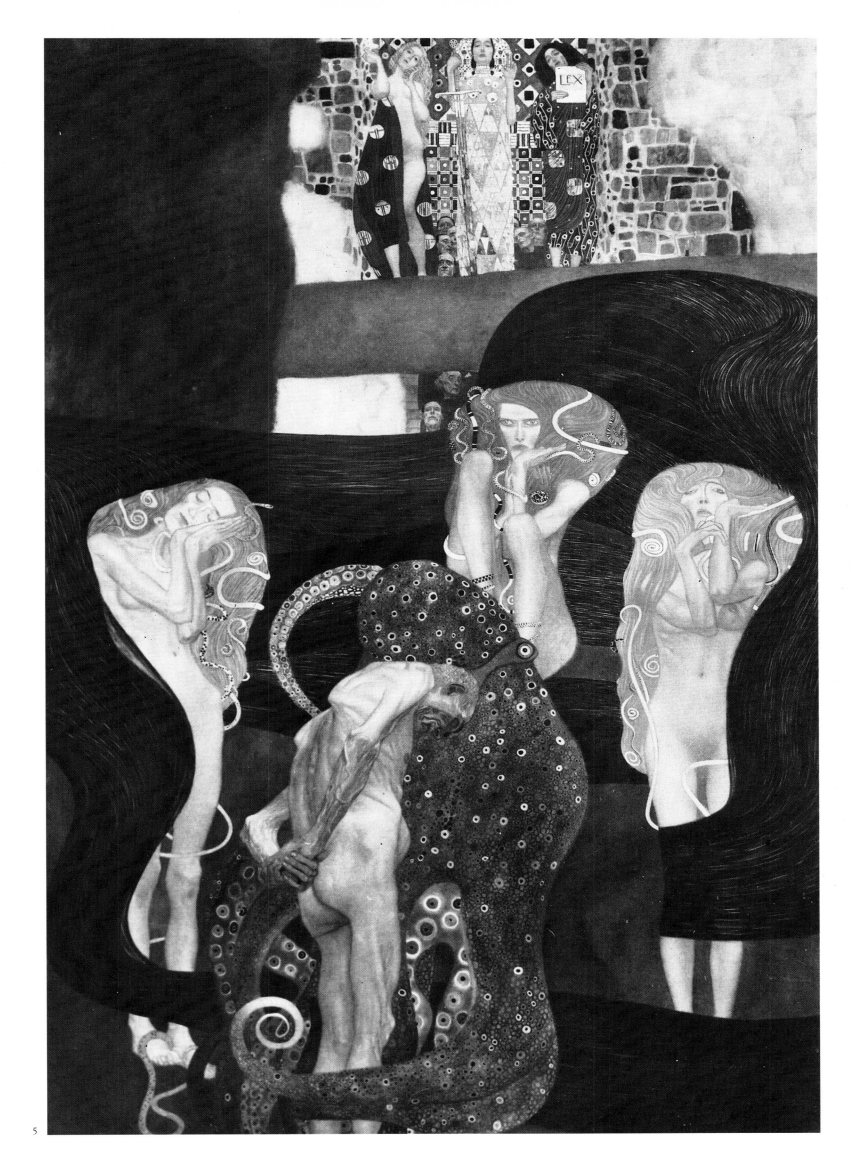

'His portraits remind one of flowers that can grow only in Austrian soil.' (Bertha Zuckerkandl)

No art can survive without the support of patrons and the Secessionists' work less than most, given their revolutionary ambitions. It was among the industrial bourgeoisie of Vienna that the Secession artists, Klimt particularly, found their clients and the backing they needed. Klimt's patrons from 1898 onwards are no secret to us: he was well established among their social circle as a portrait painter, particularly of women.

The first in the line of Klimt's highly distinctive portraits was his square painting of *Sonja Knips*, carried out in 1898 when the Secession was already established. Sonja Knips's family had links with the metallurgical business and the Anstalt Bank. Her house had been done up by the architect Josef Hoffmann and her walls were decorated with Klimt's pictures, among them her own portrait, and the landscape *Fruit Trees* (1903). She was quick to reveal a taste for modern art. Both she and her husband Antonio numbered among the élite of the artistic circles of Vienna and took a great interest in the Wiener Werkstätte. In the photograph above right, taken thirteen years after her portrait was painted, she is wearing a dress made by the Wiener Werkstätte and sitting in a chair from the same source.

The portrait, still under the inspiration of Symbolist and Naturalist painting, is more innovatory in its form than its substance. A number of the features that characterise Klimt's art are already becoming apparent. First is the square format, which he used with particular frequency after 1900, notably in his landscapes. This format dictates an unusual layout: Klimt positions his model diagonally, thus dividing the picture into two areas, one full and one empty, an arrangement inspired by Japanese prints and developed by Klimt in his illustrations for the journal *Ver Sacrum*. The 'two-sided' effect in the painting is most perfectly achieved in his later portraits of *Fritza Riedler* (1906) and *Adele Bloch-Bauer* (1907). The fluidity of Klimt's rendering of the material of the dress is another feature of his painting, seen also in his portraits of *Serena Lederer* (1899) or *Hermine Gallia* (1904), both of whom wear long white flowing dresses.

1 Photograph of Sonja Knips in 1911.

2
This *Portrait of Sonja Knips* is produced in a restricted range of colour. Klimt enriched it at one sitting by adding a little red book of hers.

2 *Portrait of Sonja Knips*, 1898
Oil on canvas, 145 x 145 cm
Österreichische Galerie, Vienna

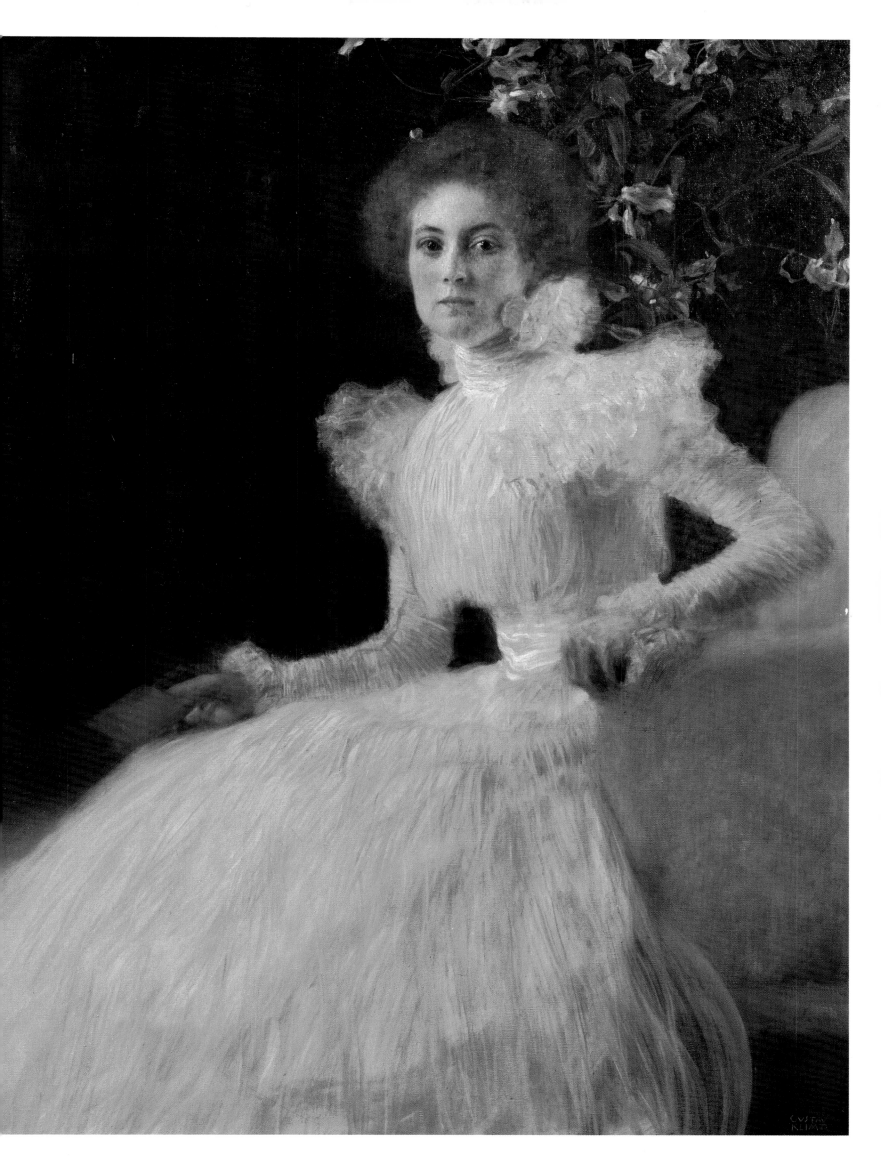

The work of a decorative painter, such as Klimt, has to adapt itself to the framework prescribed. The Secession, too, prescribed a framework: the square format. This can perhaps be explained by a desire for clarity of form. The square entered into everything: the illustrations for *Ver Sacrum* (the journal itself was square), graphic art, clothes, architecture. Klimt made extensive use of the square format right up to his death in 1918. The composition of *Baby* (or *Cradle*) is an interesting example: the artist sets his subject within a square inside another geometric shape, the triangle. The triangle is itself defined by further triangles of empty space in both the upper corners. Within the main triangle, from top to bottom, are undulating lines representing variously coloured materials. *Field of Poppies* also uses the square as a way of determining space and a subject: the interior is almost entirely taken up by the field, the area allocated to the (empty) sky reduced to a minimum. Klimt experimented not only within the square – as in the curves and angles of his name and initials (above right) – but also with the square itself. A detail of the robe worn by the man in *Fulfilment* shows that a shape can be repeated endlessly within itself, like a modern mandala in which the basic pattern is square, even if applied irregularly. Koloman Moser and Josef Hoffmann moved a stage further by producing perfect chequer-board effects on furniture and material, even in book illustrations, striving towards a purity of form they hoped to achieve in this geometry of the everyday.

1

1/6
Klimt is undoubtedly one of the modern artists to have worked most on form, and format, in relation to the composition of a picture. A subject that preoccupied the Secession, it provided no great obstacle to an artist who had successfully produced architectural decorations of every shape and size, including medallions, spandrels and lunettes.

2

1 *Portrait of Emilie Flöge*
(detail: signature & monogram), 1902
Oil on canvas. Historisches Museum der Stadt, Vienna

2 *Numbering: 2*, 1901
Ver Sacrum, p.105

3 Vignettes for *Ver Sacrum*

4 *Fulfilment* (detail of robe), 1905-9
Cartoon of *Stoclet Frieze*, 194.6 x 120.3 cm
Österreichische Museum, Vienna

5 *Field of Poppies*, 1907
Oil on canvas, 110 x 110 cm
Österreichische Galerie, Vienna

6 *Baby* (or *Cradle*), unfinished, 1917-18
Oil on canvas, 110 x 110 cm
Private collection, New York

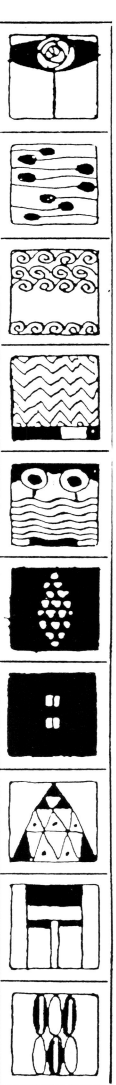

3

4

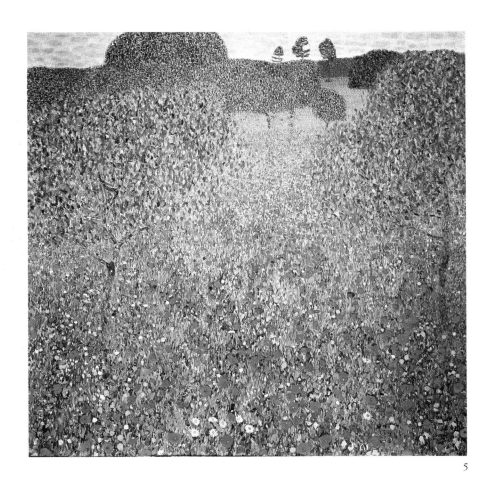

5

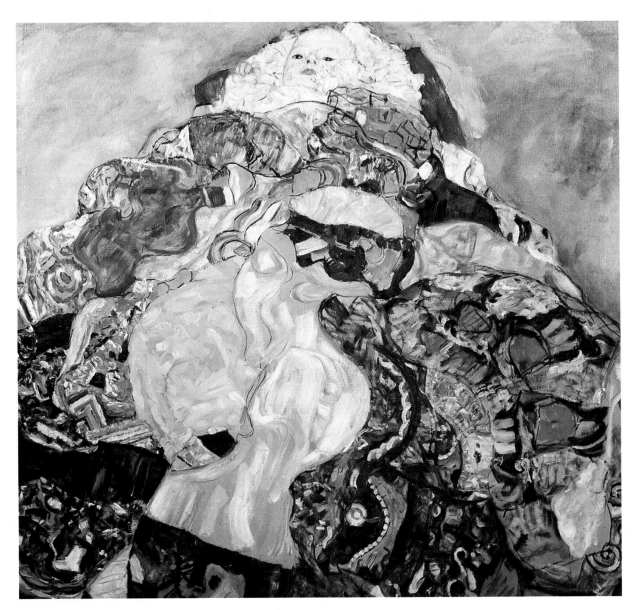

6

SECESSION

'Our Secession is not a battle between modern and traditional artists but a battle to promote artists instead of the pedlars who would pass themselves off as artists and who benefit financially when true art cannot flourish,' declared Hermann Bahr, the mentor of the Secessionists. A group of young artists within the House of Artists – founded in 1861 – could no longer tolerate the authority of the older generation and demanded their own exhibition premises, to be exempt from 'commercial considerations'. Their aim was also to put an end to the cultural isolation of Vienna, to be free to invite foreign artists, and make their own work known in the West. Their programme was clear. They were not waging an 'aesthetic war', but fighting for 'the right to create', for Art itself; and they had a specific mission: to make no distinction between 'great art' and the 'lesser arts', between 'art for the rich and art for the poor'.

Numerous discussions paved the way to the Secession. These were held from 1890 onwards in the cafés of Vienna where the young artists used to gather. On 3 April 1897 the split took place. The Secession was founded, with Klimt as president. Initially the association remained within the House of Artists, but finally broke away on 25 May the following year. The Secession's first exhibition was held in the greenhouses of the Society of Horticulture. For the occasion, Klimt designed a poster representing the battle of Theseus and the Minotaur (above), under the aegis of Athena who occupies the right-hand side. Athena, already adopted by Franz von Stuck as the emblem of the Munich Secession, was to be a recurrent motif in Klimt's work during his Secessionist period. The poster amounts, in fact, to a manifesto. The use of mythological characters is heavily symbolic: Theseus represents struggle for the new, allied to clarity and lightness, while the Minotaur is plunged in darkness and on the point of being speared by Theseus. Athena, who sprang full-grown and fully armed from the head of Zeus, is the goddess of wisdom, an appropriate figurehead in a time of intellectual ferment. Klimt provided Athena with a shield displaying a Gorgon's fearsome head, which petrified any onlooker. This highly stylised drawing was Klimt's 'entry' as decorator/illustrator of *Ver Sacrum*.

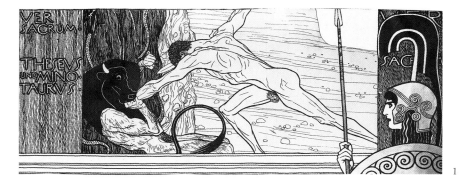

1

2

*'We want to declare war
on sterile routine and rigid Byzantinism,
on bad taste of all kinds.' (Hermann Bahr)*

2 *Theseus and the Minotaur*,
poster for the first Secession exhibition, 1897
Lithograph, 97 x 70 cm
Historisches Museum der Stadt, Vienna

3 *Opening of first Secession exhibition*, 1898.
Rudolf Bacher
Drawing, lead pencil, 34.5 x 45.6 cm
Historisches Museum der Stadt, Vienna

1/2
Already in 1898 Klimt had to contend with moral disapproval: notwithstanding the fig-leaf, he had to add tree-trunks to his poster to cover Theseus's nudity.

3

The Emperor visiting the first exhibition of the Secession (*l-r*) ADC to Franz-Josef, the Emperor, Gustav Klimt, Rudolf von Alt, Joseph Engelhart, Otto Friedrich, Carl Moll, Adolf Hölzel, Hans Tichy, Kolo Moser, Joseph Maria Olbrich, Rudolf Jettmar.

3

5

Photograph of the founder members of the Secession including Carl Moll, leaning on his stick, then Gustav Klimt, Kolo Moser with a bowler hat, Hoffmann seated in the front row.

4

4

Josef Hoffmann, photographed here in 1898 in Kolo Moser's studio, was a pupil of Otto Wagner. From 1905, he became a friend of such artists as J. M. Olbrich, Kolo Moser, Max Kurtweil. He was a member of the Club of Seven before joining the Vienna Secession and co-founding the Wiener Werkstätte in 1903.

5

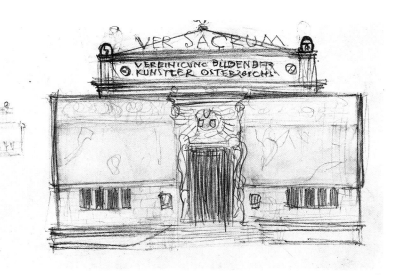

'To Each Age its Art, to Art its Freedom'

The Secession's many international exhibitions were highly successful. The first three alone brought in enough money to finance the construction of a Secession building. Klimt produced a series of sketches for this project, on the classical lines of a Greek temple. The work of the architect Joseph Maria Olbrich, 'this temple of art' is composed of purely geometric elements: the cube, the parallelepiped and the sphere. Above a majestic entrance one can read the programme-cum-motto of the Secession: 'To Each Age its Art, to Art its Freedom'.

On 17 November 1897, the city granted a building plot; on 28 April 1898 the first stone was laid; and on 7 November 1898 the building was ready for use.

From their very first exhibition the Secessionists sought to show the public a range of contemporary international works of art. They exhibited Giovanni Segantini, Ferdinand Khnopff, Constantin Meunier, Puvis de Chavannes, Auguste Rodin, Franz von Stuck, Max Klinger, and others. Some 57,000 visitors attended.

The magnificent white building designed by Olbrich was in use from the end of 1898. In 1902, on the occasion of the *Beethoven* exhibition, it provided the setting for a 'total work of art'. There were other notable exhibitions, featuring, for example, Japanese art, the Impressionists, and the work of Charles Rennie Mackintosh and Margaret Macdonald, the young Scots who had such a strong influence on the Viennese.

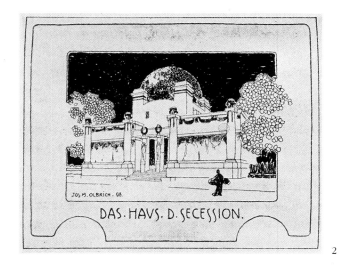

DAS·HAVS·D·SECESSION.

1 *Study for Secession building, c.* 1897
Drawing, 9.5 x 13.5 cm
Historisches Museum der Stadt, Vienna

2 *Postcard of Secession building,*
1898. J. M. Olbrich

3 Old photograph of Secession building

4 *Portrait of Helene Klimt, 1898*
Oil on cardboard, 60 x 40 cm
Private collection, Vienna

4
This portrait of Helene, Klimt's niece, the daughter of his brother Ernst, was shown at the Secession's first exhibition in the Olbrich building.

1 *Little girls*: border for *Ver Sacrum*, 1898

2 *Nuda Veritas*: *Ver Sacrum*, 1898

3 *Sacred Spring*: *Ver Sacrum*, 1898

4 *Envy*: *Ver Sacrum*, 1898

5 Border for *Ver Sacrum*, 1898

6 *Music*: *Ver Sacrum*, 1901. Lithograph

1/6
The choice of a vertical format and the truncated motifs evoke Pierre Bonnard's series *Paravents* (1891). In representing subjects already handled in his paintings (*Music, Nuda Veritas*), Klimt makes ample use of curving lines and stylised decoration.

'Truth is Fire, and Fire means to illuminate and to burn' (L. Scheffer)

Even prior to its foundation, the Secession had wanted to publish a journal which would put into practice the idea of a 'total work of art' by integrating the text and the illustrations. 'The disgraceful fact that Austria boasts not a single illustrated art magazine enjoying a wide circulation and tailored to its particular needs has prevented artists from becoming known. This journal should prove of help to them,' explained Hermann Bahr. The journal was called *Ver Sacrum* (Sacred Spring), in itself a symbolic title. First issued in 1898, it appeared until 1903, monthly in 1898-9, fortnightly thereafter. The journal was expensive to produce and expensive to buy, being conceived as a work of art in itself. Its purpose was to report on the Secession's activities and thinking through illustrated articles. The literary contributors included Hugo von Hofmannsthal, Adolf Loos, Peter Altenberg, and Rainer Maria Rilke. Hermann Bahr published his exhortations there: 'Surround our people in Austrian beauty!', while Ludwig Hevesi promoted the Secessionists' painting and became their official critic. The Secession's initiatives were twofold: in affirming the desire to open Austria to the cultural influences of Europe, the association advocated 'a purely Austrian art and culture which will bring together the many elements of the peoples of the Empire in a new unity'. It was thought that art could transcend the ethnic conflicts which were to tear the Empire apart and bring about its downfall.

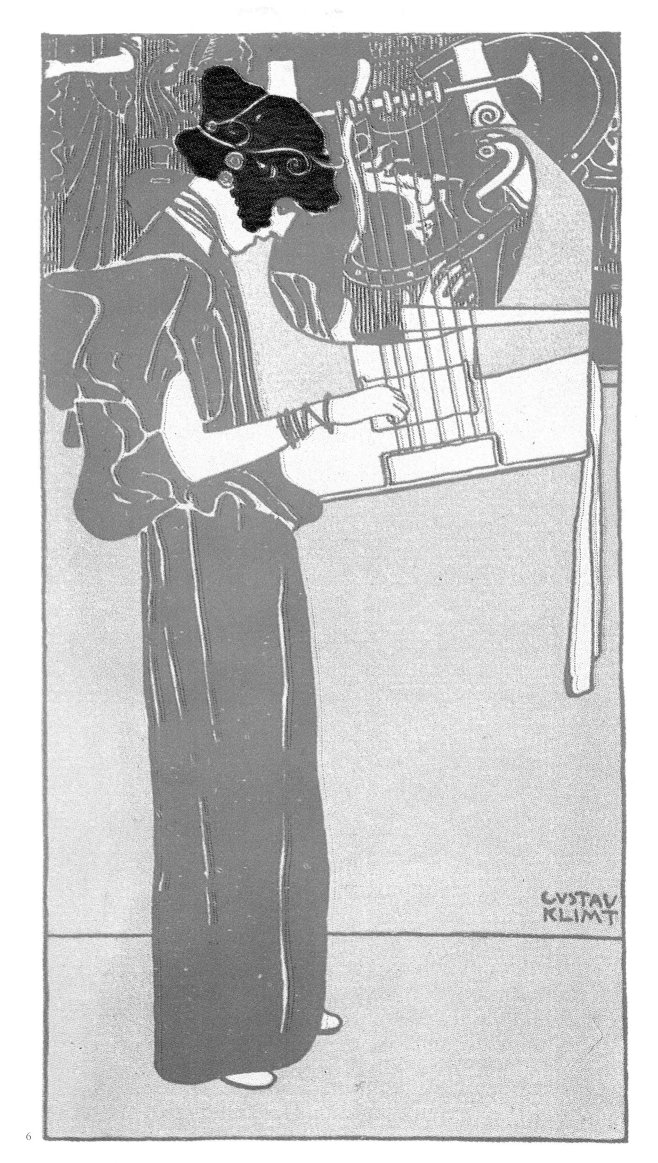

Nikolaus Dumba, son of a Greek businessman from Macedonia, had accumulated a vast fortune trading in the East, in addition to which he had interests in banking and the textile industry. A patron of the arts, both music and painting, he commissioned Klimt to decorate the music room in his villa. The dining room was by Hans Makart. The two panels done before the renovation of the room were allegories of music. As in *The Globe Theatre* for the Burgtheater, in his paintings above the two doors Klimt sets Mythology and Reality in opposition to each other. In *Schubert at the Piano* he evokes the lost paradise of a former age, a time when life was stable and an untroubled society could comfortably devote itself to music. The scene is bathed in a gentle light which softens the forms of the female figures. Music is personified by a half-muse, half-*femme fatale* playing the lyre, instrument of Apollo. As in Nietzsche's *Birth of Tragedy*, music is linked to the cosmos and the world of buried instincts. The figure of Music seems to serve only to disconcert the traveller (the viewer), who is then brought face to face with the enigma of the sphinx. This symbol of mystery is associated with the Oedipus legend and the story of Thebes. Taking up position on a mountain west of Thebes to punish the city for Laïos' crime, the sphinx devoured whoever fell into its clutches and failed to reply to its riddles. Oedipus alone found the right answer and thus saved his life. As in Nietzsche, the world of Apollo mingles with that of Dionysus and in the background two figures stand out, one of which represents Silenus, companion of Dionysus, amidst a stylised tangle of vines. A sarcophagus in the middle ground suggests a necropolis. Klimt makes ample use in this work of images drawn from Greek archaeology which seemed to hold a deep fascination for him.

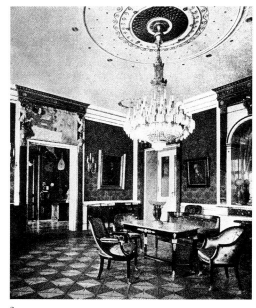
1

2

3

1
Music II bears some resemblance in its composition to *Music I* (1895, Neue Pinakothek, Munich) but the young woman's pose is that of *The Girl from Tanagra*. The symbolic elements, sphinx, lyre, mask and dandelion balls, occupy almost all the picture.

2
The interior of the Music Room was designed entirely by Klimt who chose the mahogany furniture and gilded bronzes on the door mouldings. Unfortunately all has been destroyed.

3
Study of the wall on which *Music* features above the door (watercolour, private collection, Geneva).

1 *Music II*, 1898
Oil on canvas, 150 x 200 cm
Above door in Music Room, Dumba Villa, Vienna
Destroyed at Schloss Immendorf in 1945

2 *Schubert at the Piano*, 1898-9
Preparatory painting, oil on canvas, 30 x 39 cm
Private collection

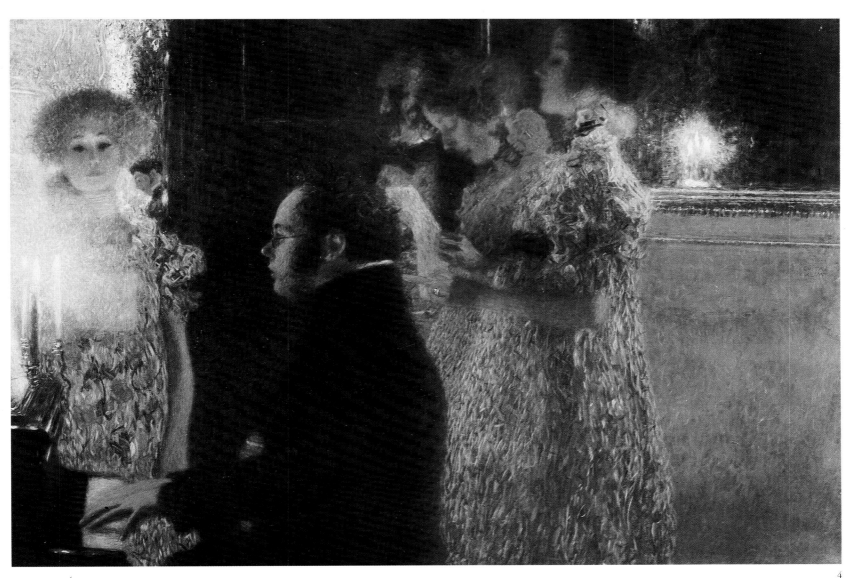

4

4

Schubert is not the pianist either
here or in the preparatory
drawings. He was portrayed only
in the final version, now
destroyed, painted after an 1821
water-colour by Leopold
Kupewieser which was in
Dumba's possession. *Schubert at
the Piano* is a work of Klimt's
transitional period, before he
came under the influence of
modern art.

'A kiss
for the whole world'
(Ode to Joy, Schiller)

Klimt's room at the exhibition, including a partial view of the *Beethoven Frieze*. On the right, Max Klinger's statue of Beethoven is visible.

2
Plan of the prescribed route through the exhibition, taken from a 1902 catalogue. A veritable temple of art celebrating a prescribed ritual, this exhibition was a momentous occasion.

The period in which Klimt worked on the controversial paintings for the University was also that in which he produced the *Beethoven Frieze* for the Secession's fourteenth exhibition on 15 April 1902. The *Frieze* provoked a storm of protest in the press. The focal point of the exhibition was a statue of Beethoven by Max Klinger, while the interior design was the work of Josef Hoffmann who aspired to 'as great a simplicity as can be achieved by the use of materials and forms'. In practice this meant rough concrete and the colour white (the floor was grey), so that the decoration would be unobtrusive and concentrate the attention on the works of art. The unifying theme of this 'total work of art' was its subject, a homage to Beethoven. Gustav Mahler, then Director of the Vienna Opera, opened the exhibition. To mark the occasion he directed the fourth movement of the Ninth Symphony, which he himself had re-orchestrated for an ensemble of wood and brass. After the rediscovery of his works by Franz Liszt and above all Richard Wagner, Beethoven was regarded as close to divine and capable of saving the soul of mankind. Klimt's *Frieze* was constructed in three stages: first *The Longing for Happiness*, next the *Hostile Powers* on the centre wall, progressing finally to two scenes in illustration of two lines from Schiller's *Ode to Joy*: 'Joy, thou purest spark divine' and 'A kiss for the whole world'. These were the same lines on which Beethoven's Ninth Symphony came to a close. Klimt thus gave a clear indication that the *Frieze* should be read as a symbolic transposition of Beethoven's symphony. However the knight clad in golden armour – a copy of armour made in 1485 for Archduke Siegmund von Tirol, now in the Kunsthistorisches Museum, Vienna – bears the features of Gustav Mahler; reality and fiction meet.

3
This *Bust of Mahler* was executed by Auguste Rodin at the request of Carl Moll, spokesman for a good number of artists and friends. It was a tribute to the composer on his leaving the Vienna Opera in 1907 for the Metropolitan Opera in New York.

3

3 *Bust of Gustav Mahler*, 1909. Rodin
Bronze, 34 x 24 x 22 cm
Musée Rodin, Paris

4 *Beethoven Frieze*, 1902
Casein paint on plaster inlaid with various materials
Left panel: *The Longing for Happiness*, 13.78 m
Central panel: *The Hostile Powers*, 6.38 m
Right panel: *The Longing for Happiness
Finds Fulfilment in Poetry*,
5.11 m + 4 m unpainted + 4.7 m
Österreichische Galerie, Vienna

5 Details of *Beethoven Frieze*:
The Golden Knight (p.64); *The Three Gorgons and the Giant Typhoeus* (p.65); *Poetry Playing the Lyre* (p.66); *A Kiss for the Whole World* (p.67); *Lust, Lasciviousness, Excess* (p.68)

4
The *Beethoven Frieze* spans a length of 24 m and the seven panels measure 2.2 m in height. Carl Reininghaus bought it after the exhibition, and thus saved it. It was eventually purchased by the Austrian State in 1973, restored and returned to the Secession Building, where it had been originally displayed. It has been on view there since 1986.

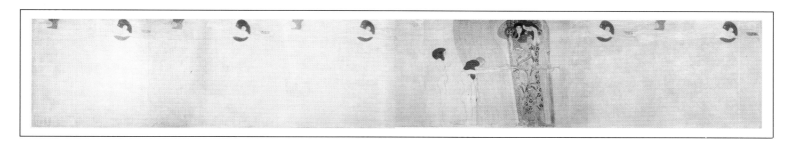

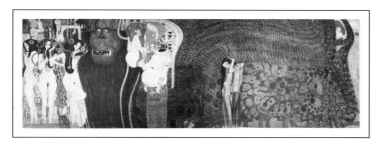

4

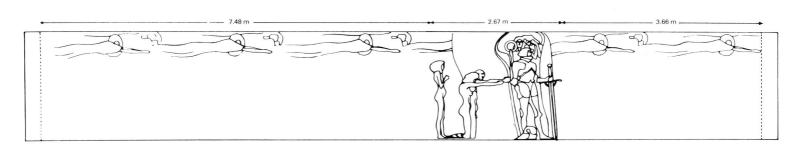

7.48 m 2.67 m 3.66 m

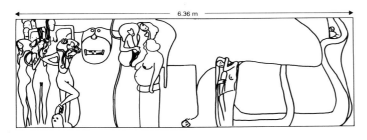

6.36 m

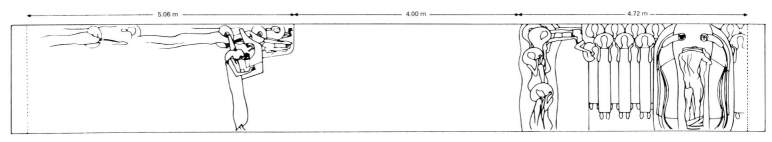

5.06 m 4.00 m 4.72 m

5

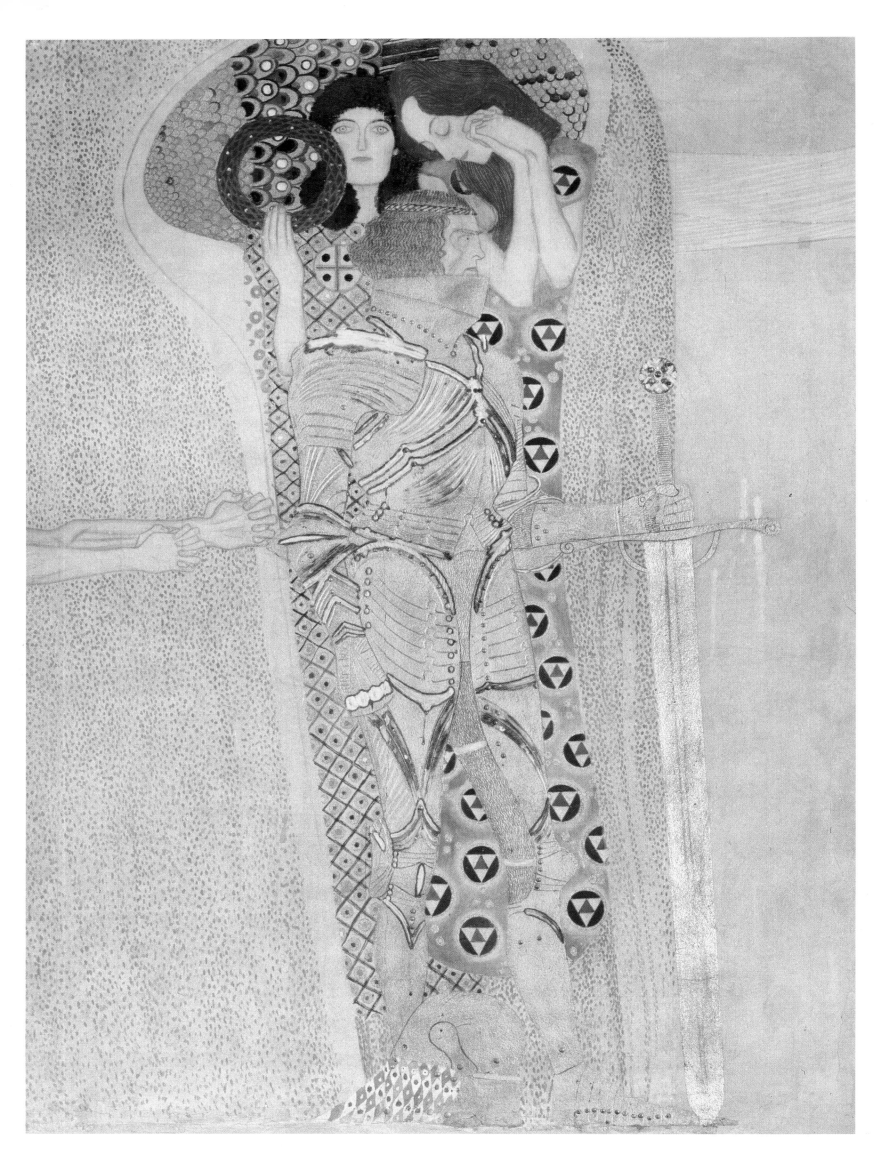

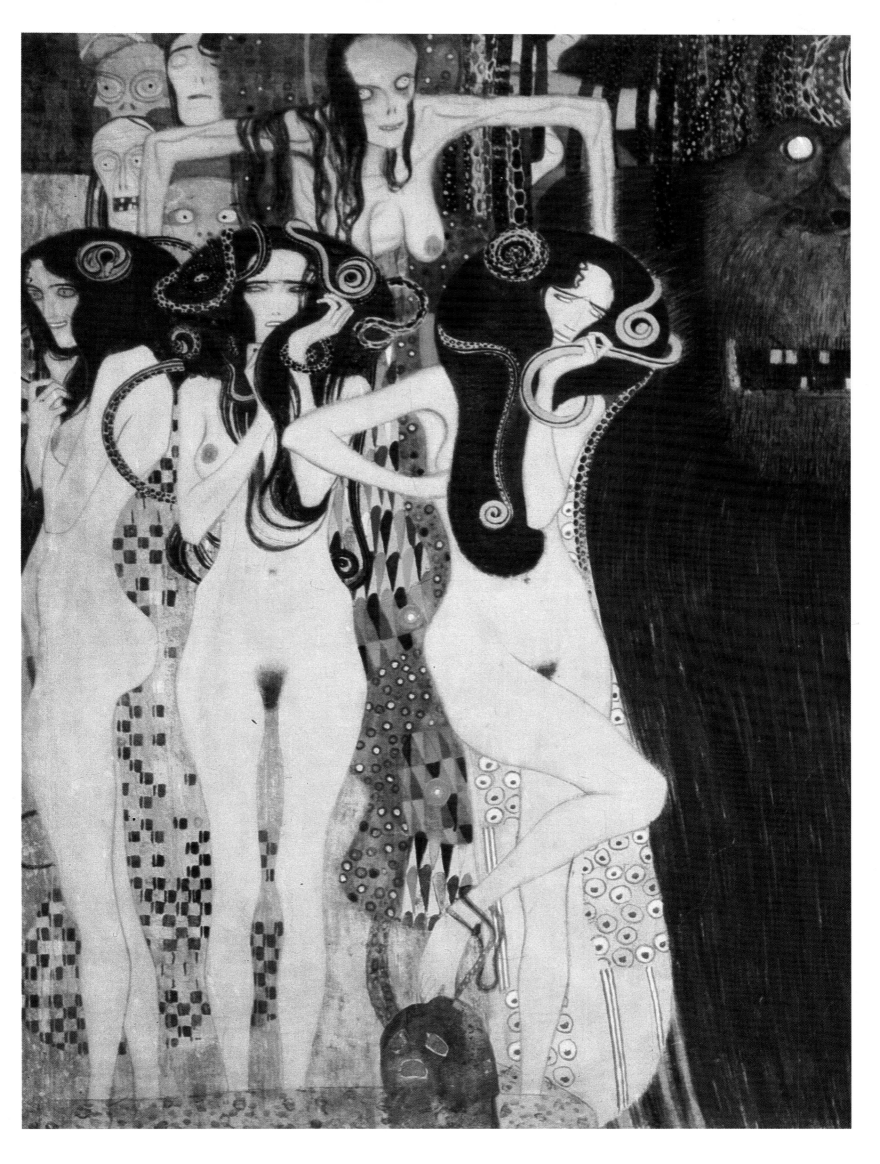

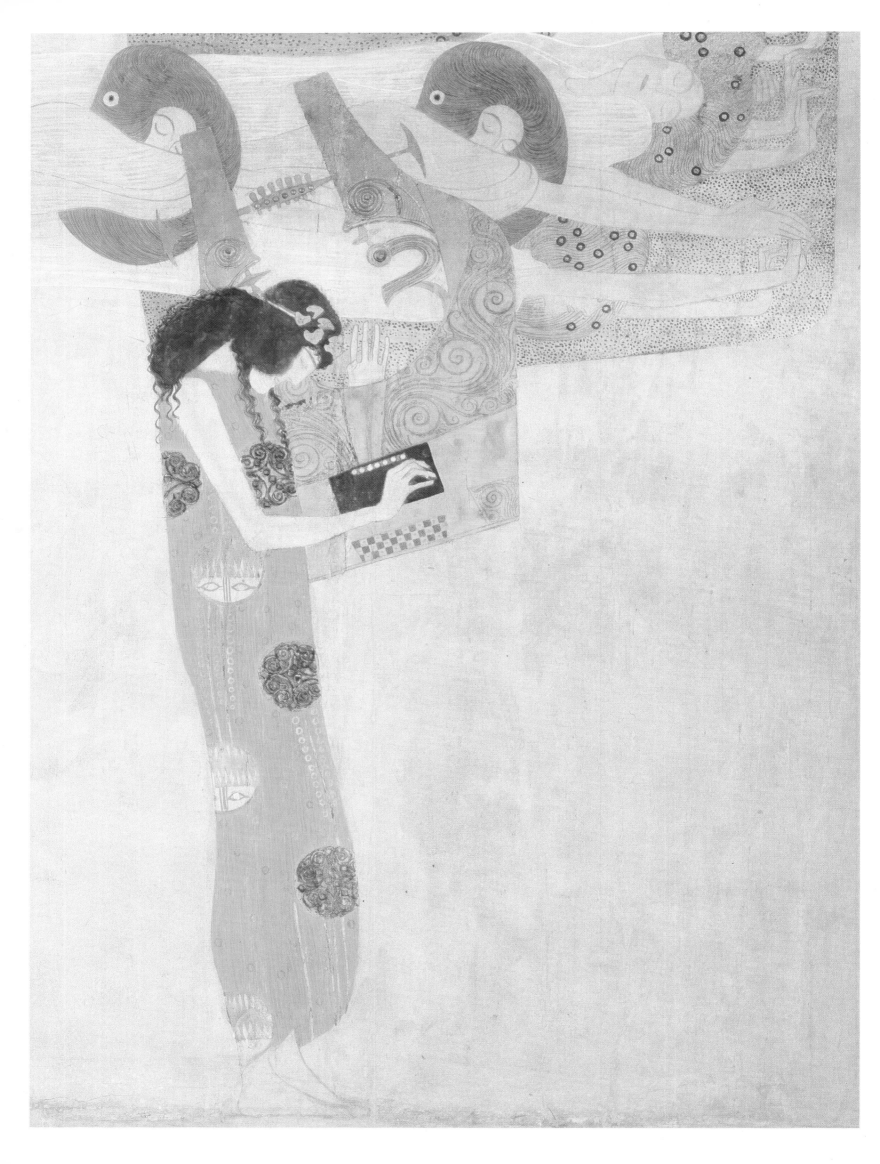

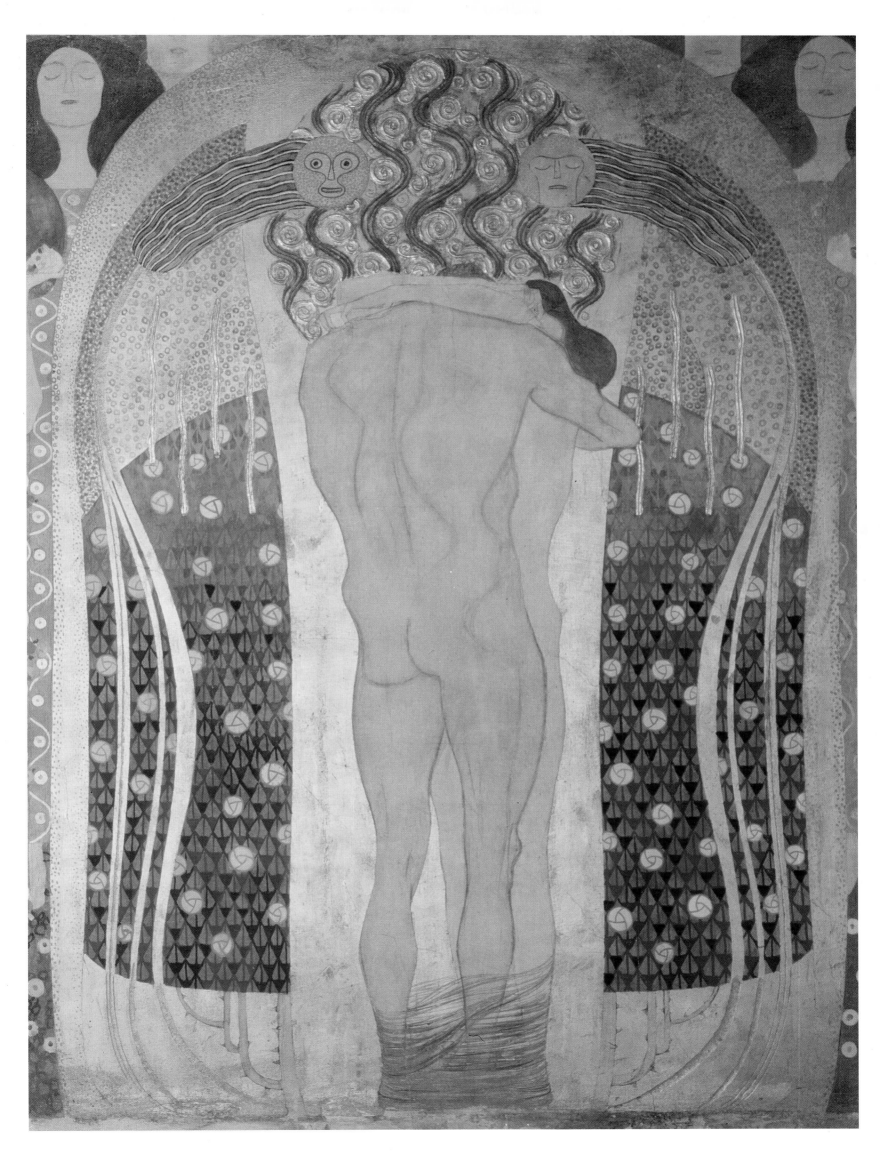

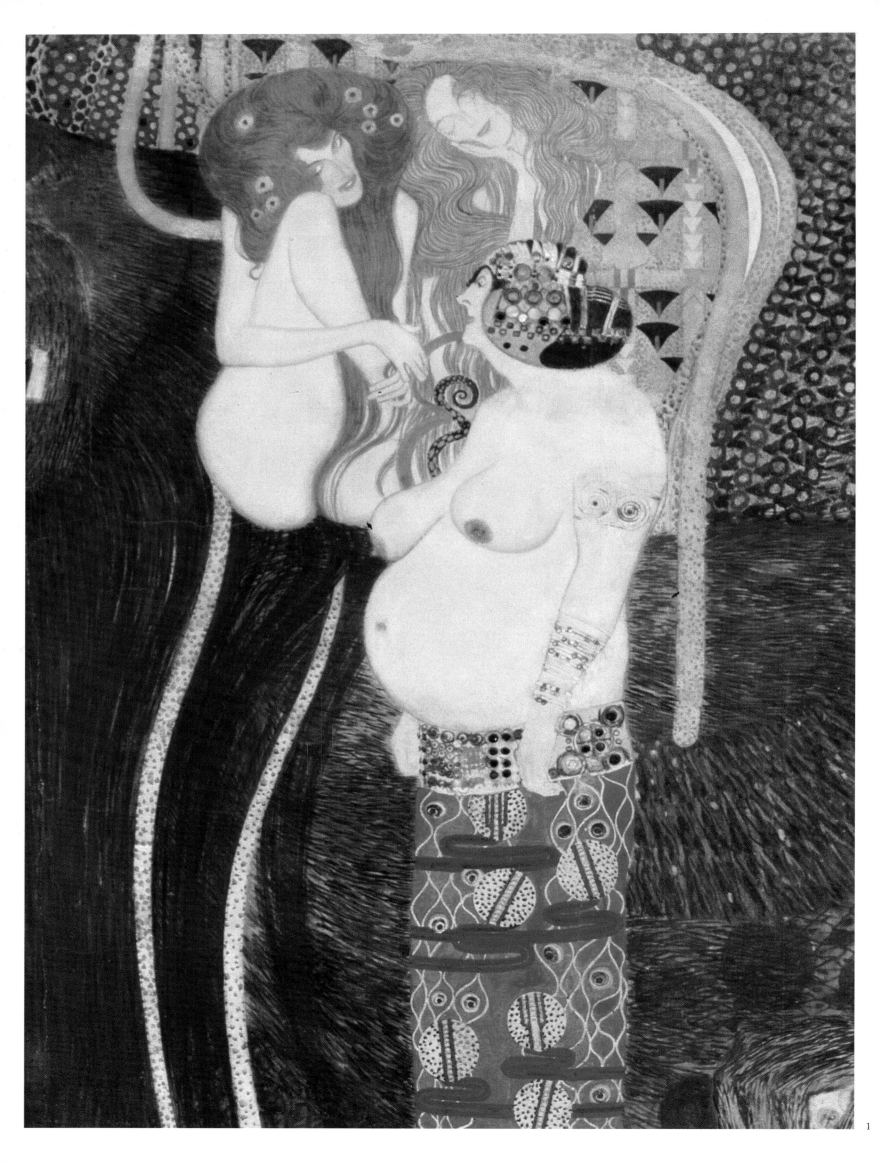

2

2
This drawing, which can be described as Expressionist, shows Klimt's method of working towards his final result: a work of art inlaid with gold and a variety of other materials (mother of pearl, mirrorwork, etc).

3
The drawings of Aubrey Beardsley (1872-98) were highly successful. They are distinguished for their purity of line and the play of black and white against a background set off by ornament. This picture shows the extent to which Beardsley was an influence on Klimt.

1
The three 'scandalous' figures of *Lust, Lasciviousness* and *Excess* indicate the importance of the role played in the frieze by sexuality. Their effect is reinforced by the gold background against which the male phallus and female sexual parts are set. Klimt's unveiling of the human body and Freud's researches into sexuality occurred at the same time.

3

1 *Lust, Lasciviousness, Excess*
(panel of *Hostile Powers*)

2 Study for the figure of *Excess*, 1902
Black chalk, 44 x 30 cm
Present whereabouts unknown

3 Cover for *Ali Baba and the Forty Thieves*,
1897. Aubrey Beardsley

Following pages:
4 *Study for a Man Kneeling*, 1902
Black chalk, 44.8 x 31.7 cm
Albertina, Vienna

5 Study for the couple in *The Kiss*, 1902
Black chalk, 45 x 30.8 cm
Albertina, Vienna

The explanatory comments on the *Frieze* in the exhibition catalogue are as follows: 'The paintings which are arranged as a frieze on the upper part of the three walls of the room are by Gustav Klimt. Materials: casein paint, stucco, gilding. Decorative principle: to respect the arrangement of the room; plaster surface, with ornamentation. The three painted walls constitute one whole. First long wall: the burning desire for happiness; the sufferings of feeble mankind; the two driving forces which appeal, externally on the one hand, to the strong and well-armed individual, and, internally on the other, to compassion and pity, both incitements to engage in the struggle for happiness. Short wall: the hostile powers. The giant Typhoeus, against whom the gods themselves fought in vain; his daughters the three Gorgons; sickness, madness, death, lust, lasciviousness, excess, gnawing grief. The cravings and desires of mankind float above. Second long wall: the desire for happiness finds fulfilment in poetry. The arts lead us to an ideal kingdom in which we can find joy, happiness, pure love. The heavenly choirs of angels: "Joy thou purest spark divine. A kiss for the whole world." '

The Beethoven drama of 1901-2 apart, one needs to consider, while avoiding oversimplification, the background to the critical hostility directed both at Klimt and the Secession. The redemptive power of art, symbolised by the kiss and final embrace, was a theme current among Viennese artists. Egon Schiele expressed the idea with even greater clarity in these words: 'He who isn't hungry for art is verging on decrepitude.'

Auguste Rodin saw the *Beethoven Frieze* in 1902 on a visit to Vienna recounted by Bertha Zuckerkandl in her *Memoirs*. The occasion made a strong impression on Rodin who congratulated Klimt on a work of art 'so tragic and so divine'. Auguste Rodin was well known in Vienna, his work having been exhibited since 1882. The lives and the art of the two men were interconnected in a number of ways and it is significant that Rodin, on his way back from a trip to Prague, should have stopped in Vienna to visit the Beethoven exhibition.

G·K

4

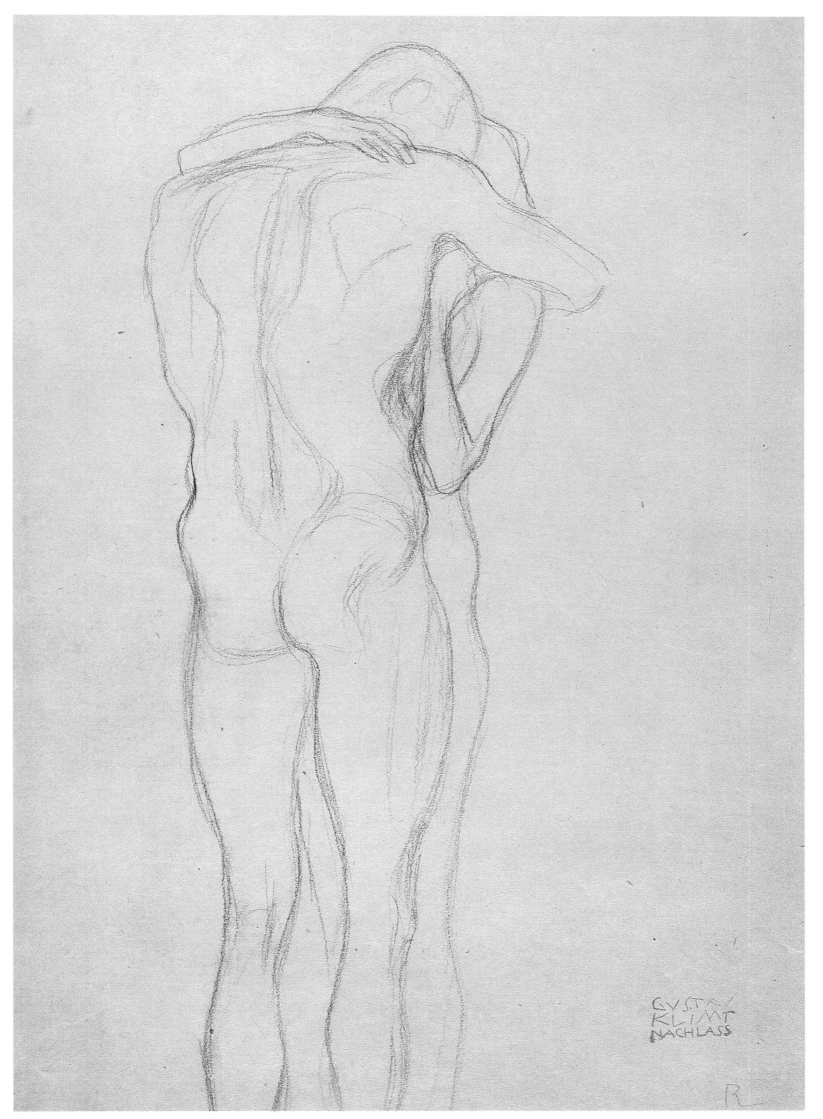

1

While Klimt was the butt of critical attacks on account of his pictures for the Great Hall of the University (particularly *Philosophy*, shown at the seventh Secession exhibition), he began to paint landscapes bearing an aesthetic resemblance to the Impressionists and Post-Impressionists.

The sixteenth exhibition of the Vienna Secession, held in January-February 1903, was devoted to the Impressionists, who had themselves a few years previously been the pariahs of modern art. The Post-Impressionists were also exhibited on this occasion: Cézanne, van Gogh, Gauguin, Toulouse-Lautrec, Vuillard, Bonnard. Klimt's landscape painting was clearly inspired by the French. To begin with, around 1900, it was Claude Monet whose work provided a model for Klimt, in particular his paintings of water and reflections on water. Klimt produced a fair number of variations on this theme during his months by the Attersee, where he was able to relax and enjoy the scenery. His views of lake and countryside, busily dotted with colour, fill the entire canvas to the virtual or total exclusion of sky, a result of Klimt's original use of the square format. They are noticeably lacking in human presence, though his early landscapes include a few animals, hens or cattle, enjoying the Austrian countryside. His subsequent landscapes, like his figurative paintings, tend to return to the same subjects: lake, treetrunks (forests), apple or pear tree, gardens, and the symbolic sunflower so dear to the Impressionists. The painter's state of mind is reflected in the intimist character of his landscapes at this period.

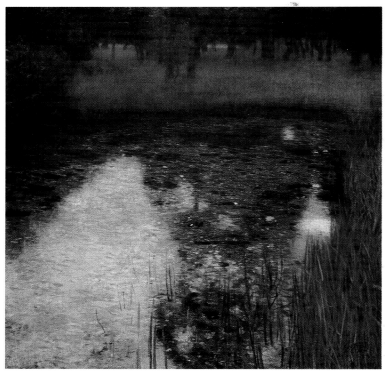

2

1 *Section of the Seine near Giverny II*, 1897. Monet
Oil on canvas, 87 x 93 cm
Museum of Fine Arts (gift of Walter Scott Fitz), Boston

2 *The Pond*, 1900
Oil on canvas, 80 x 80 cm
Present whereabouts unknown

3 *The Tall Poplars II*, 1903
Oil on canvas, 100 x 100 cm
Private collection, Vienna

1
Monet knew better than any of the Impressionists how to recreate the atmosphere of the banks of the Seine on his canvases. At the age of fifty-six, settled at Giverny, he loved to paint the pink skies of sunset. From 1890 he stopped painting figures to concentrate on the effects of water and light.

2
From 1900 Klimt's work seemed to echo the divisionism practised by the Impressionists, and Claude Monet in particular, to render the subtle and variegated effects of light on water.

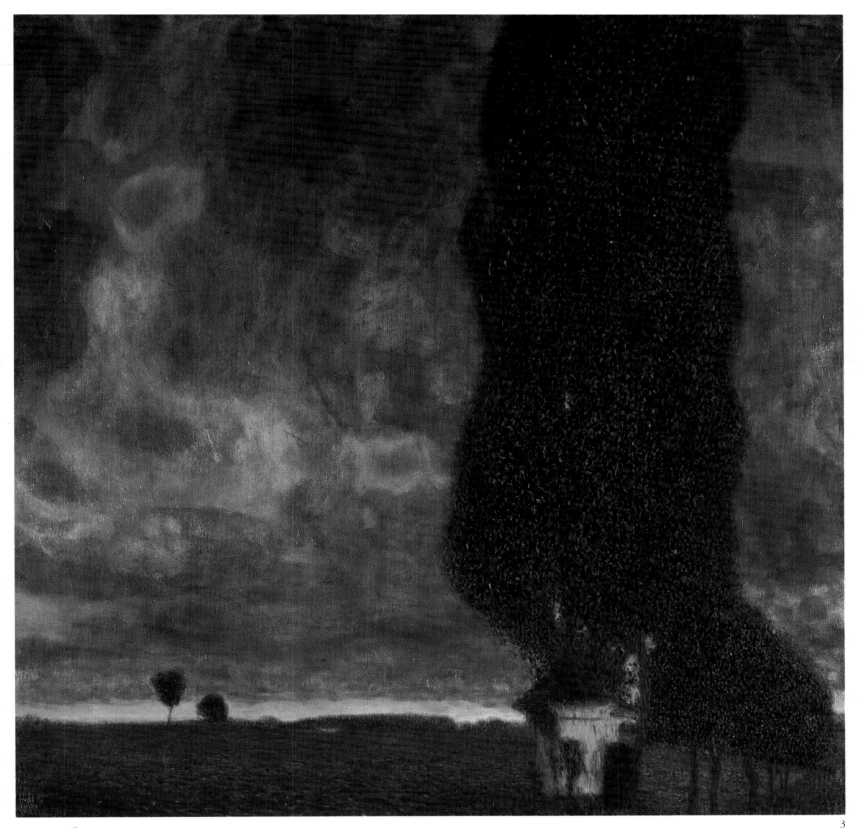

3

The Tall Poplars, a subject Klimt
painted twice, was a picture
associated with the Attersee. Until
1928, near Kammer am Attersee, a
tall poplar was to be found
standing by a little chapel. The
extensive spread of the stormy sky
is unusual in Klimt's landscapes.

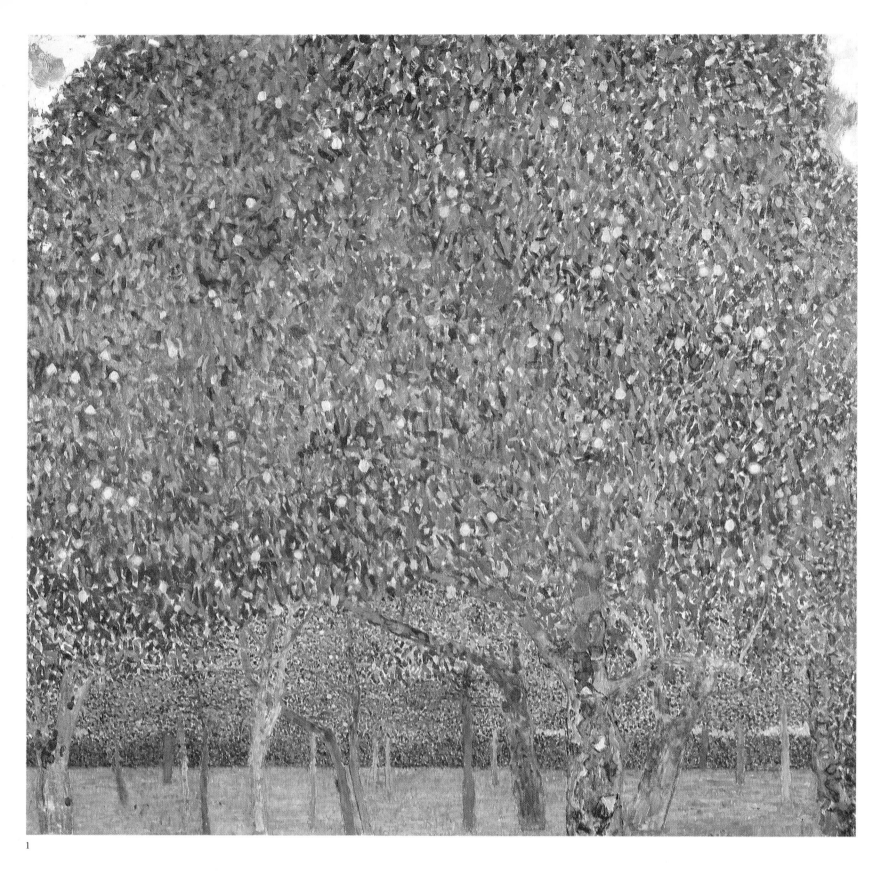

1

1
The Pear Tree evokes the
Pointillist work of the Post-
Impressionists; the brushstrokes,
larger in the foreground where
the foliage is most imposing,
diminish in size as they vanish
into infinity.

1 *The Pear Tree*, 1903
Oil on canvas, 100 x 100 cm
Harvard University Art Museum, Cambridge

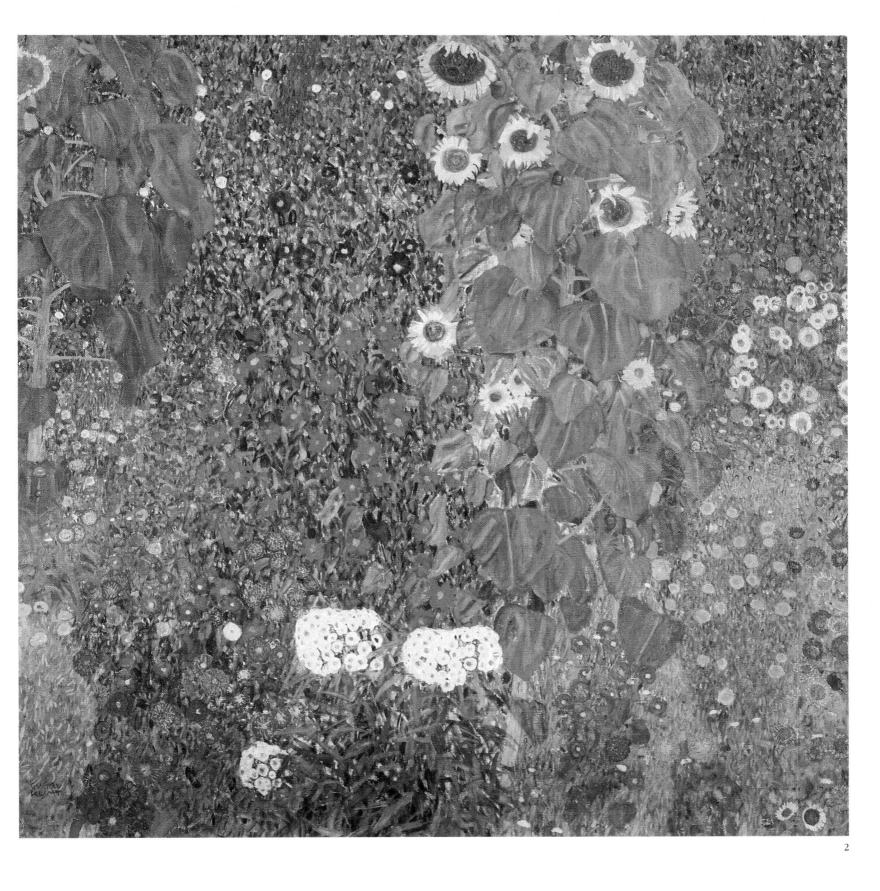

2
This work was painted in the
garden of an inn while Klimt was
visiting Litzberg on the Attersee in
1905 or 1906. Densely textured
and highly coloured, the picture is
notable for its format and
composition, in which the
sunflower majestically stands out.

2 *Garden with Sunflowers, c.* 1905-6
Oil on canvas, 110 x 110 cm
Österreichische Galerie, Vienna

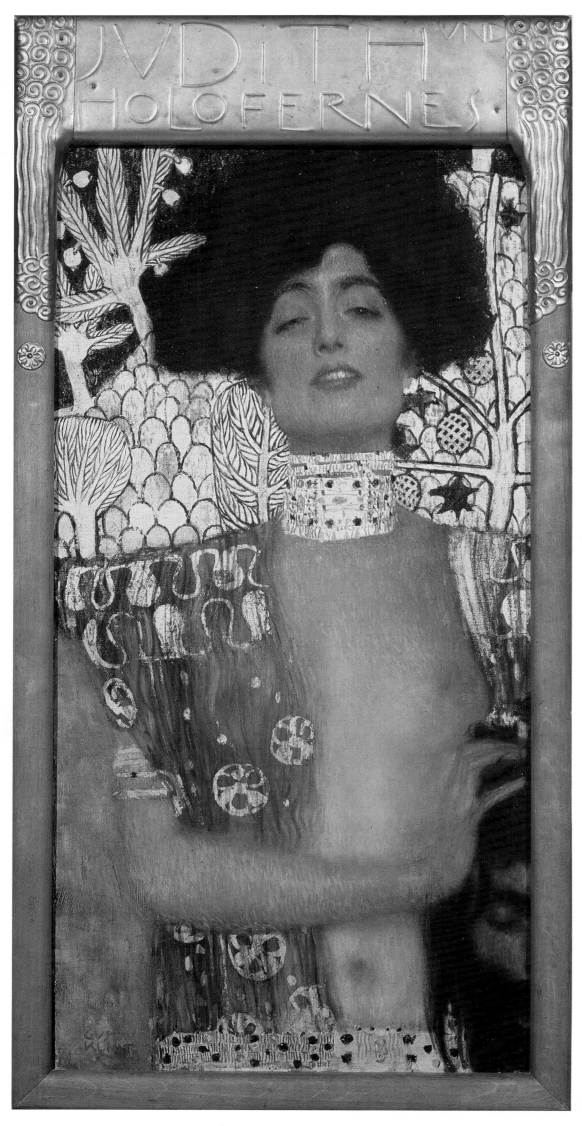

Judith

1
Judith and Holofernes, a veritable icon, is set in a metal frame similar in style to that used in *Pallas Athene* (1898). The rich background, in the form of a stylised and ornamented apple tree, the necklace, the decoration of the dress, all speak of Klimt's 'Golden Period'.

2
This image of *Judith and Holofernes* is intrinsically linked to its large gilded frame, which sets a limit to the sinuous lines of the composition on the left and the right. In 1909 Klimt began to abandon the use of gold in his pictures, in favour of warm colours such as the orange-red used in the background here.

1

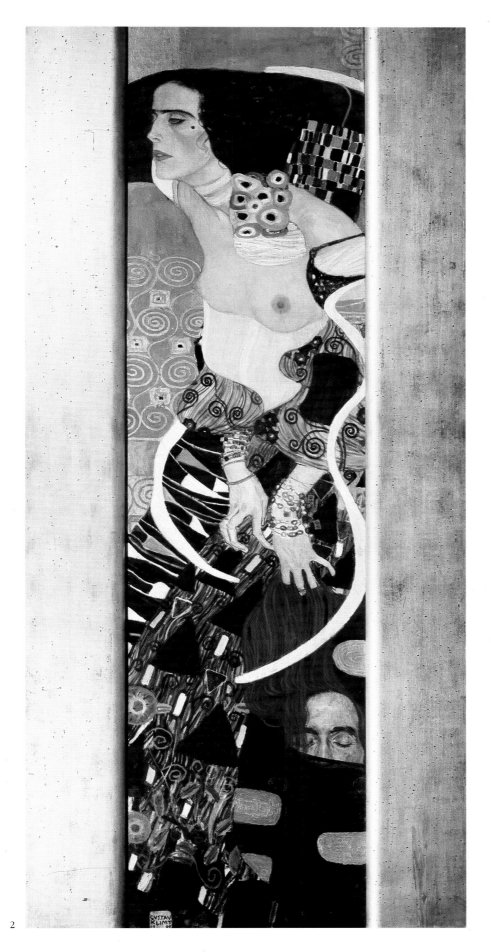

2

These two versions of *Judith and Holofernes*, done at an interval of eight years, are apt illustrations of the theme of the *femme fatale* in Klimt's work. The biblical heroine, who seduced General Holofernes then cut off his head in order to save her city, is an incarnation of courage and determination in pursuit of an ideal. The first picture (1901), in which the heroine is presented from the front, concentrates on the psychological aspect of the beautiful Viennese woman who sat for Judith. Klimt, in painting a contemporary, does not seek to make her timeless. The necklace she is wearing accords with the fashion of the period. The second version (1909) approaches the subject differently. Judith is no longer presented from the front and the picture is constructed to emphasise height. The new Judith, of a disturbing sensuality, drags the head of Holofernes triumphantly by the hair. Judith's face and bare breasts and long curving fingers emerge from a tangle of intricate decorative effects. Holofernes, as in the first *Judith*, has his eyes closed. The man punished by a woman meets the sentence of death. In this sense Judith is the castrating heroine *par excellence*, a characteristic she shares with Salome. Indeed, these two paintings have often been entitled erroneously *Salome*.

1 *Judith and Holofernes I*, 1901
Oil on canvas, 84 x 42 cm
Österreichische Galerie, Vienna

2 *Judith and Holofernes II*, 1909
Oil on canvas, 178 x 46 cm
Gallery of Modern Art, Venice

Gustav Klimt often turned to drawing in his search for sources of inspiration. Alice Strobl lists a little under 4000 drawings in her catalogue, to which should be added the thousands of sheets the artist is said by his contemporaries to have destroyed. Klimt made extensive use of models in his work, finding them either through a form of agency in Vienna, or in his own neighbourhood. An example is the old man to be seen in a number of his works, among them *Jurisprudence*. The story behind *Hope I*, a painting considered scandalous, obscene and sheer madness at the time, is an illustration of the extent to which Klimt was attached to his models and grateful to them. An account exists, in Viennese dialect, of the circumstances in which the picture came to be produced. The model, a young girl by the name of Herma, had often posed for Klimt and one day suddenly disappeared. Klimt, first angry, then worried, tried to find her. He discovered that she was pregnant, a disaster for her family who relied on her earnings for their livelihood. Moved by the problems his favourite model was suffering, Klimt employed her to pose for him in her pregnant state. All pure-minded people were shocked that an artist should have a pregnant women sit for him. Insults were heaped on Klimt's head. But this was how he came to paint the picture entitled *Hope*, of a young woman with a vast belly, like 'a living receptacle in which the hope of humanity ripens'. Klimt's generosity towards his models when they were in need was not infrequent and he was idolised by his models, male and female.

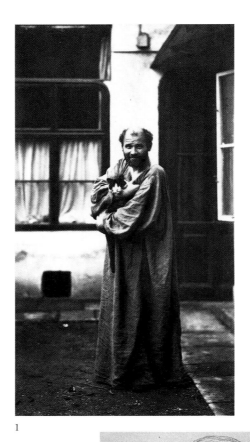

1

2

1
This photograph of Klimt in the garden of his studio suggests a moment of relaxation between sittings. Smiling, a cat in his arms, he seems full of the humanity his models have described.

2
Around 1902 Klimt abandoned the technique of parallel hatching and instead underlined contours heavily in black chalk. He began to make use of the continuous line in his work.

2 *Study for the Gorgon in the Beethoven Frieze*, 1902
Black chalk, 45.2 x 30.9 cm
Albertina, Vienna

3 *Hope I*, 1903
Oil on canvas, 181 x 67 cm
National Gallery of Canada, Ottawa

Following pages:
1 *Study of a Seated Woman*, 1908-9
Pencil, 56 x 37 cm
Albertina, Vienna
2 *Woman in Profile Reading a Letter*, 1907
Pencil, 56.5 x 36.8 cm
Albertina, Vienna

3
Hope I, produced in 1903, was not exhibited in Vienna until 1909 at the Kunstschau, with *Hope II*, painted in 1907. It was bought by Fritz Waerndorfer, one of the founders of the Wiener Werkstätte. Klimt had been unable to exhibit the painting in 1903 because of the scandal caused by *Philosophy*, *Jurisprudence* and *Medicine*. *Hope* was regarded as equally indecent.

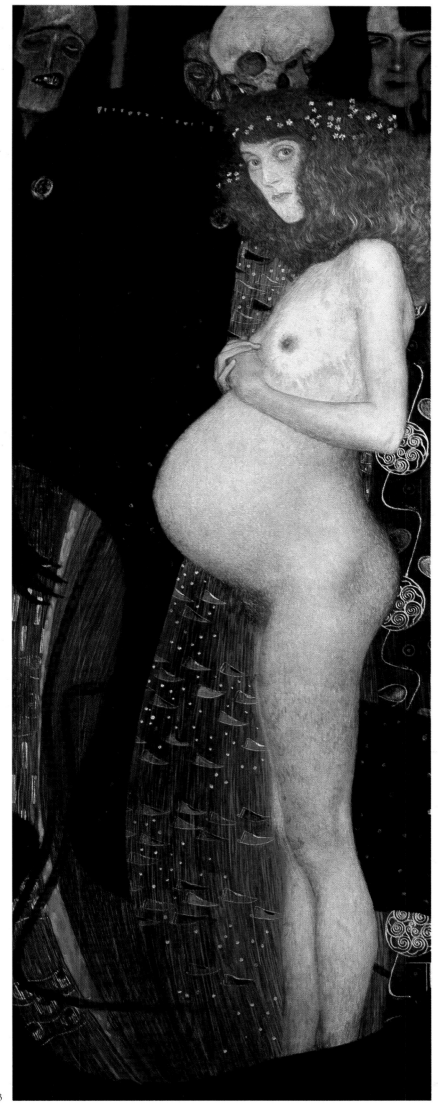

3

GVSTAV
KLIMT
NACHLASS

1

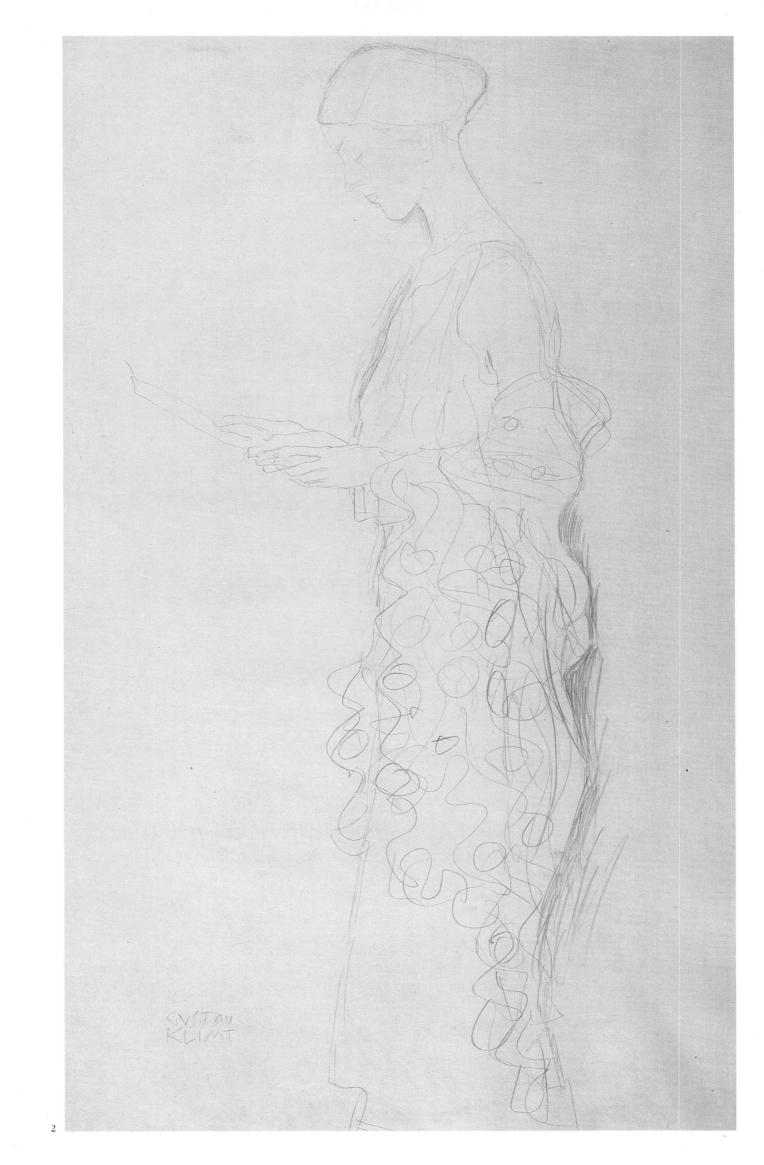

2

Emilie Flöge, Klimt's companion, owned a fashion salon, La Casa Piccola, in Vienna, which she ran with her sisters. The salon was a gathering place for the avant-garde of Vienna. The Flöge sisters worked closely with the Wiener Werkstätte which supplied them with materials, jewellery and a variety of objects for their salon: statuettes, cushions, items of clothing. Emilie Flöge, who designed the clothes herself, was very influenced by Slavic folklore, above all Romanian embroidery. This is apparent in her heavily embroidered dresses, brightly coloured materials and wrap-over skirts.

Gustav Klimt was very interested in Emilie's work and only too ready to offer assistance, designing samples of long, simply cut dresses that hung away from the body, somewhat like kimonos. The design of these dresses derived originally from the well-known tunic of North African inspiration which was worn by Klimt himself. Emilie Flöge had given it to him, having had it made in the Wiener Werkstätte. Klimkt not only designed dresses, but took up fashion photography in quite a professional manner. His photographs were published in magazines and used to advertise the dresses. Emilie Flöge modelled her own creations wearing long necklaces designed and produced by the Wiener Werkstätte, and given to her by Klimt. The Flöge sisters' salon operated successfully up until the end of the First World War. The post-war period saw the end of their prosperous clientele. And the Second World War forced them to close their workshop on account of the dearth of suppliers.

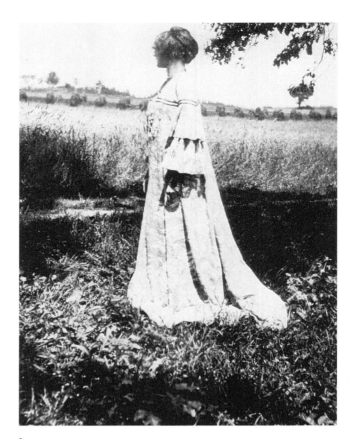

1
Emilie Flöge in a tea-gown.
Photograph by Gustav Klimt, 1907.

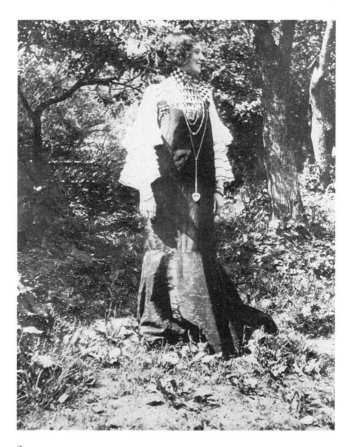

2
Emilie Flöge in an evening dress.
Her necklace was given to her by Klimt. It was made by the Wiener Werkstätte (Hoffmann).
Photograph
by Gustav Klimt, 1907.

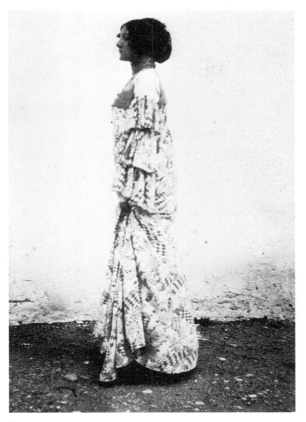

3
Emilie Flöge in a tea-gown.
Photograph by Gustav Klimt, 1907.

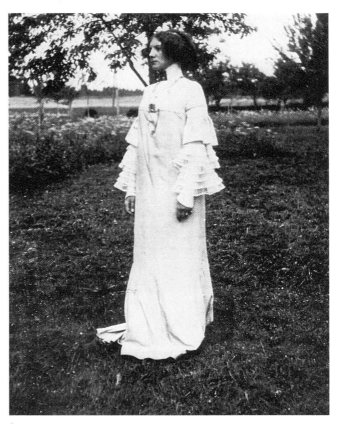

4
Emilie Flöge in a party dress.
Photograph by Gustav Klimt, 1907.

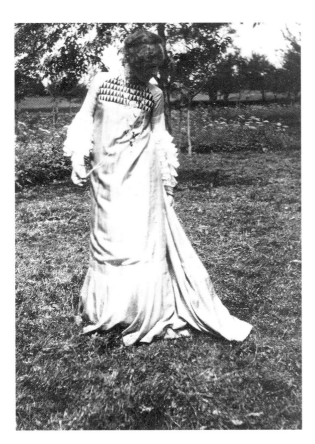

5
Emilie Flöge in a summer dress.
Photograph by Gustav Klimt, 1907.

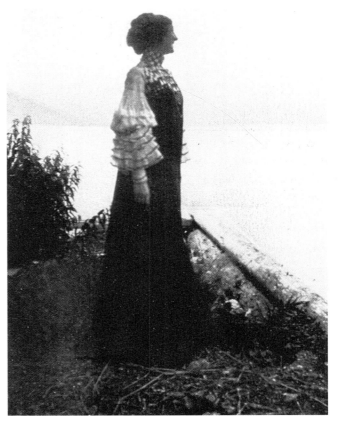

6
Emilie Flöge in an evening dress.
Photograph by Gustav Klimt, 1907.

'Your water-people seem to have emerged from a novel by Victor Hugo, so sad and languishing do they seem, and yet so strangely natural.'
(Peter Altenberg, Lecture, 1917)

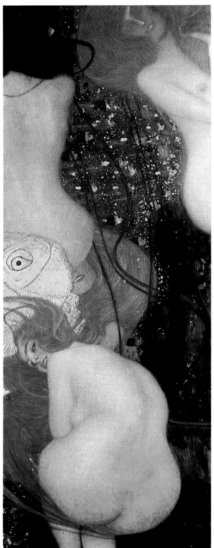

Klimt's 'fish women' express dreams of water which are overtly sensual. Undulating forms, their bodies float among the long tresses of their hair. The flowing, curving brushstrokes seem to trace the path of the nymphs swept away by the water. The serpentine line is Jugendstil incarnate, while the brushstrokes characteristic of this period, already applied so distinctively in the *Portrait of Sonja Knips*, are influenced by the work of James McNeill Whistler. Klimt admirably renders the vaporous quality of the naked bodies abandoned to the waters. *Mermaids*, lascivious and provocative figures on a background touched with gold, is a theme that recurs in the later paintings, *Water-Snakes I/II* (1904/7).

1
The curvaceous nudes of this composition are an image that recurs later in Klimt's paintings, *Philosophy* and *Medicine*, for the Great Hall of the University.

2
Goldfish, a painting which Klimt started probably before 1901, was used by him as a form of retort to the various attacks made on *Medicine*. Klimt wanted, not without humour, to dedicate the picture 'to my detractors'.

1 *Flowing Water*, 1898
Oil on canvas, 53.3 x 66.3 cm
Private collection, New York

2 *Goldfish*, 1901-2
Oil on canvas, 181 x 66.5 cm
Private collection, Switzerland

3 *Mermaids (Whitefish)*, c. 1899
Oil on canvas, 82 x 52 cm
Zentralsparkasse der gemeinde, Vienna

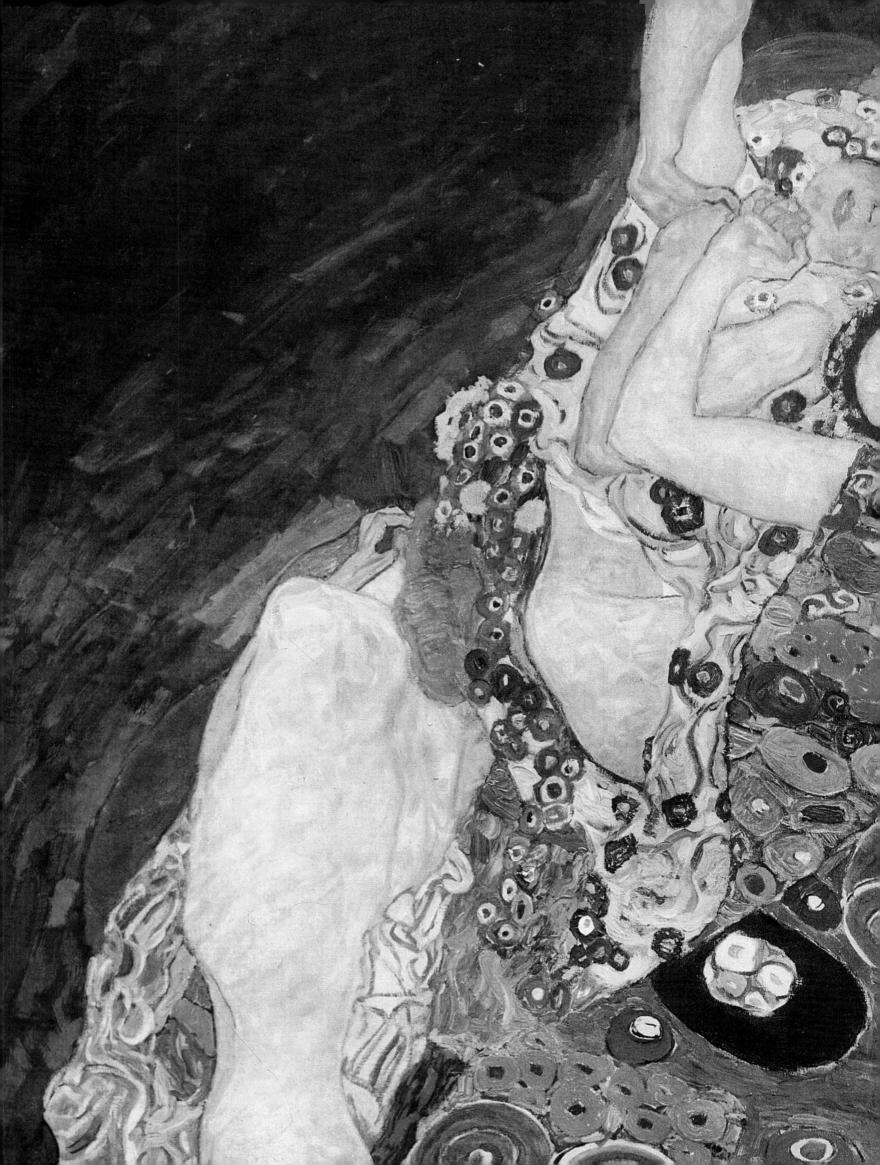

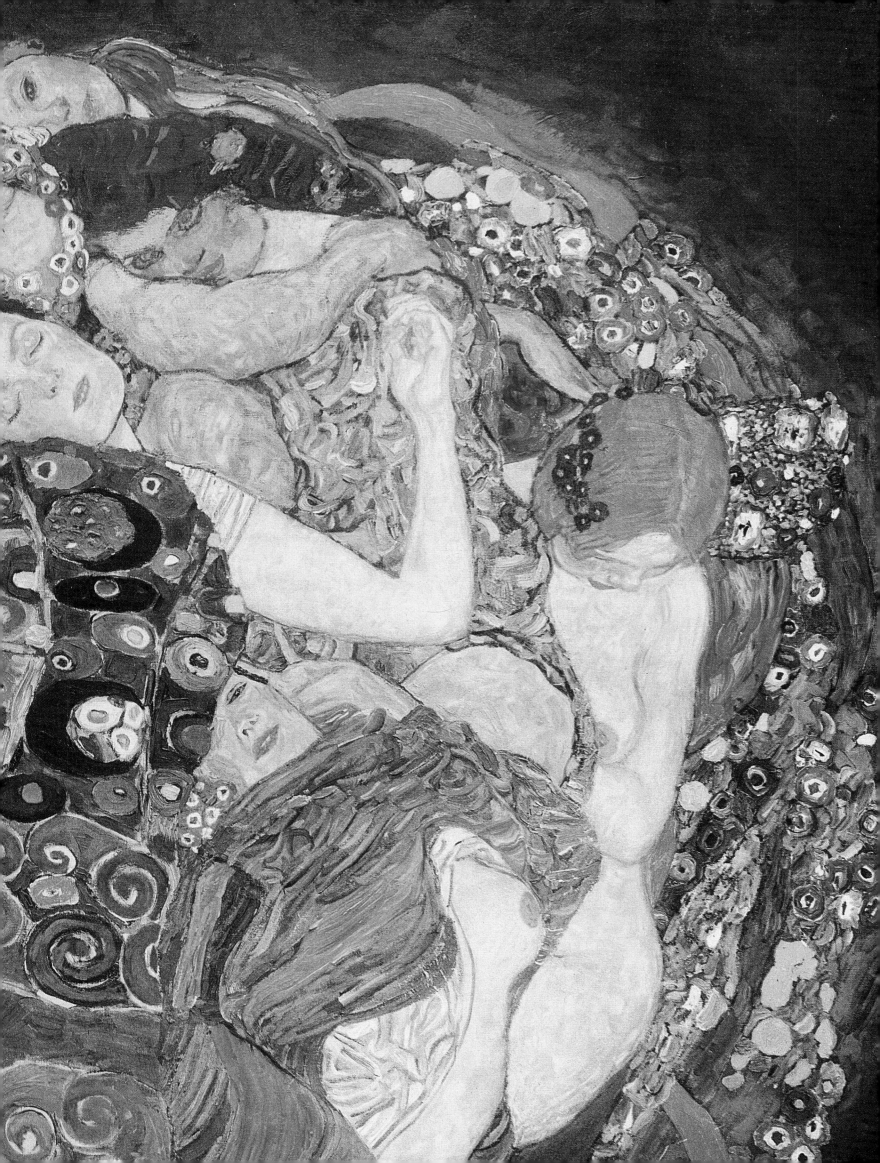

Golden rain

The importance of the part played by Eros in Klimt's painting is reflected by the recurrence of erotic themes throughout his oeuvre. Eros appears on several occasions – the *Beethoven Frieze*, *Mermaids*, *The Kiss* – and particularly forcefully in works such as *Danaë* or *Leda* (destroyed at Schloss Immendorf in 1945). *Danaë*, her body coiling round itself to receive the golden rain that symbolises Jupiter, is a very original composition: the subject had never before been approached in such a realistic and concentrated manner. There are virtually no geometric elements in the work, curves being clearly predominant, and this applies even to the decorative motifs on the flimsy violet veil. The abundant use of gold is characteristic of the years 1907-8.

It was in 1907 that Klimt first met Egon Schiele, and proved a determining influence on the latter's work. Around 1910 the influence operated in reverse, as is apparent from Klimt's late painting *Leda* (1917). A drawing of *Danaë* by Schiele shows his knowledge of this academic subject and the wish to handle the subject on conventional lines. What is interesting is that he completely reverses the composition. Klimt did the same thing when he painted *Leda* towards the end of his life. The points where the two pictures and, indeed, the two artists converge show that there was a genuine and creative spirit of emulation at work between a first-generation Viennese painter and his colleague twenty-eight years younger.

1

2

3

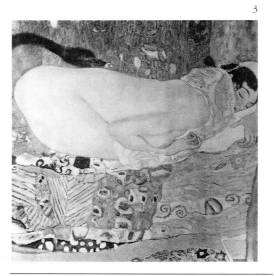

3/4/5
These paintings seem voyeuristic in their rendering of the latent sexuality of the sleeping women, caught in the middle of an erotic dream. Klimt's eroticism here is at its most shameless and indiscreet. *Danaë* shows the extent to which he was captivated by the female form.

1 *Preparatory study for Danaë*,
c. 1909. Egon Schiele
Drawing with squaring (verso)
Albertina, Vienna

2 *Preparatory study for Leda*, 1913-14
Pencil, 56 x 39.1 cm
Leopold Collection, Vienna

3 *Leda*, c. 1917
Oil on canvas, 99 x 99 cm
Destroyed at Schloss Immendorf in 1945

4 *Danaë*, c. 1907-8
Oil on canvas, 22 x 83 cm
Private collection, Graz

5 (& detail, previous pages)
The Virgin, 1912-13
Oil on canvas, 190 x 200 cm
Národní Gallery, Prague

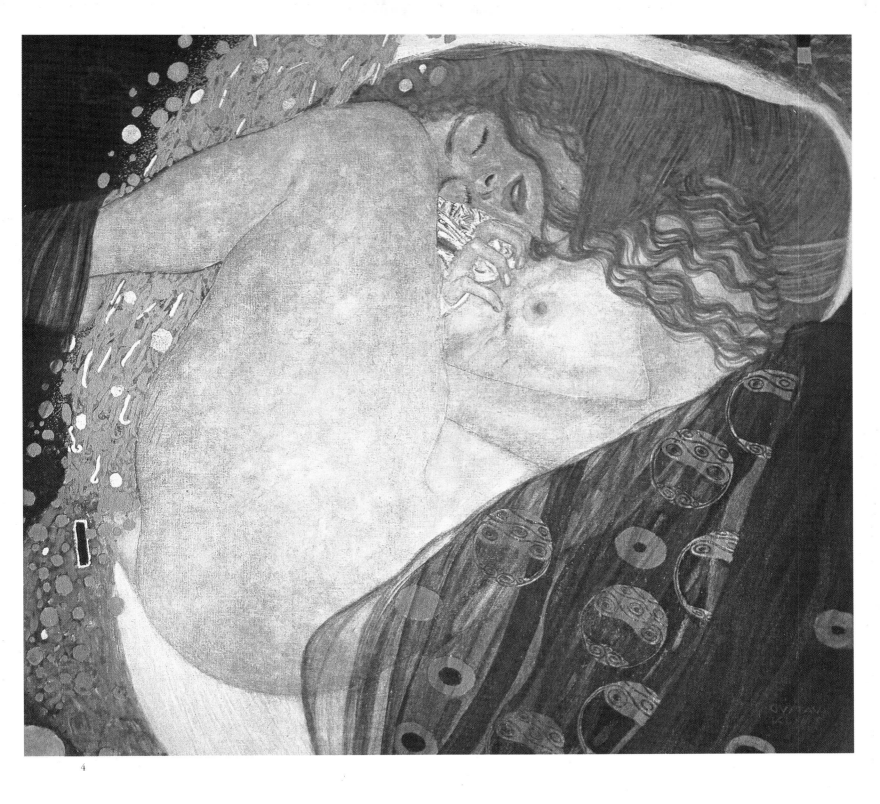

4

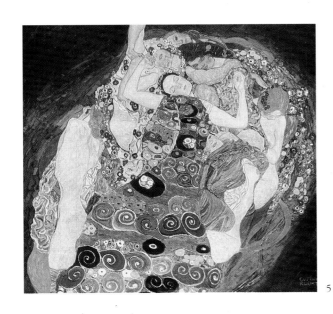

5

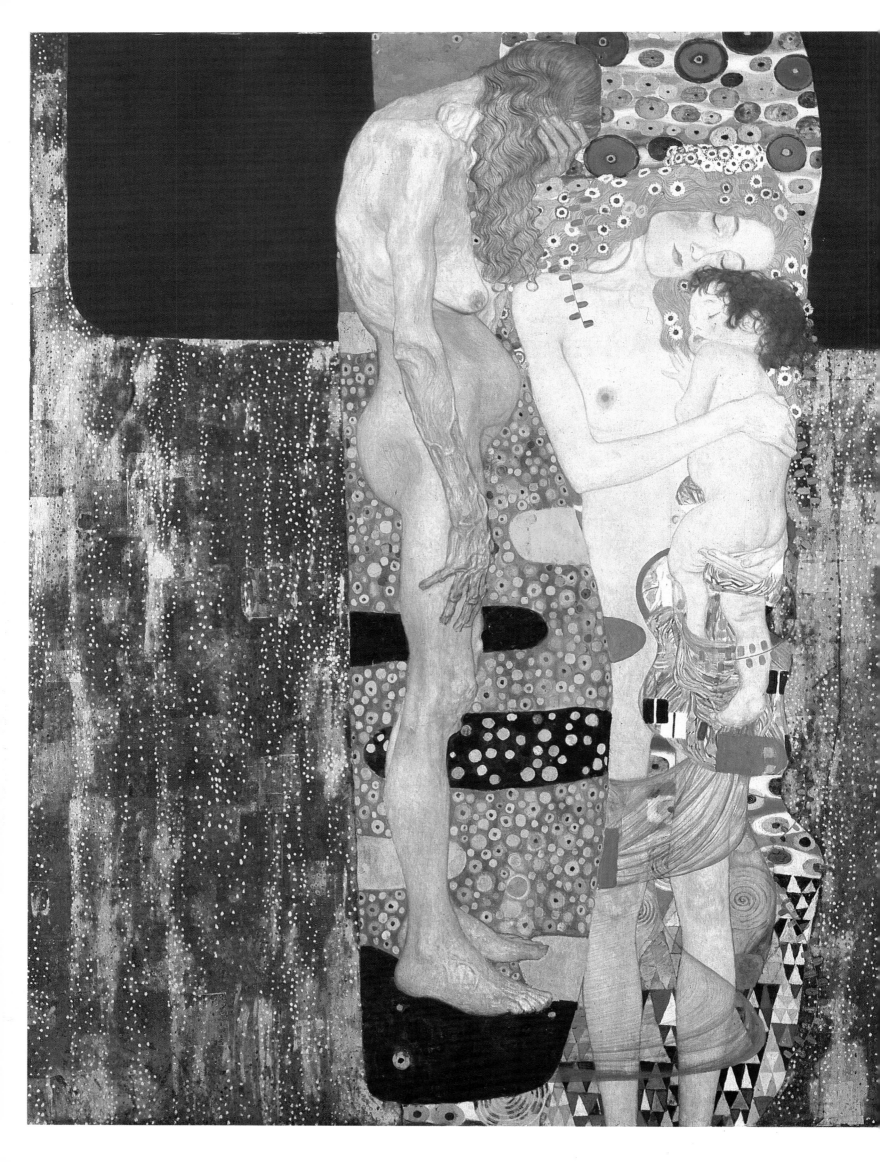

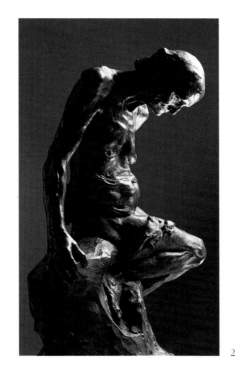

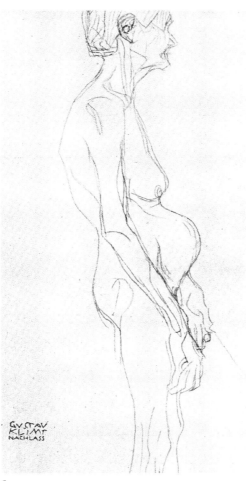

1 *The Three Ages of Woman*, 1905
Oil on canvas, 180 x 180 cm
Galleria Nazionale d'Arte Moderna, Rome

2 *Celle qui fut la belle Heaulmière*,
1880-3. Auguste Rodin
Bronze, 50 x 30 x 26.5 cm
Musée Rodin, Paris (photo B. Jarret)

3 *Study for the Old Woman*
(for *Medicine*), 1905
Pencil, 44 x 31.4 cm
Galleria Nazionale d'Arte Moderna, Rome

*T*he Three Ages of Woman is another of
Klimt's allegorical and symbolic works, in the
same genre as his masterly University paint-
ings. He practised this genre until the end of
his life, the last, and unfinished, example
being *The Bride* (1917-18).

The old woman is inspired by Rodin's
bronze, *Celle qui fut la belle Heaulmière*. It is
another instance of the interaction of these
two great portrayers of the female form. The
subject of the picture, a pretext for Klimt to
elaborate his favourite images, is densely
composed and concentrated in its use of dec-
orative effects. On the right a little girl, in the
arms of a young woman caught in a swirl of
veil, sleeps with an expression of genuine
contentment and happiness on her face. The
old woman with bowed head, isolated on the
left, covers her eyes with her left hand. Is she
weeping at the horrors of the passage of time?
Black plays an important part in the decora-
tive background, which is unusual in Klimt's
work; indeed it seems to struggle for pre-
dominance against the gilded effects, produc-
ing patches of unbroken darkness.

The portrait of *Margaret Stonborough-Wittgenstein* (1905) was commissioned from Klimt by her father the year of her marriage to Stonborough. Margaret, who belonged to one of the richest families of the Vienna bourgeoisie, was the older sister of the philosopher Ludwig Wittgenstein, a strange and complex personality. Having renounced his share of his paternal inheritance, he worked as a country schoolmaster from 1919 to 1929. His sister then asked him to take charge of the construction of her house, the plans of which were by Paul Engelmann. This occupied him from 1926 to 1928. He thought out and designed the minutest details of the interior decoration of the building. The façade was striking in the stark simplicity of its geometrical lines, recalling the buildings of Adolf Loos.

Margaret was a strong character. A friend of Freud, she formed part of the intellectual and cultural élite of Vienna. Klimt's portrait of her is arresting in its combination of modern decorative background and naturalist rendering of the dress. It is also interesting in its psychological approach to the sitter, akin to that of *Portrait of Sonja Knips* (1898). The flowing brushstrokes, the floral decoration of the dress – white on white – the roundness of the bare shoulders, contrast with the square and rectangles composing the background. By presenting Margaret standing, turned three-quarters towards the viewer, Klimt broke the current practice of full-frontal portraits. He accentuated the picture's vertical effect by his use of geometric forms in the background. The horizontal lines in a composition that is vertically conceived are a later addition by the artist. He was not satisfied with his initial work and refused to accept the agreed fee of 5000 guilders until he had made alterations.

1

1/2
Ludwig Wittgenstein published a single work in his lifetime, *Tractatus logico-philosophicus* (1921), investigating the limits of language. The opportunity to design the interior of his sister's house allowed him to put *Tractatus* into practice by creating an architectural form of expression in which clarity, simplicity and rigour work in unison.

2

1 *Portrait of Ludwig Wittgenstein*, 1951
Drawing signed K.B.
Österreichische Nationalbibliothek, Vienna

2 Exterior of Wittgenstein House
Kundmangasse 19, south side
Photograph by Moritz Naehr, 1928

3 *Portrait of Margaret
Stonborough-Wittgenstein*, 1905
Oil on canvas, 180 x 90 cm
Bayerische Staatsgemäldesammlungen,
Neue Pinakothek, Munich

3
When this portrait was exhibited in Berlin at the second exhibition of Deutscher Künstlerbund in the autumn of 1905, it lacked the architectural decorative motif inspired by Josef Hoffmann and the dark horizontal band below. These details were later additions by the artist, who was dissatisfied with his original work.

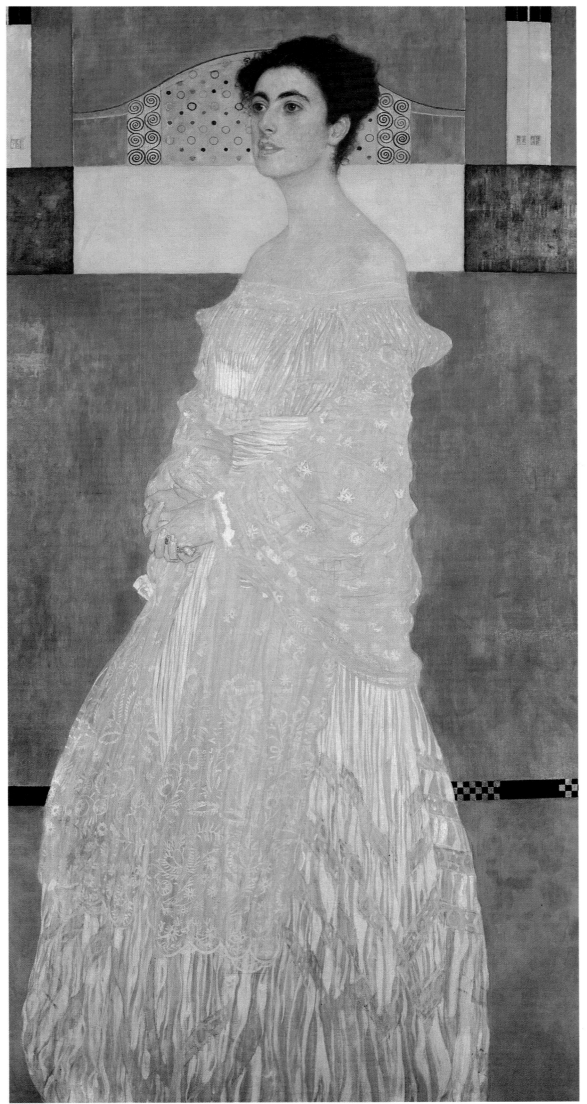

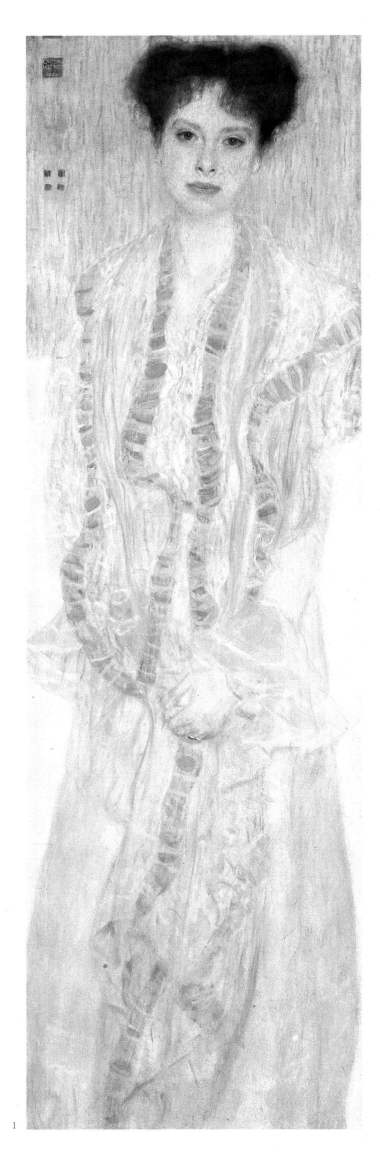

Ladies of Vienna

1
Klimt became the established
portrait painter of the Vienna
bourgeoisie, as these two portraits
confirm. The sitter here was the
daughter of Dr Anton Löw. She
first married Eissler-Terramare,
then on a remarriage became
Mme Felsövanyi. In this painting,
which was commissioned, Klimt is
less experimental in style than
elsewhere. This stands out in
comparison with the *Portrait of
Emilie Flöge*, also produced in
1902. There are nonetheless,
above on the left, square motifs,
the form so dear to the Secession
artists.

2
The *Portrait of Hermine Gallia*
was shown in unfinished state at
the Secession's 1903 exhibition
and completed in 1904. It was the
first commissioned portrait to
incorporate geometric elements,
visible on the skirt of the dress
and on the carpet. Klimt paid
careful attention to the hands and
to the psychology of the sitter,
who is wearing a dress of the kind
created by Emilie Flöge.

1 *Portrait of Gertha Felsövanyi*, 1902
Oil on canvas, 150 x 45.5 cm
Private collection

2 *Portrait of Hermine Gallia*, 1904
Oil on canvas, 170.5 x 96.05
National Gallery, London

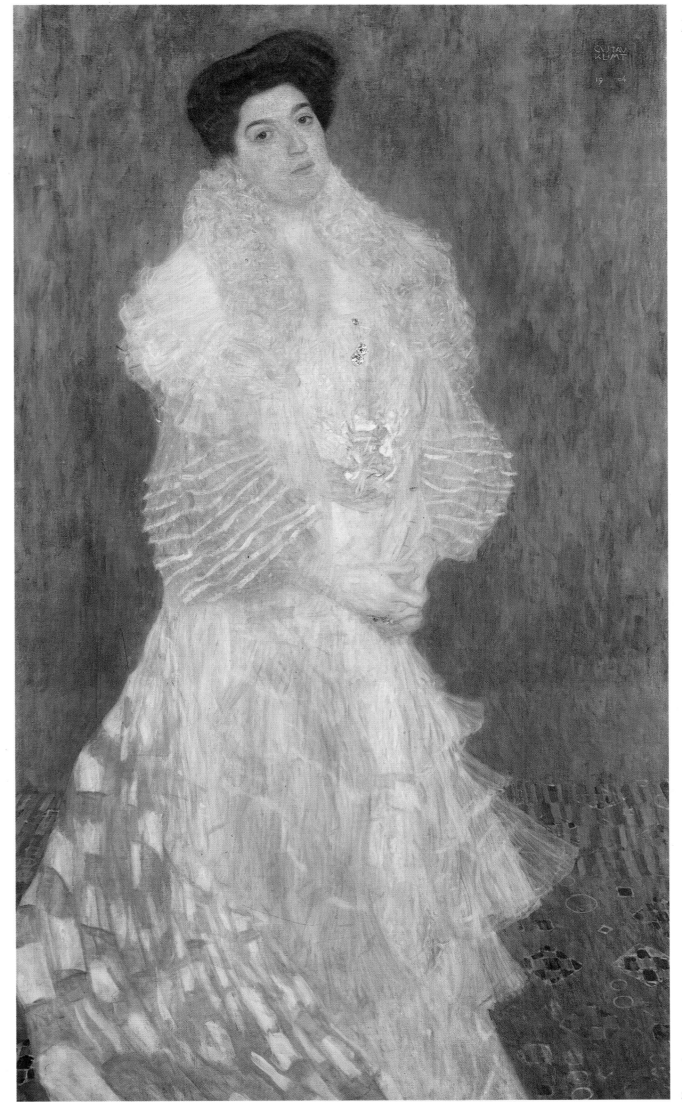

2

Gustav Klimt's companion, whom he never married, was painted only once by the artist. The stylised decorative motifs accentuating Emilie Flöge's elongated silhouette appear for the first time in this composition, dated 1902. The dress is imprinted with a spiral design and decorated with simple geometric motifs (square, oval, circle) picked out with gold. The material and style of the dress seem to be entirely the product of the artist's imagination when one compares them to the dresses Emilie designed and wore. The modernity of the garment indeed caused consternation to Klimt's mother, who was horrified when the painting was exhibited at the Kunstschau in 1908. A postcard Klimt sent to Emilie Flöge on 6 July 1908 reported: 'I was taken to task by my mother yesterday.' She would have preferred Emilie in one of the embroidered or frilly dresses seen in her photographs and lamented the portrait's lack of femininity. It is true that the pattern of the dress resembles that of a carpet, an impression reinforced by contrast with the sombre neutrality of the two-coloured background. It is hard to tell what Klimt is representing behind Emilie's head: the inside of a hat, an umbrella, a fan fixed to the wall? The material, differing from that of the dress in its triangular motifs, enhances Emilie's face framed by its symmetrically arranged mass of hair. A third and fourth decorative motif appear on the upper part of the dress – a scarf? – and on the diaphanous sleeves which almost allow us to see the arms inside them. Amidst all the decorative profusion, what stands out are Emilie's face with its Symbolist allure and her elongated hands.

1

3
Emilie Flöge, portrayed standing, seems linked to the tradition of formal portraits that evolved, above all, in the eighteenth century. Klimt, however, adds a different note with the inventive flair of his ornamental motifs.

2

1 Emilie Flöge, 1909. Photograph by Ora Banda

2 Emilie Flöge, 1910. Photograph by Ora Banda
Bildarchiv, Österreichische Nationalbibliothek

3 *Portrait of Emilie Flöge*, 1902
Oil on canvas, 178 x 80 cm
Historisches Museum der Stadt, Vienna

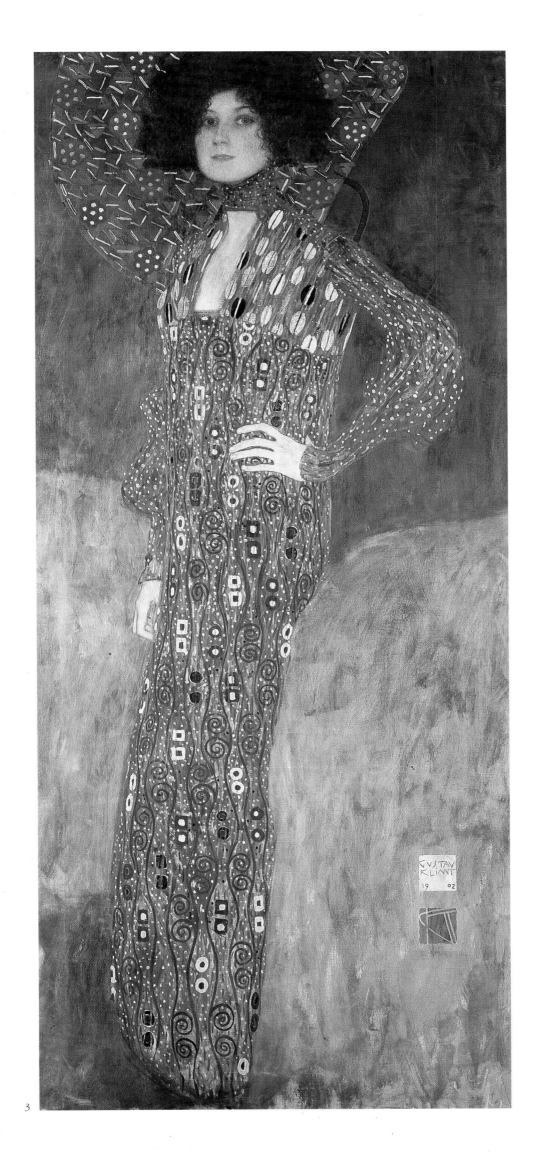

3

Attersee

It was relatively late in his life, when financial circumstances were easier, that Gustav Klimt began to frequent the Attersee. He went there with his companion, Emilie Flöge, and his family. The lake had become a popular holiday spot in the 1880s, a haven of tranquillity removed from the hubbub of life in Vienna. There were no concerts or festivals, and few hotels. Klimt could relax in the company of his relations and a few friends.

It was to the Attersee that he came in search of peace, after the storms of protest engendered by his University paintings. It was also there that he began to paint landscapes, featuring gardens, the lake, architecture (particularly Schloss Kammer). Klimt could be extremely unsociable and hated being disturbed at his work. Tranquillity was essential to his painting. This was so much so that he produced nothing at Golling in 1899 or Mayrhofen in 1917, both places of more bustle and commotion. At Attersee he could enjoy painting in the open air, a practice rendered fashionable by the Impressionists.

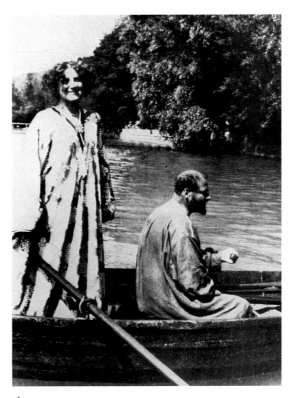

1
Emilie Flöge and Gustav Klimt in a boat on the Attersee, 1910.

2
Klimt in the garden of a house at Seewalchen, on the shores of the Attersee, with Irma Fischer and Dr Helene Schreiner, c. 1910.

3 *Avenue in Schloss Kammer Park*, 1912
Oil on canvas, 110 x 110 cm
Österreichische Galerie, Vienna

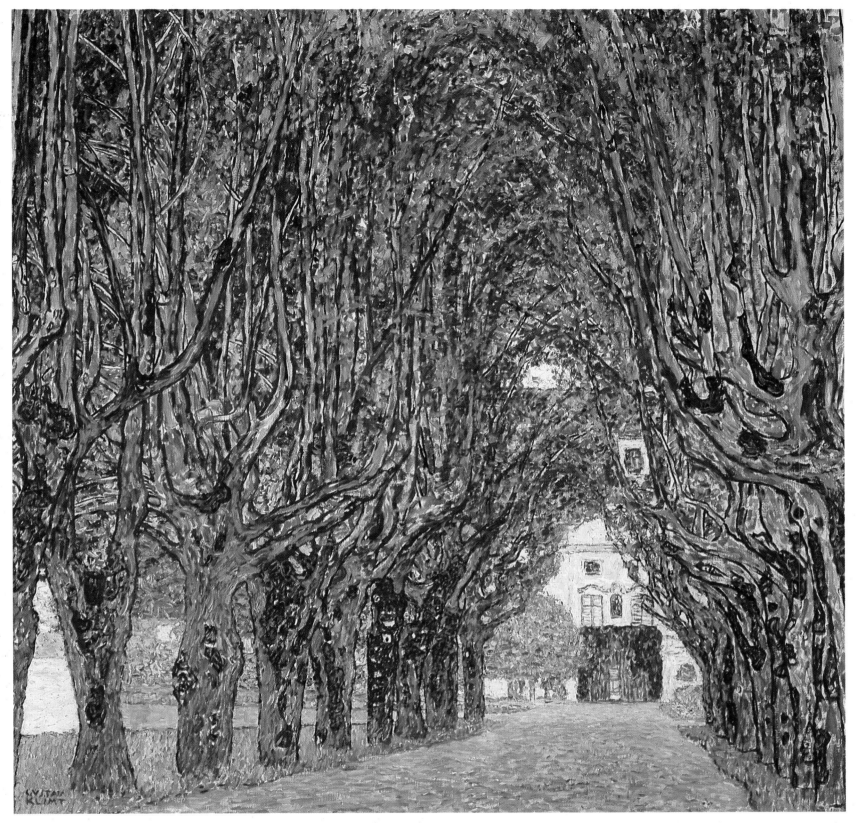

3

3
Klimt's painting of the avenue
leading to Schloss Kammer, dated
1912, is a late echo of the work of
van Gogh.

*'The landscapes of Gustav Klimt, the greatest of the Austrian
painters, are melodies from Schubert translated into colour.'
(Bertha Zuckerkandl)*

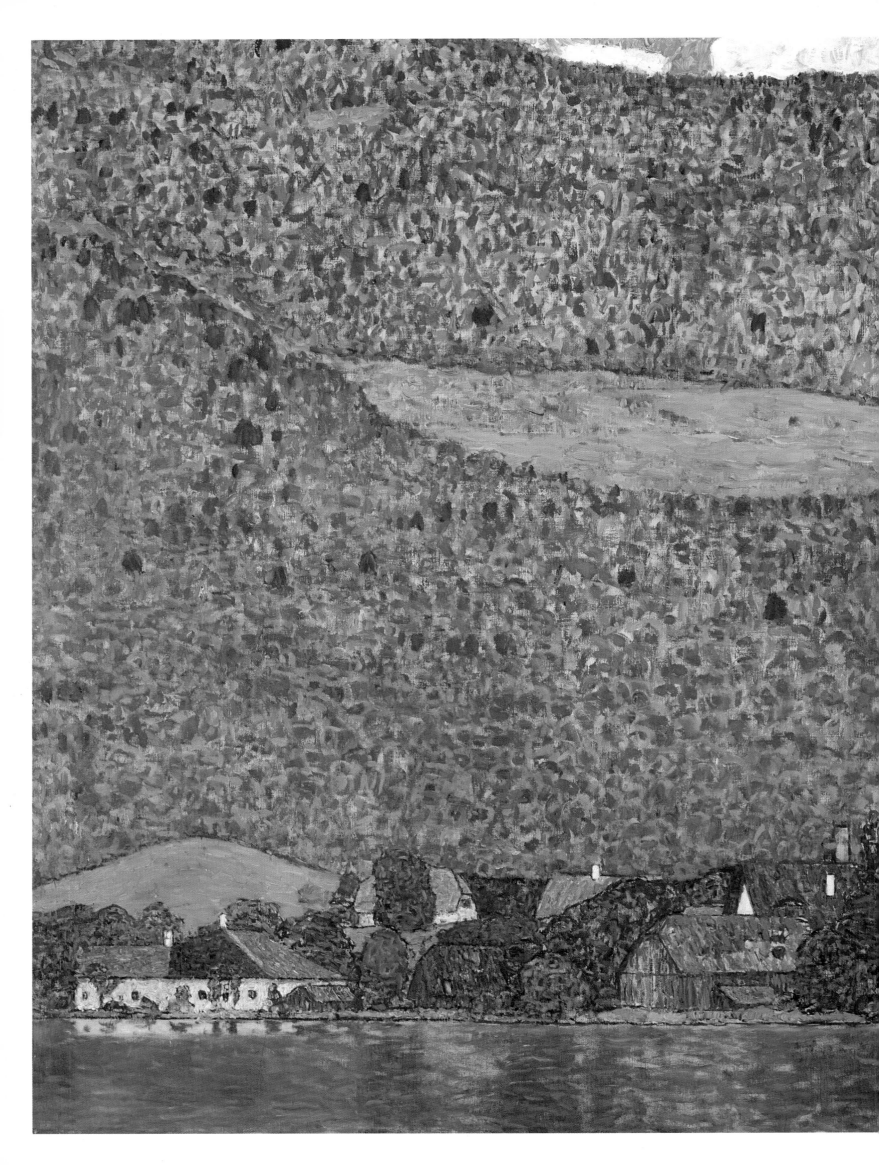

2
Klimt, Emilie Flöge (with hat) and
two others walk by the Attersee, *c.*
1910.

2

Gustav Klimt enjoyed outdoor sports.
He went canoeing and sailing on the lake. At
Attersee he was the first owner of a motor-
boat and acted as referee in a regatta. This
photograph of Gustav and Emilie in a boat
shows them both wearing their copious tun-
ics, even on holiday.

3
Gustav Klimt and friends in a
motor-boat leaving a house on the
Attersee, 1910.

3

1 *Unterach am Attersee*, 1915
Oil on canvas, 110 x 110 cm
Residenzgalerie, Salzburg

1

Brasserie Litzberg

1
The Brasserie Litzberg, as it is today after renovations. Klimt stayed in the rooms behind the balcony. From 1900 to 1907 he spent his summer holidays at the Brasserie with the Flöge family. Between 1908 and 1912 he stayed in a villa, the Oleandervilla. And from 1914 to 1916 Gustav and Emilie lived in a forester's house.

2
The island (left) and the Brasserie Litzberg in the trees. It is the island Klimt painted in the far background of some of his lake views, this one being an example.

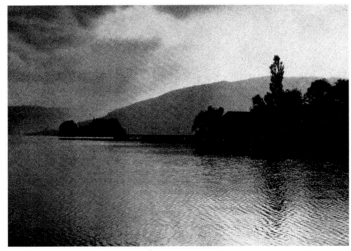

The Brasserie in the trees

3 *Island in the Attersee, c.* 1901
Oil on canvas, 100 x 100 cm
Private collection, New York

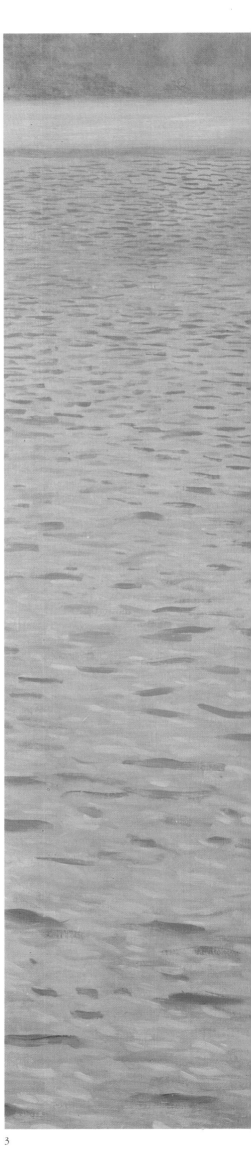

3

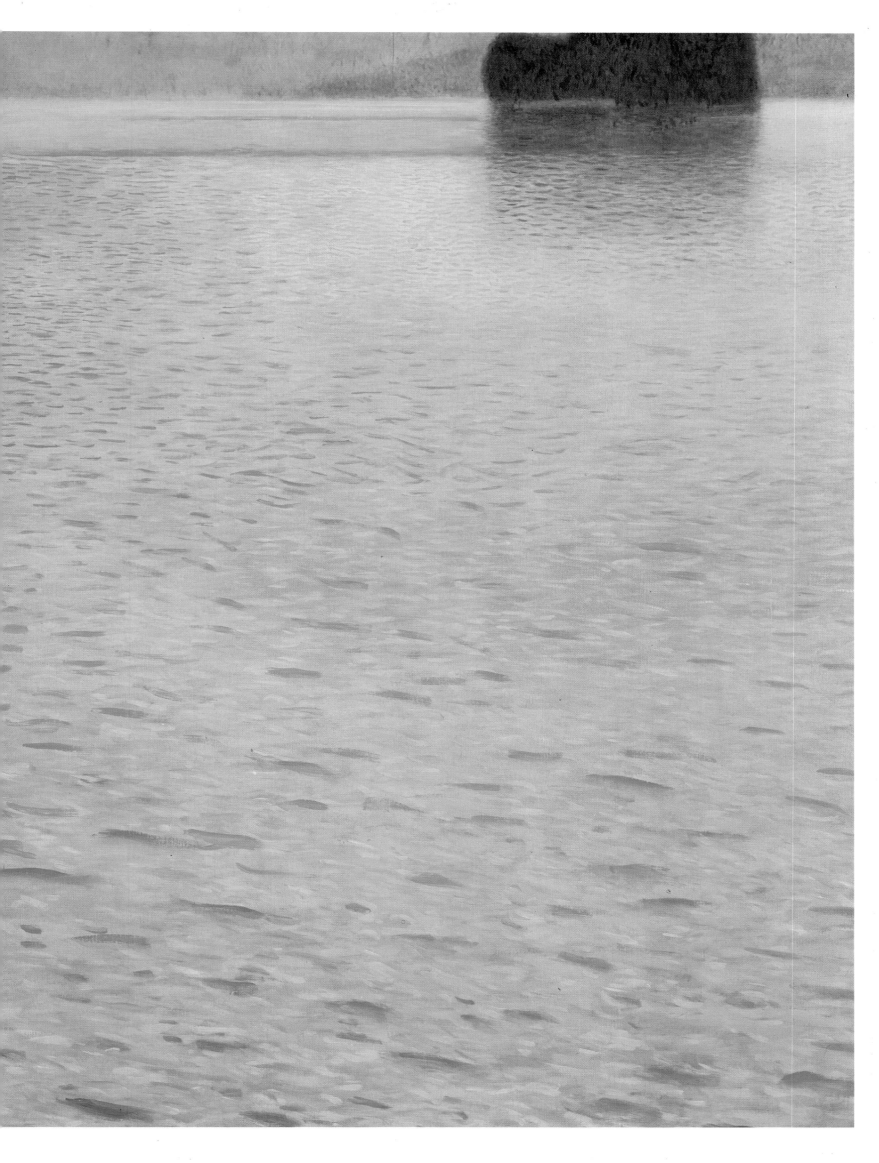

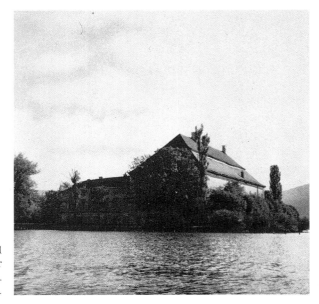

1
Schloss Kammer
at Attersee.
Photo of east shore of lake.

2
View of Attersee and the
peaceful landscape
painted by Klimt.

3
This painting is a
variation on a theme
which Klimt painted
several times. The
close-up effect, like that
of a photograph, is
characteristic of his
work. He almost never
painted sky, and clouds
even less. The facade, on
which he chooses to
concentrate, fills almost
all the canvas if one
includes its reflection, so
pleasingly rendered on
the water.

3 *Schloss Kammer on the Attersee III*, 1910
(detail on following pages)
Oil on canvas, 110 x 110 cm
Österreichische Galerie, Vienna

4 *Pond in Schloss Kammer Park*, c. 1899
Oil on canvas, 74 x 74 cm
Marco Danilovatz Collection, Vienna

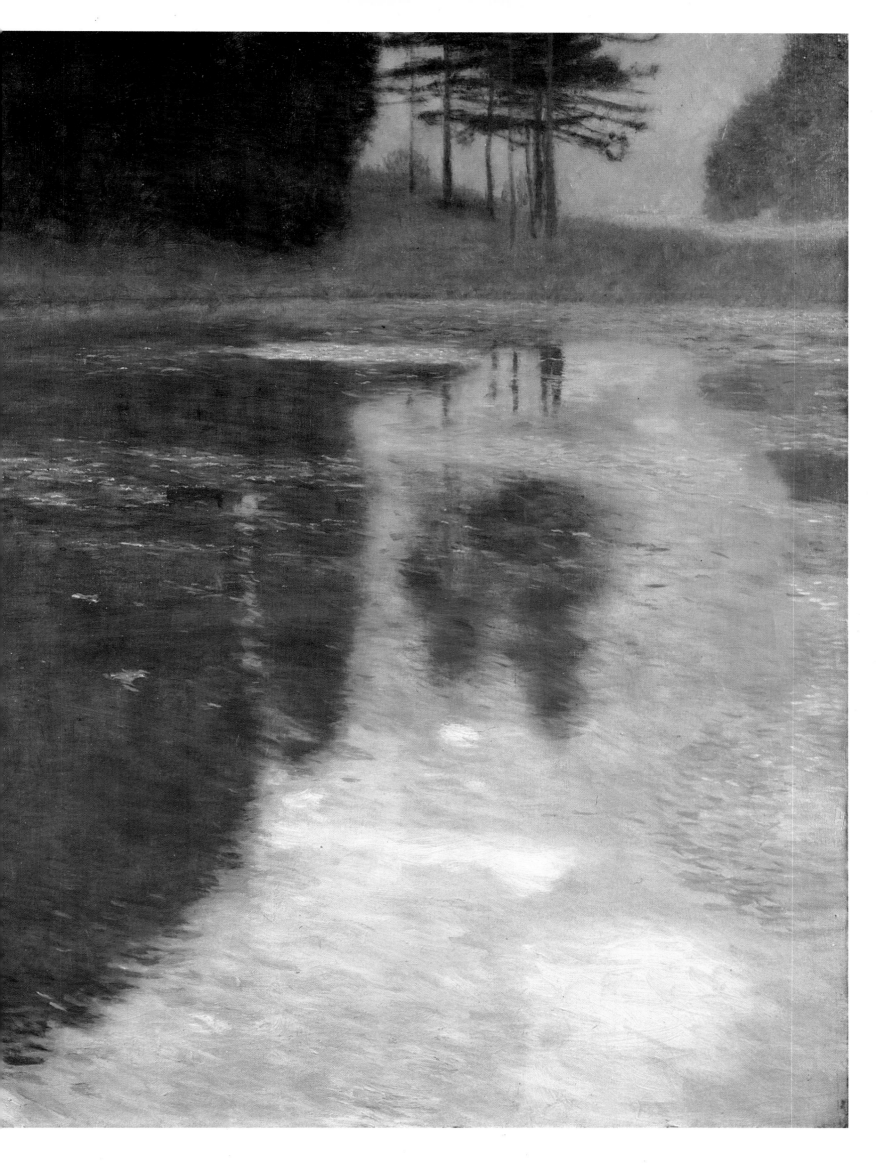

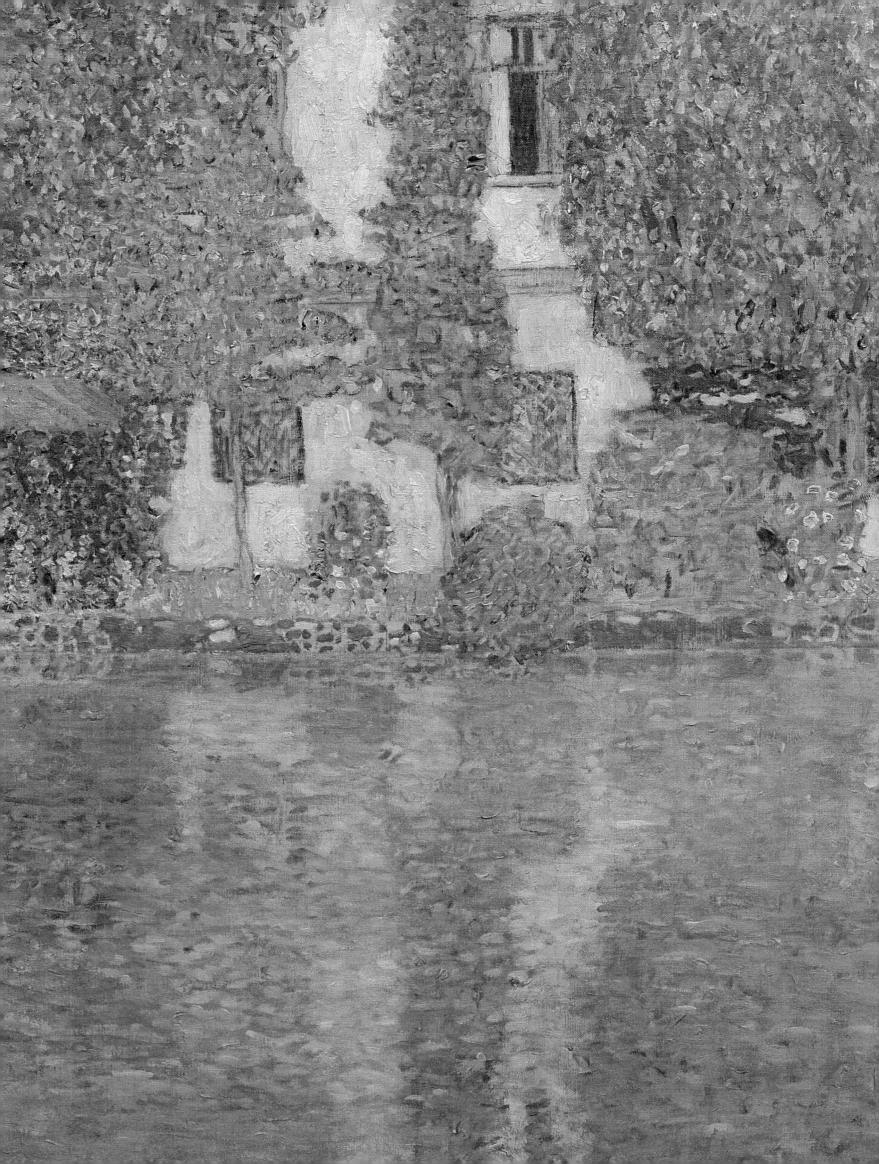

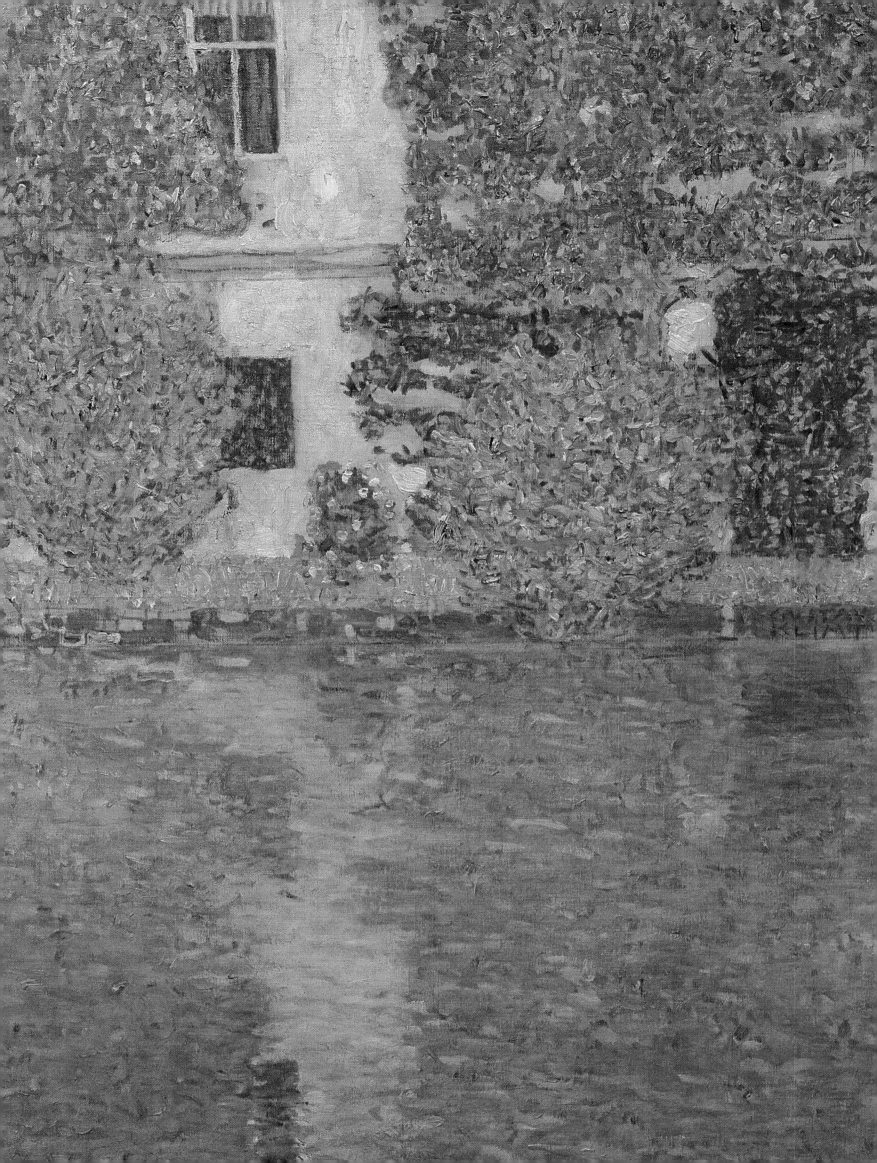

Following the violent argument provoked by his paintings for the University, Klimt ceased to exhibit in Vienna. This lasted from 1903 until the Kunstschau exhibition in 1908, organised by those who had left the Secession. In a speech opening the exhibition, he revealed his latest ideas about art and spoke of the Kunstschau's aspiration to form 'a community of artists'. The militant aims of the Secession were no longer in force in 1908. In their place the exhibition catalogue quoted the words of Oscar Wilde: 'Art never expresses anything but itself.'

In 1908 seventeen paintings by Klimt were shown at the Kunstschau. *The Kiss*, the masterpiece of his 'Golden Period', and the *Portrait of Emilie Flöge* were bought by the city. That year Klimt's fame was at its height. It is noteworthy that 1908 was also the year that Klimt gave encouragement to two young artists recently arrived on the Viennese scene: Egon Schiele and Oskar Kokoschka. Klimt effectively launched the latter, who showed his gratitude by dedicating to Klimt a book of stories he had written: *The Dreaming Boys*. Kokoschka's work was harshly received by

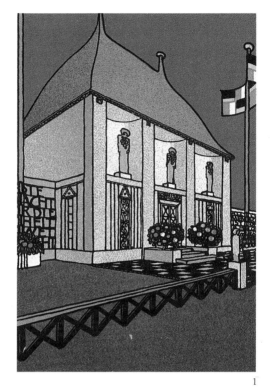

1/2
Josef Hoffmann belonged to the Klimt group that broke away from the Secession in 1905. Hoffmann was responsible for the architectural design of the Kunstschau.

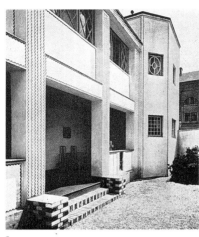

1 2

3
Kokoschka started his career as an artist at the Wiener Werkstätte where he produced illustrated postcards. *The Dreaming Boys*, a book of stories, was conceived and published by the Wiener Werkstätte and included original lithographs by Kokoschka. The figures could be representing Klimt and Schiele.

3 4

the public, although it was defended by Klimt. Schiele showed four paintings at the Kunstschau, thanks to the backing provided by Klimt and Josef Hoffmann, one of the first to buy his works. The interest Klimt took in these much younger artists is yet another indication of his openness and receptivity to all creative undertakings, even those that differed from his own. Kokoschka and Schiele were setting out on the difficult road to Expressionism.

1 *Entrance Pavilion to the Kunstschau*, 1908. J. Hoffmann
Postcard No 1 of Wiener Werkstätte series
14 x 9.1 cm
Historisches Museum der Stadt, Vienna

2 Villa, Josef Hoffmann
Deutsche Kunst und Dekoration, 1908-9, S.37

3 Illustration for *The Dreaming Boys*,
1907-8. O. Kokoschka. Lithograph
Historisches Museum der Stadt, Vienna

4 Photograph of Klimt's studio; on the wall: *Hope II*

5 *Hope II*, 1907-8
Oil on canvas, 110 x 110 cm
Museum of Modern Art, New York

5
Hope II, exhibited at the Kunstschau, returns to a subject painted in 1903, but here Klimt introduces decorative motifs on the dress covering the pregnant woman, as he had already done in *The Kiss* or *The Three Ages of Woman*. The death-head and the three other figures, who seem to be asleep, are symbolic evocations of the passage of time. The picture, still in Klimt's studio in 1914, not having found a buyer, was reworked by the artist.

'Art never expresses anything but itself' (Oscar Wilde)

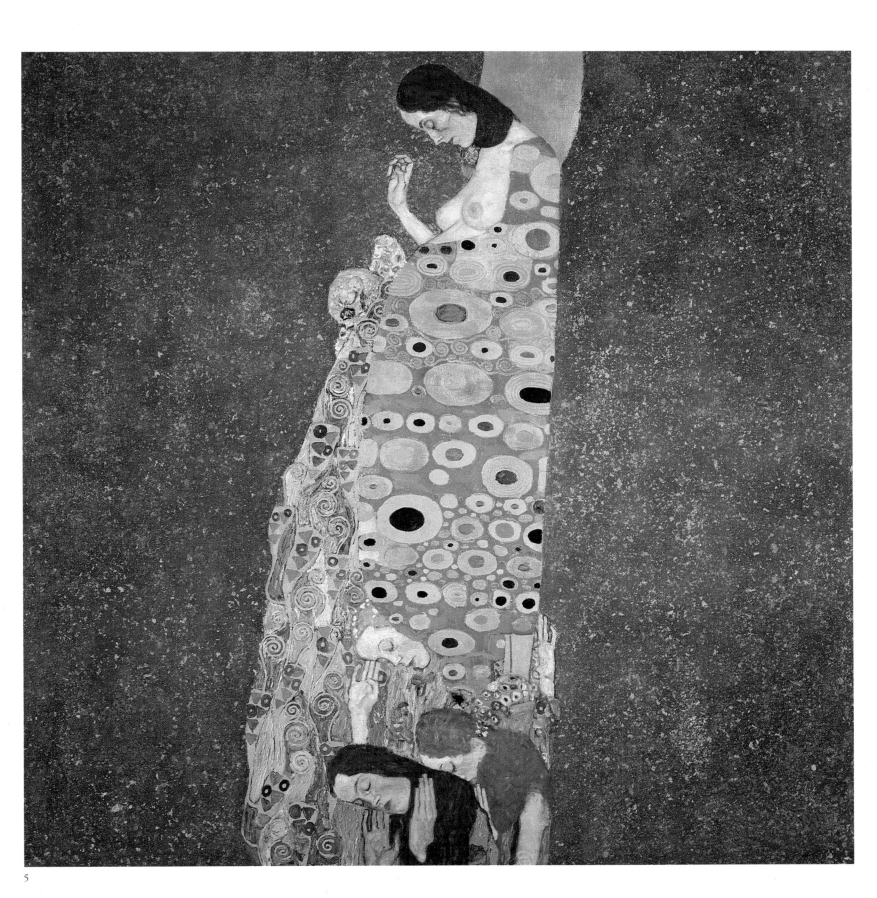

The arrangement of the figures in *The Family* (known also as *The Mother*, *The Refugees*, or *The Widow*) influenced both Schiele and Kokoschka. Their paintings some years later hold echoes of Klimt's. While it is possible to trace the composition back to Rodin – Klimt had been to Paris in 1909 and probably seen his statue of *Mother and Dying Daughter* – Klimt's rendering is of a striking pathos. This is one of his rare Expressionist works.

1
The compact mass of Rodin's mother and child, in which the two figures are inseparable, made an impression on Klimt. Rodin polished only the faces of his statue and Klimt echoed this effect by detailing only the heads of his figures.

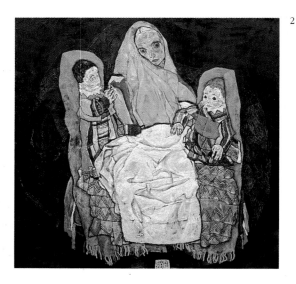

2

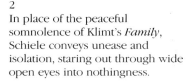

2
In place of the peaceful somnolence of Klimt's *Family*, Schiele conveys unease and isolation, staring out through wide open eyes into nothingness.

The subject is one that could not fail to attract Schiele and Kokoschka, in these years highly receptive to Klimt's influence, both as an artist and as a man. According to a number of art critics, *The Family*, which was exhibited at the ninth biennale in Venice in 1910, would there have directly influenced Schiele. *Mother and Two Children III* (1917) is a clear demonstration of the stylistic and moral differences that underlie the similarities in the two artists' composition. In Klimt's group the children are arranged, harmoniously and conventionally, round the mother's inclined head, their eyes closed, conveying a sense of peace. Schiele's *Mother and Two Children*, on the other hand, is characterised by the highly symmetrical, angular presentation of the figures, the eyes of the mother and the child on the right opened wide to their fate. This is true also of the child Kokoschka portrays, held tight in its mother's arms. The art of Schiele and Kokoschka, the inheritors of the Secession and Klimt in particular, renders Klimt's subject in highly personal terms, introducing tragedy, ugliness and great emotional intensity. They give birth to an Expressionism that Klimt was content to approach in this one painting.

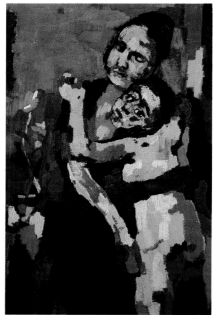

3
Mother and Child is a subject that recurs in Kokoschka's work. This painting, in which the two figures and the background become confused in a medley of coloured surfaces, is an expression of anguish communicated through the eyes of the child.

3

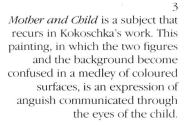

1 *Mother and Dying Daughter*, 1910. Rodin
Marble, 105 x 94 x 70.7 cm
Musée Rodin, Paris

2 *Mother and Two Children III*,
1917. Egon Schiele
Oil on canvas, 150 x 159 cm
Österreichische Galerie, Vienna

3 *Mother and Child (Entwined)*,
1921-2. Oskar Kokoschka
Oil on canvas, 117 x 80 cm
Private collection, USA

4 *The Family*, 1909-10
Oil on canvas, 90 x 90 cm
Private collection

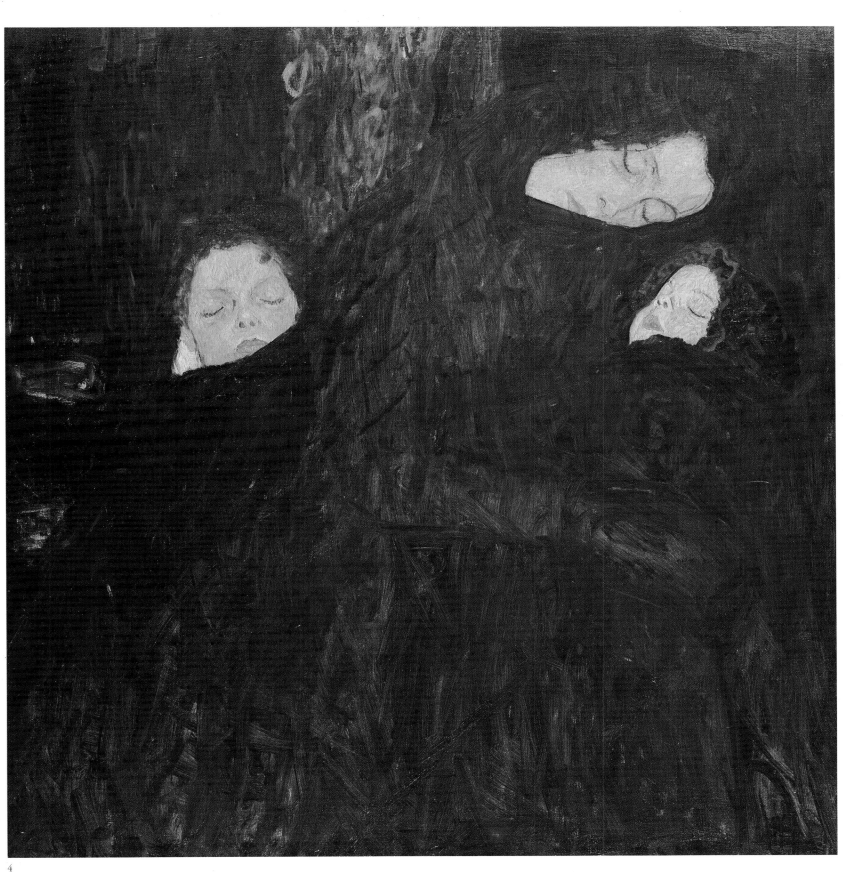

1
Josef Hoffmann, Koloman Moser: letterhead of the Wiener Werkstätte (1903-10). Within the rectangle on the right is its symbol, a rose.

2
Josef Hoffmann: drawing for the Austrian pavilion at the World Exhibition in Rome in 1911.

3
The 'Klimt room' designed by Hoffmann. Clarity was the new guiding principle in the organising of exhibitions.

The Wiener Werkstätte was a group of Viennese craftsmen formed early in the summer of 1903 by the architect Josef Hoffmann, the designer and painter Koloman Moser and the industrialist Fritz Waerndorfer. In their programme, issued in 1905, Moser and Hoffmann invoke Ruskin and Morris, founders of the Arts & Crafts movement. The idea was to replace machine-belt production by the work, often unique, of craftsmen: 'We want to bring about close contact between the public, the designer and the craftsman, and to create simple utensils ... To give back the joy of creation to the worker and a way of life that respects human dignity, this is our most noble task.' The Wiener Werkstätte fell victim to its own contradictions. Too expensive to produce, because made of the best materials, the resulting objects were effectively the prerogative of a clientele of millionaires, who alone had the means to commission the total refurbishment of their houses, as was done by Adolphe Stoclet in Brussels.

4
The Wiener Werkstätte's room at the World Exhibition held at Mannheim in 1907. Design by Josef Hoffmann. On the wall is the *Portrait of Adele Bloch-Bauer I* in front of which are statuettes by Minne.

5
Photograph of Klimt's studio furnished by Hoffmann and the Wiener Werkstätte.

6
Otto Wagner: telegram office of *Die Zeit*, 1902. Entrance rebuilt. Historisches Museum der Stadt, Vienna. Hoffmann was a pupil of Wagner's who afterwards worked with him.

7
Josef Hoffmann: set of glasses with carafes, 1910-11. Design and production notes. Private collection, Vienna.

8
Emilie Flöge's fashion salon. Furniture and decoration by Josef Hoffmann.

'The furniture of our period, mere reproductions and poor substitutes, can satisfy only the parvenu. The middle classes of today and the workers should have enough pride fully to appreciate their worth ... Our middle classes have not yet – far from it – accomplished the cultural task before them. It now falls on them to take in hand the course of history.' (Extract from Hoffmann and Moser's programme, 1905)

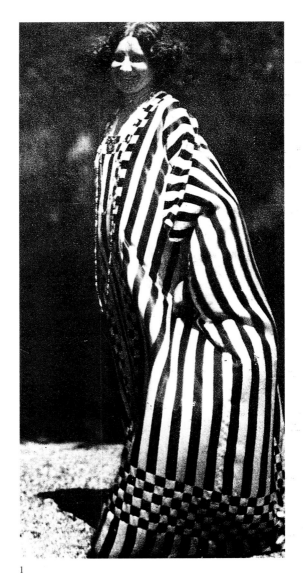

1
Emilie Flöge wears a dress designed by Klimt. The black and white stripes and chequer-board effects were favourite motifs of the Secessionists.

2
Klimt designed this ribbon for Emilie Flöge's fashion salon. He is again making use of the square in his decorative effects.

'All art is erotic' (Adolf Loos)

2

Ornamentation became increasingly profusive in Klimt's art, in marked contrast to his early works. This development ran contrary to the ideas of the architect Loos, voiced in his 1908 essay *Ornament and Crime*. In Loos's eyes, 'All art is erotic. The first work of art, the first exuberant gesture of the first artist drawing on a wall, was erotic. A horizontal line was a woman lying down, a vertical line was a man penetrating her . . . But he who in our age is driven by some inner compulsion to cover walls in erotic symbols, in obscene graffiti, he is a criminal or a delinquent . . . Ornamentation is no longer an expression of our civilisation.'

In the case of Klimt, however, ornamentation entered into everything: backgrounds, clothes, armchairs, the slightest piece of empty space in a painting. A wholly original inventiveness was at work. The richness of the decorative effects communicated itself to the overall picture. Gold-leaf was generously applied, to such an extent sometimes that the background seems gold-embossed, as in the *Portrait of Adele Bloch-Bauer I*. The art critic Ludwig Hevesi, stalwart in his defence of the Secession, has beautifully described Klimt's use of decorative effect: 'Ornament to Klimt is a metaphor of matter itself in a state of perpetual mutation, ceaselessly evolving, turning, spiralling, undulating, twisting, a violent whirlwind that assumes all shapes, zigzags of lightning and flickering tongues of serpents, tangles of vines, links of chains, flowing veils, fragile threads.'

3 Detail of centre of *Tree of Life*, 1905-9
Cartoon for Stoclet Frieze, 138.8 x 102 cm
Österreichische Museum für Angewandte Kunst, Vienna

4 Detail of dress, *Portrait of Adele Bloch-Bauer I*, 1907
Oil on canvas, 138 x 138 cm
Österreichische Museum für Angewandte Kunst, Vienna

5 Detail of dress, *Fulfilment*, 1905-9
Cartoon for Stoclet Frieze, 194.6 x 120.3 cm
Österreichische Museum für Angewandte Kunst, Vienna

6 Detail of dress of Death, *Death and Life*, 1908-11
Oil on canvas, 178 x 198 cm
Private collection, Vienna

7 Detail of armchair, *Portrait of Fritza Riedler*, 1906
Oil on canvas, 153 x 133 cm
Österreichische Museum für Angewandte Kunst, Vienna

8 Background detail, *Portrait of a Woman*, 1917-18
Oil on canvas, 180 x 128 cm
Wolfgang Gurlitt Museum, Linz

3/8
Klimt experimented very widely in his decorative motifs. He made use of religious and sexual symbols and based his designs also on flowers and plants.

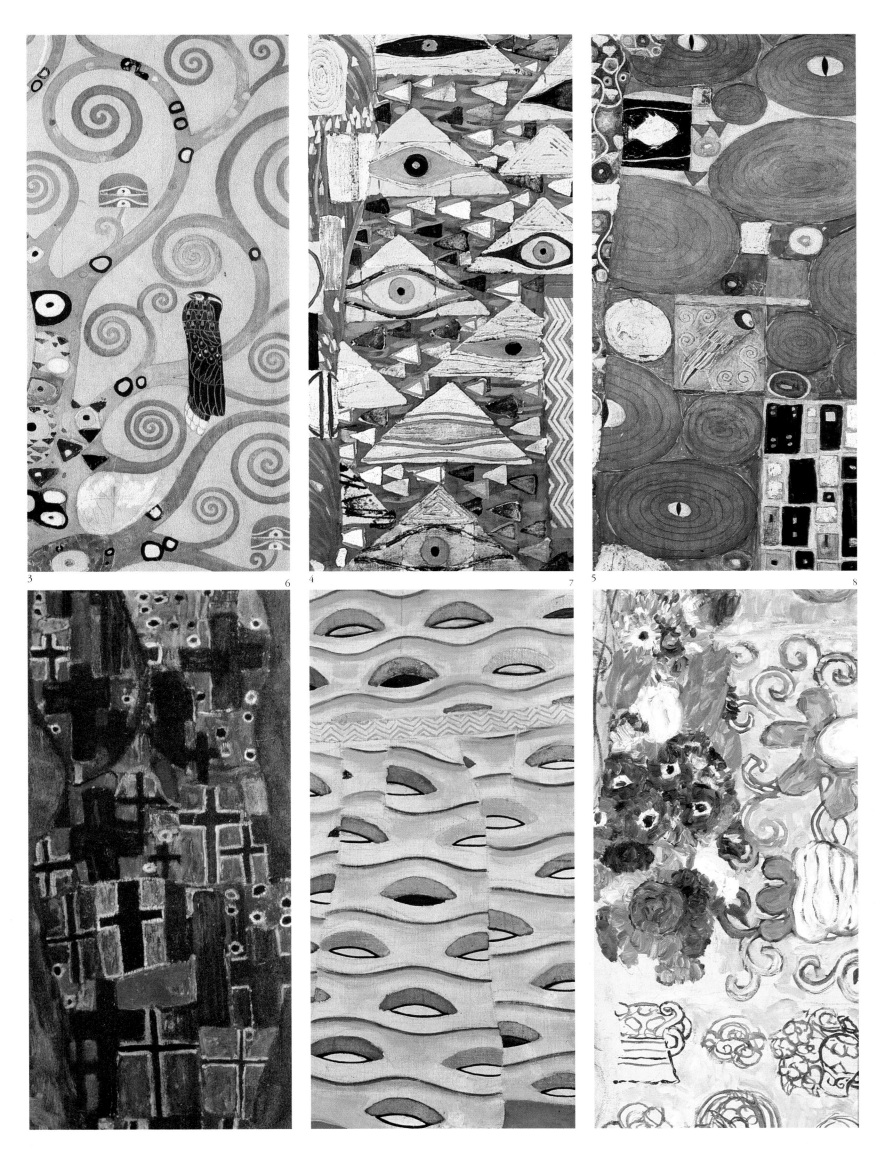

3

6

4

7

5

8

Adolphe Stoclet (1871-1949), a Belgian magnate, lived in Vienna with his wife Suzanne. He was an engineer and worked for the Belgian Railway Company. On the death of his father he returned to Brussels, and entrusted the construction of his villa there to the Wiener Werkstätte, specifically Josef Hoffmann and Gustav Klimt. Hoffmann wanted his architecture 'to replace the styles of old motifs with new' and to find the 'exact structure and proportions to suit the function' of the building (*Culture and Architecture*, 1930). He believed that architecture, painting and sculpture should interact: 'The painter will become responsible for interior design. He will no longer be obliged to produce figurative works, but will be able to express himself by arrangements of different colours without resorting to narrative details.'

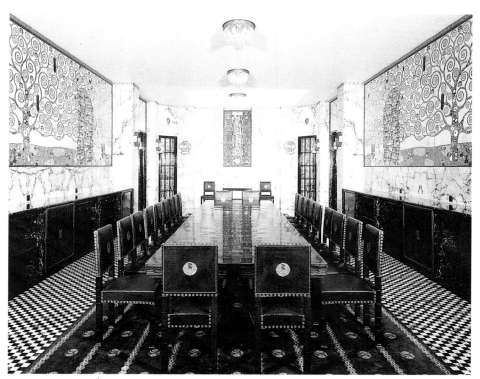

1
Photograph of exterior of Palais Stoclet in Brussels, designed by Josef Hoffmann.

2
Interior of dining room of Palais Stoclet by Hoffmann, with mosaic frieze designed by Klimt. The frieze comprises fifteen marble panels 2 m high with glass and enamel inlay. The butterflies and birds were made in the Wiener Werkstätte pottery kilns. The real jewels worn by the dancer and set into the mosaic were the work of the Wiener Werkstätte goldsmiths.

1

Taking the opposite view to Loos, Hoffmann considered that decorative designs, principally those of the Wiener Werkstätte, should be related intrinsically to their architectural setting. The originality of the Palais Stoclet, monumental in its proportions, lay in several features: its structure, based on a series of cubes; the white marble facing; and the use of copper piping to emphasise the lines of the building. Hoffmann's talent as a designer of interiors was well established after the Secession's fourteenth exhibition in 1902, organised round Max Klinger's statue of Beethoven. Klimt was responsible for the design of the decorative mosaic in the dining room of the villa. The nine panels are a mingling of stylised motifs (*Tree of Life*), with abstract and figurative ones (*Expectation I* and *Fulfilment*). Gustav Klimt had been much impressed on a trip to Ravenna by the mosaics he saw there; that which he himself produced for Stoclet, patron of the arts, was masterly.

3 *Decorative panel*, 1905-9
Cartoon for Stoclet Frieze, 197 x 91 cm
Österreichische Museum, Vienna

Following pages:
4 *Expectation*, 1905-9
Cartoon for Stoclet Frieze, 139.5 x 115 cm
Österreichische Museum, Vienna

5 *Fulfilment*, 1905-9
Cartoon for Stoclet Frieze, 194.5 x 120.3 cm
Österreichische Museum, Vienna

6 *Tree of Life* (left section), 1905-9
Cartoon for Stoclet Frieze, 197.7 x 105.4 cm
Österreichische Museum, Vienna

7 *Tree of Life* (right section with flowering bush), 1905-9
Cartoon for Stoclet Frieze, 194.6 x 120.3 cm
Österreichische Museum, Vienna

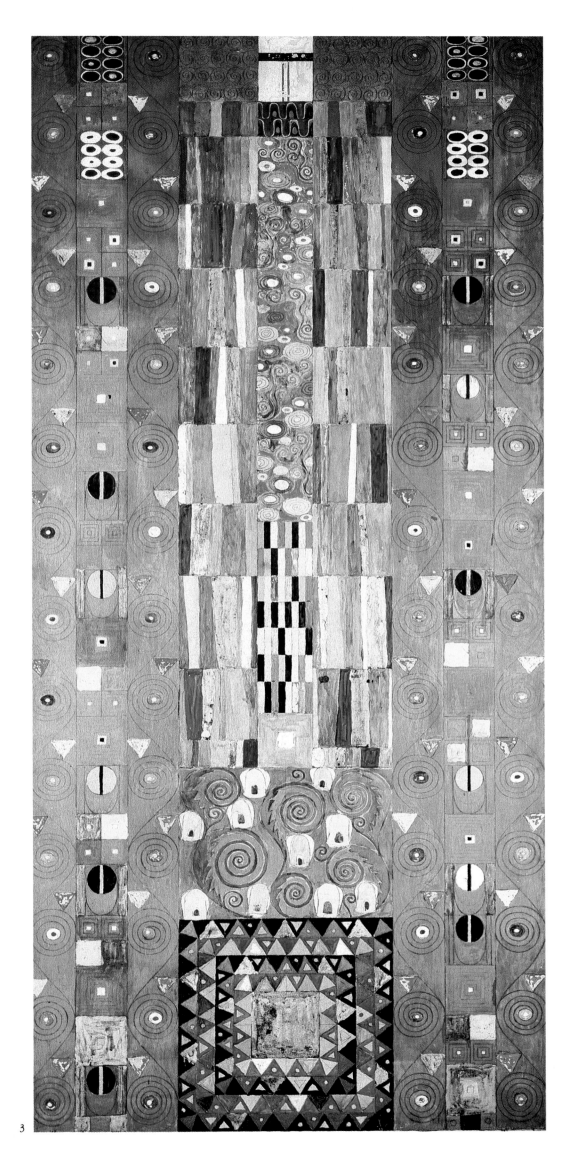

3

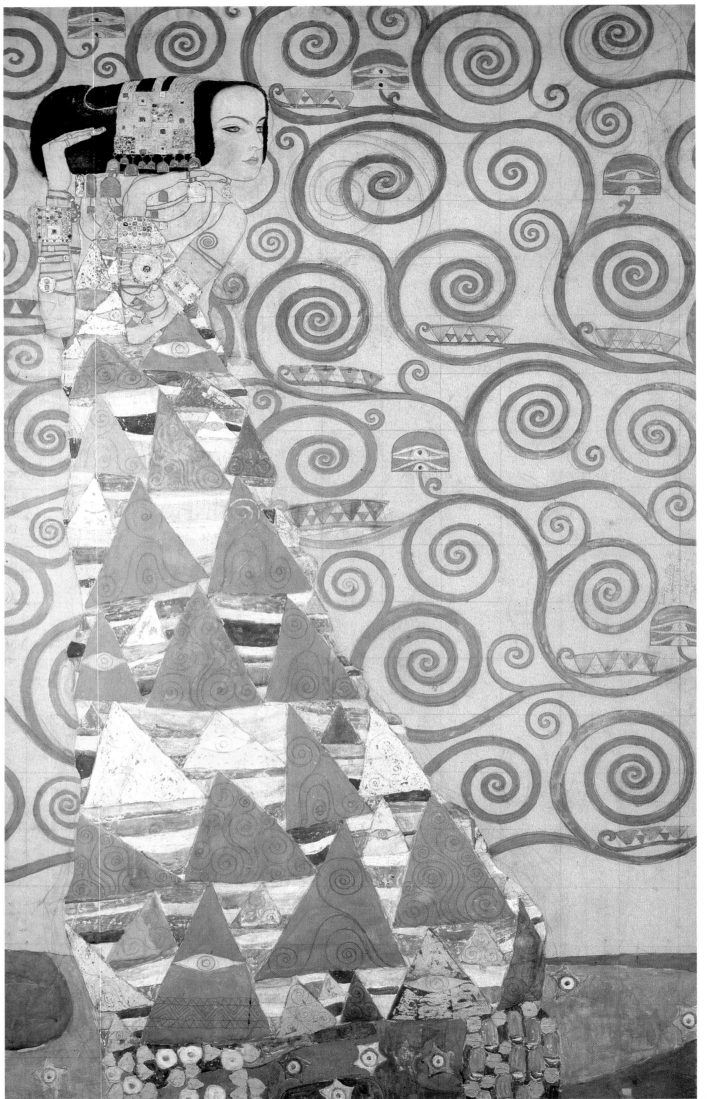

4

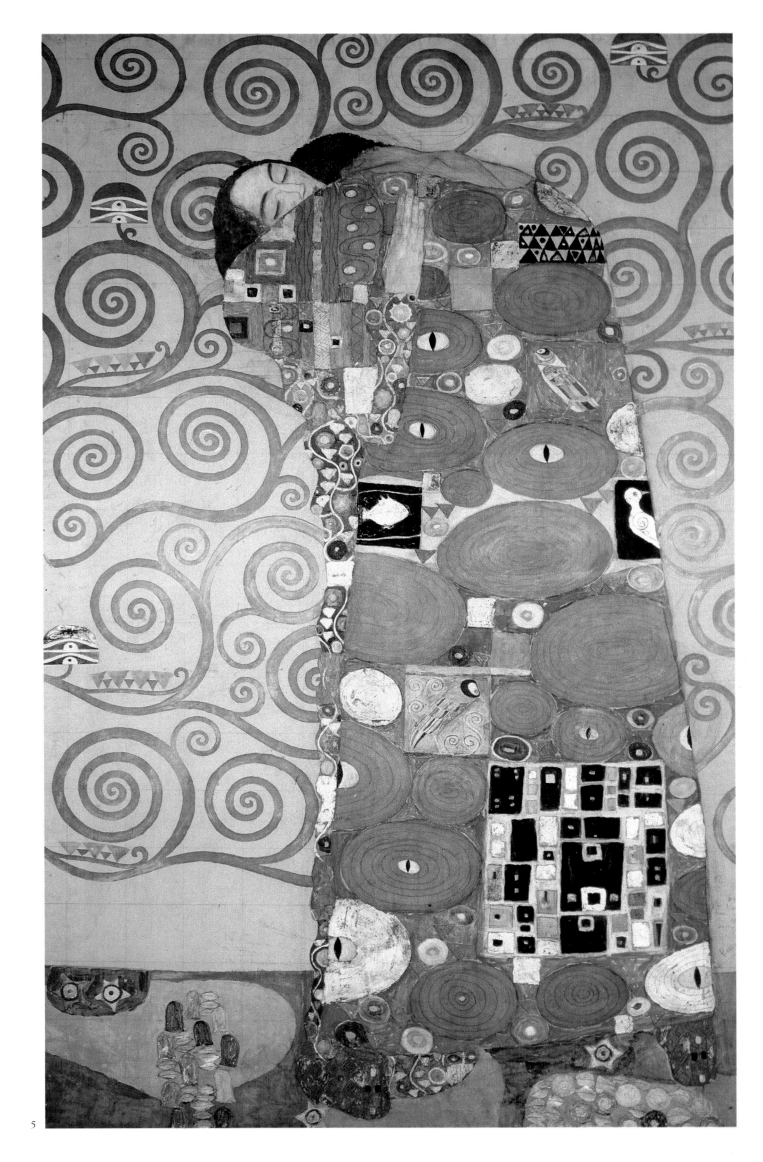

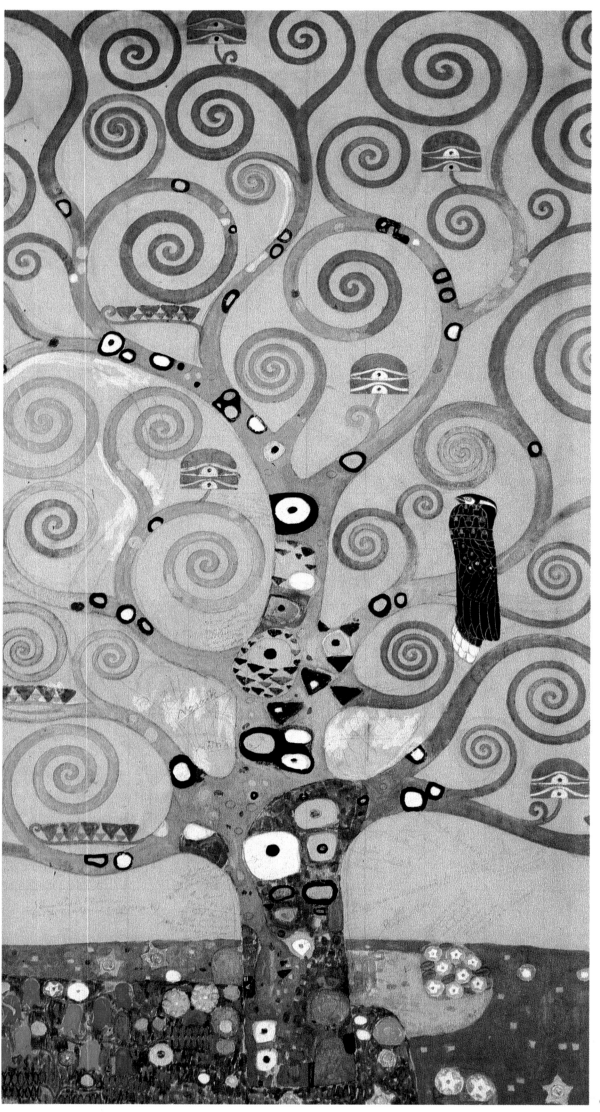

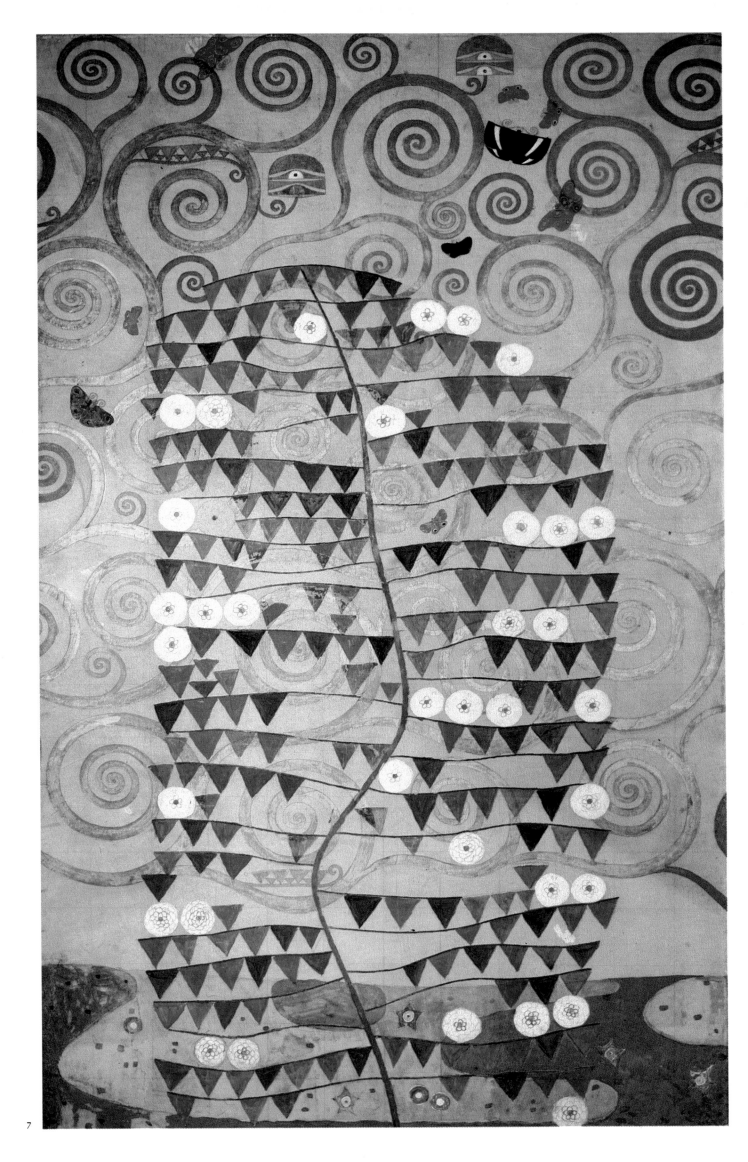

1

Postcard from Gustav Klimt to Emma Bacher, 1910: 'Happy New Year 1910. Thank you for the "busserin" [cakes]. Are the little devils arriving soon?'

2

Postcard from Gustav Klimt to his mother, 10 September 1913: 'I am leaving this place – a little rainy (unusually). All is well. Pauline and Helene are in Paris. I'm off first for Tirol. Best Wishes, Gus'

3

Letter from Gustav Klimt to the Teschners, thanking them for their supportiveness on his mother's death, February 1915: 'Herr and Frau Teschner, thank you with all my heart for your kind support. Best Wishes.'

4

Postcard from Gustav Klimt to Emilie Flöge: 'This is how one makes up for the lack of flowers.'

Writing . . .

5
First page of a letter to the painter F.A. Harta in Vienna, written from Gastein on 30 July 1917: 'I can't come as I believe Professor Hoffmann will be in Sweden and in Holland too. There is also some question of Switzerland.'

6
Letter written by Gustav Klimt to Dr Spitzer, 1905.

'Eroticism is a driving force in the work of Klimt who renders the sexual or biological aspect of things (which is hardly surprising in Freud's city). His predilection for the erotic is to be found as much in his landscapes as in his figurative compositions . . . '
(J. Dobai)

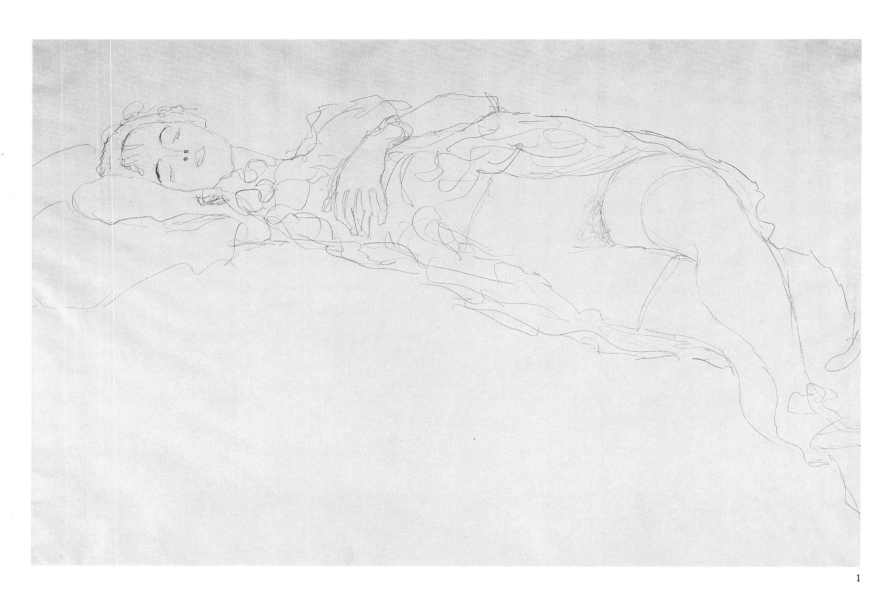

1

1 *Study of Reclining Nude*, 1914-15
Pencil, 37.5 x 57 cm
Albertina, Vienna

2 *Portrait of a Lady with a Feathered Hat*,
1907-8
Pen, Indian ink, pastel, water-colour, 54 x 34 cm
Albertina, Vienna

Following pages:
1 *Study for Fiancée*, 1917-18
Pencil, 56.6 x 37 cm
Albertina, Vienna

2 *Young Woman Seated, from the back*, 1913
Pencil, 56.5 x 36.8 cm
Albertina, Vienna

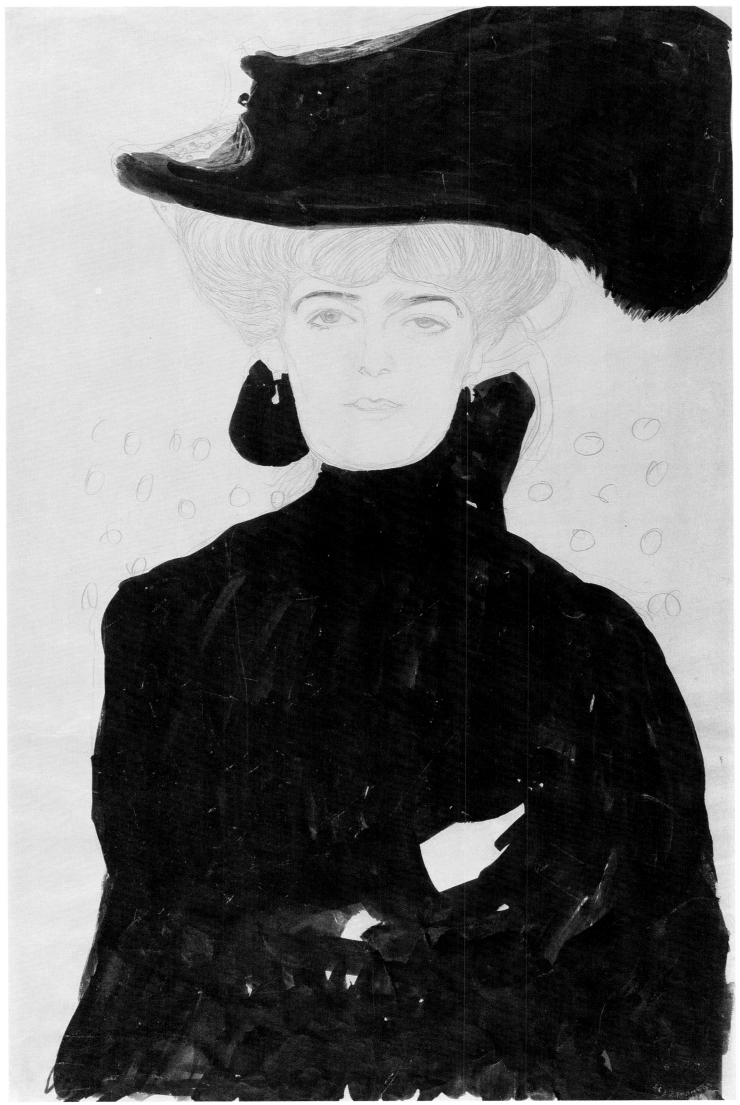

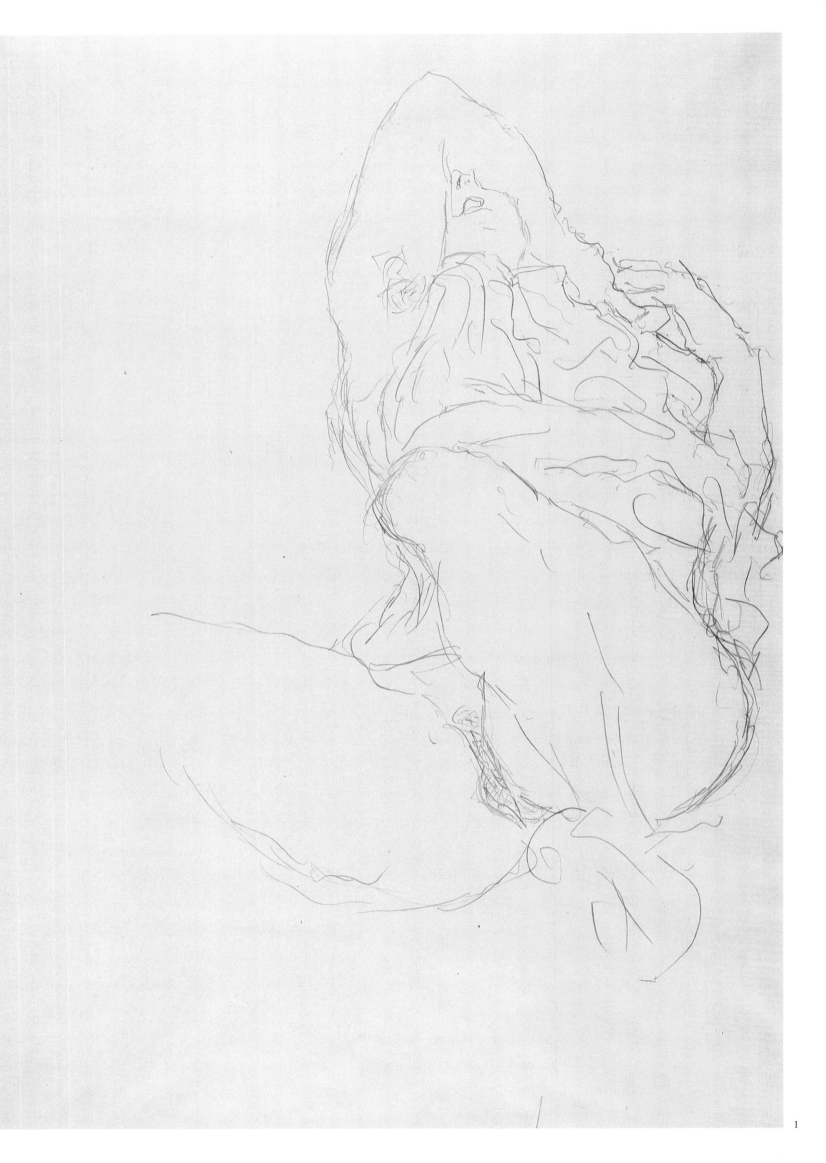

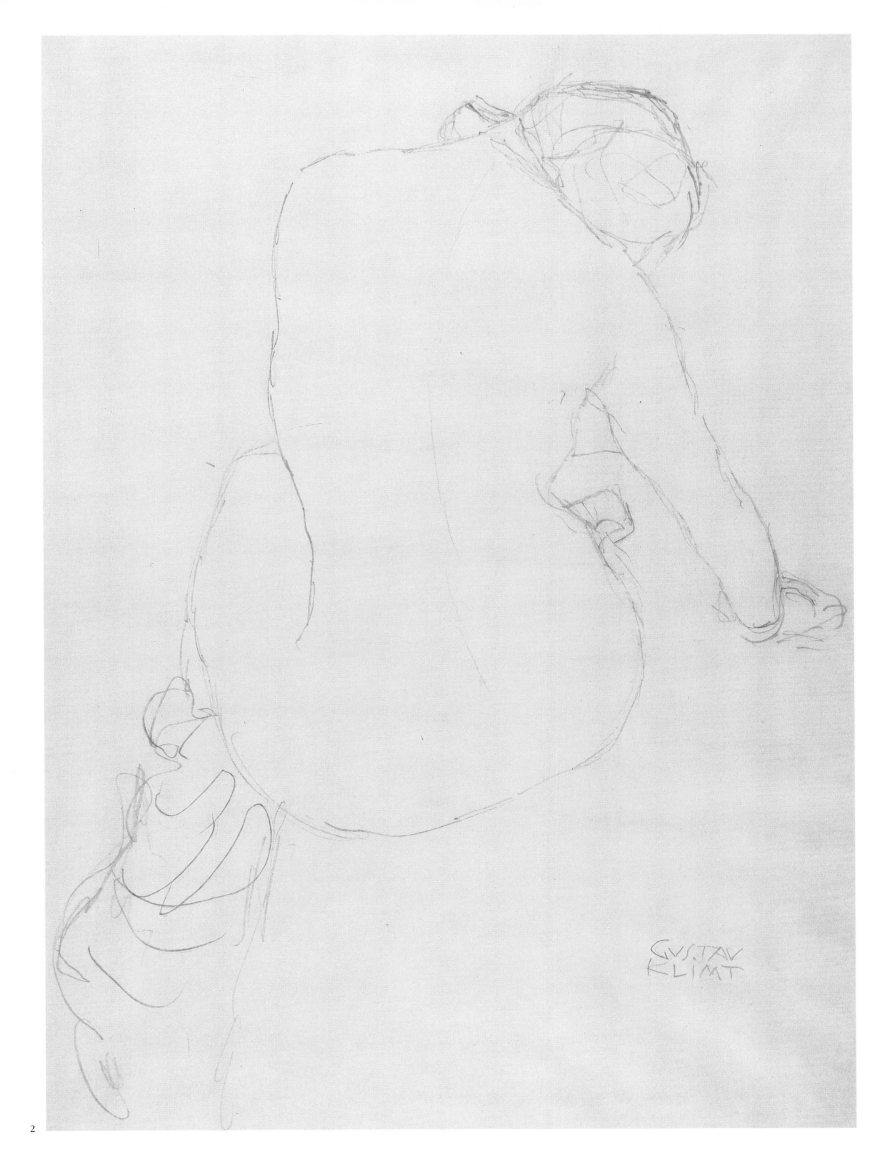

reud and Schnitzler are not the only ones to have understood that the sexual instinct and the death instinct are the deepest and most powerful in man . . . The two greatest Viennese painters of this period have handled the themes of Eros and Thanatos in many of their works and expressed the close association of the two instincts. I shall mention only two of their works: Klimt's *Death and Life* and Schiele's *Death and the Maiden*,' wrote Bruno Bettelheim.

1
In *Agony* Klimt gave his own features to the monk on the right. The fainting figure on the left is none other than Egon Schiele.

t was in Vienna, the birthplace of psychoanalysis – in 1900 Freud published *The Interpretation of Dreams* – that the interaction of the two instincts created the most complex psychological problems. Klimt explored the human psyche in his work, as Freud did by psychoanalysis, or Arthur Schnitzler in his writings. There was a striving to understand the dark forces of the mind, even as political decline brought about the collapse of the old Habsburg empire. 'What is coming to an end is not so much our country as our Empire, in other words something greater, more extensive, more noble than a country alone . . . Because we feel ourselves on the inevitable road to death, everything that confirms we are alive brings us senseless pleasure: balls, cafés, women, good living, drives, escapades of all kinds . . . '(Joseph Roth). Awareness of the decadence of Vienna seemed to emerge in the years before the First World War: the city's role as a high-seat of culture went hand in hand with the disintegration of the Empire.

2/3
The subject of Death and a young female was painted by Munch as a rendering of attraction/repulsion, and by Schiele some years later. The conflict of Eros and Thanatos is anchored firmly in the figurative art of this period. In 1910 Schiele produced an apt verbal summary of his art: 'All is death in life.'

4
Death and Life, started in 1908, remained unsold and was reworked by Klimt from 1911. A blue background 'à la Matisse' was substituted for the original gold. The ornamentation of the group of figures on the right was also changed in 1915, bringing them into line with his new way of painting.

1 *Agony*, 1912. Egon Schiele
Oil on canvas, 709 x 80 cm
Neue Pinakothek, Munich

2 *Death and the Maiden*, 1915. Egon Schiele
Oil on canvas, 150.5 x 180 cm
Österreichische Gallery, Vienna

3 *Death and the Maiden*, 1893. Edvard Munch
Distemper on canvas, 128.5 x 86 cm
Munch Museet, Oslo

4 *Death and Life*, 1908-11, reworked in 1915
Oil on canvas, 178 x 198 cm
Private collection, Vienna

'The thought of death purifies and works as does the gardener pulling up the weeds in his garden. But this garden wants always to be alone and is angered if curious people look over the wall. Thus I hide my face behind my parasol and fan, so that the thought of death can garden peacefully in me.'
(Sissy, Elisabeth of Austria)

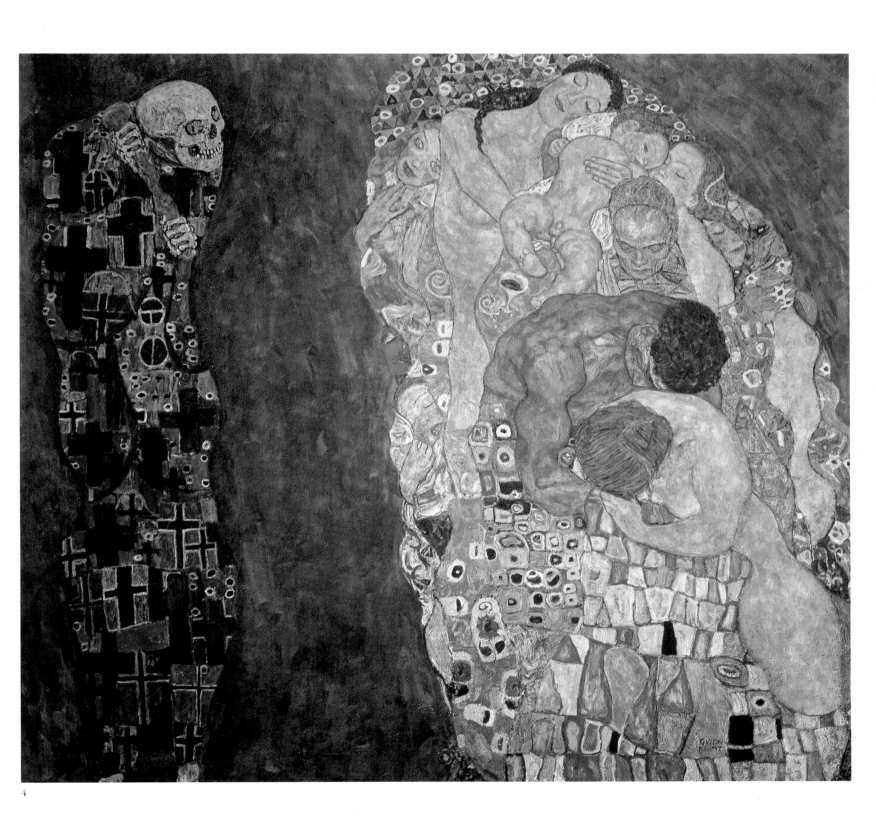

4

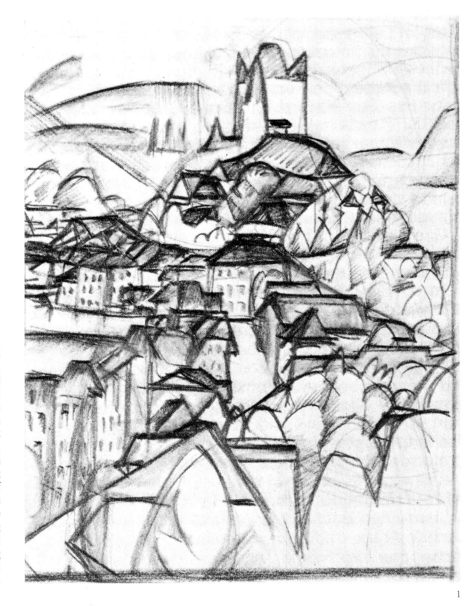

1
Johannes Itten (Thun, Switzerland, 1888 – Zurich, 1967) was acquainted with Kandinsky's and Marc's Blaue Reiter work and with Cubism. In 1916 he went to Vienna where he started his first art school. Through Alma Mahler, wife of Walter Gropius, he met musicians in the circle of Berg and Schoenberg. He was one of the first teachers in Gropius's design school at Weimar, the Bauhaus. This landscape drawing is akin in its structural composition to Klimt's painting opposite, basically a pyramid constructed of cubes.

1

1 Drawing by Johannes Itten

2 *The Church at Cassone on Lake Garda*, 1913
Oil on canvas, 110 x 110 cm
Private collection, Graz

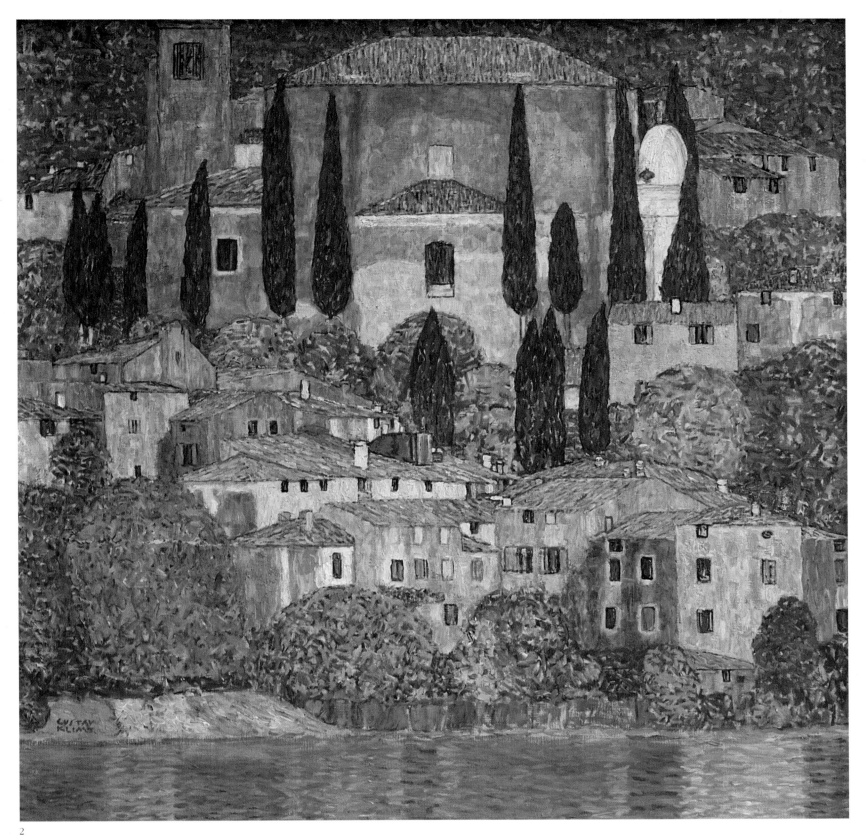

2

*The Church at Cassone on Lake
Garda* was painted on Klimt's visit
to Lake Garda in July-August 1913.
The representation of trees and
houses by using very stylised
geometrical forms marks a
development in Klimt's work
linked, undoubtedly, to what was
then happening in France. He had
been to Paris in the autumn of
1909.

1

1
'I have admired wonderful things
... and peaceful houses with roofs
like soft cushions.'
(Egon Schiele, *Prison Diary*, 1912)

If Gustav Klimt's influence on Schiele was apparent from 1907-8, Schiele was to have a reciprocal influence on Klimt. The composition of this landscape of Lake Garda by Klimt is very close to that of Schiele's painting. There is an obvious parallel in the way the houses are grouped on the water's edge. The overall effect is nonetheless somewhat different. Schiele's pointed houses with their open windows give way in Klimt's picture to cubic shapes, accentuated by the almost flat roofs that typify the architecture of Lake Garda in Italy. The mood of the two works is also distinct. While Schiele's little houses communicate a strangely menacing atmosphere, Klimt's give a sense of size and show an original play of colour. It is characteristic of both men, however, to portray towns denuded of human life. Klimt never included figures of men or women in his landscapes.

1 *Krumau on the Moldau* (or *The Little Town III*),
1913. Egon Schiele
Oil on canvas, 89.5 x 90.5 cm
Private collection, Graz

2 *Malcesine on Lake Garda*, 1913
Oil on canvas, 110 x 110 cm
Destroyed at Schloss Immendorf in 1945

Following pages:
1 *Portrait of a Lady with Cape and Hat*,
three-quarters profile, 1897-8
Black & red chalk, 44.6 x 31.8 cm
Albertina, Vienna

2 *Study for a Gorgon, Woman's Head*, 1902
Black chalk, 45 x 31.3 cm
Albertina, Vienna

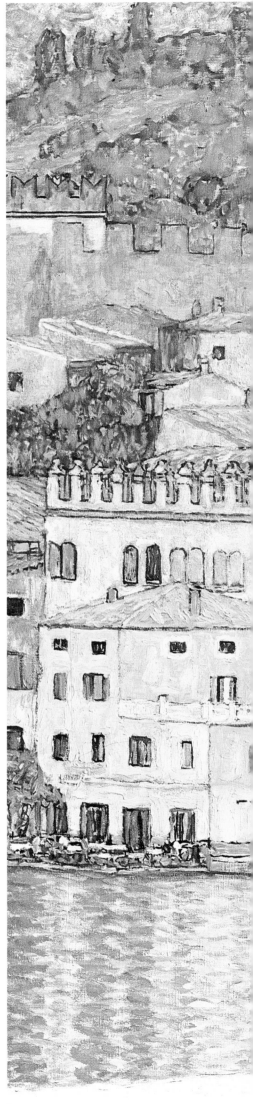

2

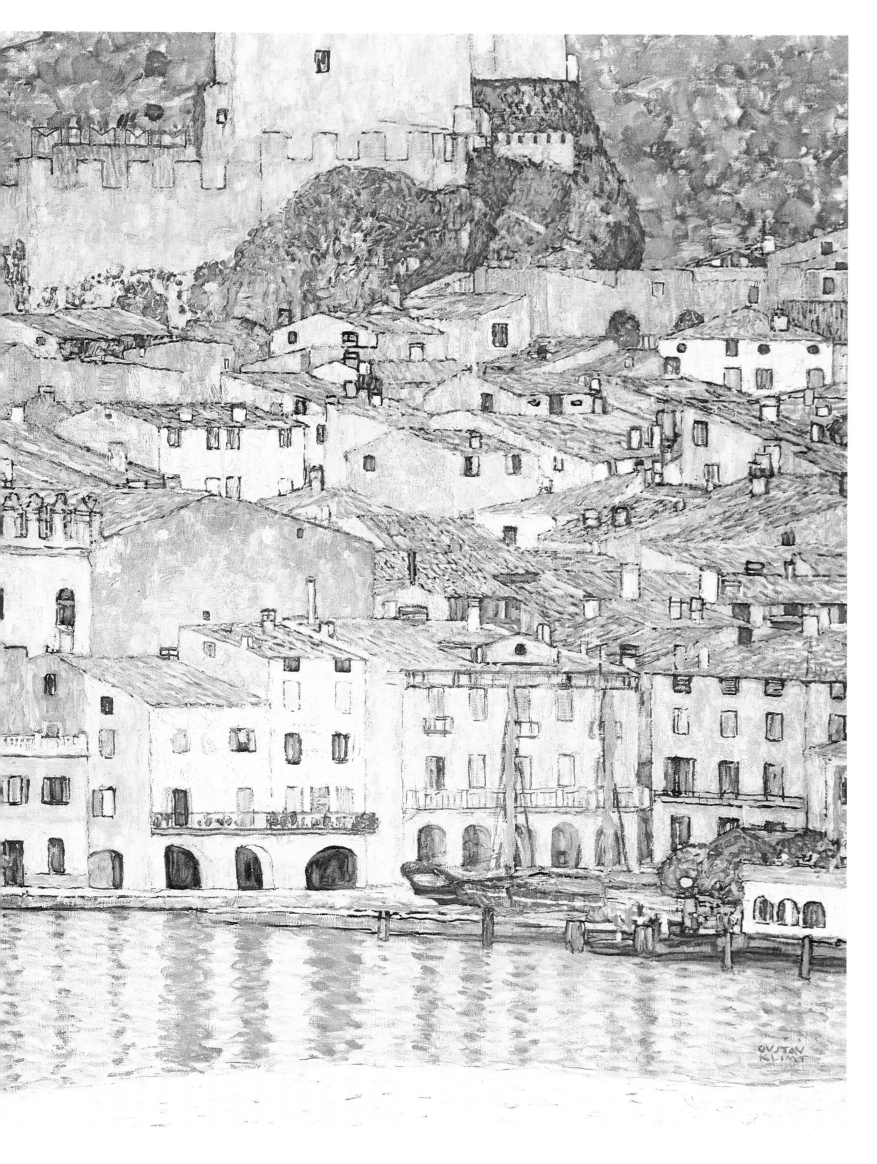

GVSTAV
KLIMT
NACHLASS

2

From 1873 onwards, Japan sent a great many objects and works of art to the World Exhibition in Vienna. The opening of the country's doors to the West at the end of the nineteenth century started a tremendous fashion for Japanese prints. Artists began to collect and to study them. Painters such as Whistler, Monet and van Gogh were fascinated especially by the vivid colours of the prints, devoid of shading. Entire collections were devoted to their study. Japonism became an important element in art nouveau at the beginning of the twentieth century and the influence of Japanese culture was felt almost everywhere in the West. Gustav Klimt collected prints and objects from Japan. Inspired first by the presentation of the Japanese pictures, conceived on one plane only without depth and shadow (such as *Portrait of Sonja Knips*), it was only in his late work that he began to feature Japanese motifs. He had already adopted, however, the naturalism of Japanese art, seen in the Tree of Life motifs in the background of *Fulfilment*, and the flowers and birds in the Stoclet

1

Van Gogh's *Le Père Tanguy*, enthroned amidst the Japanese prints of Hiroshige which overrun the background, may have inspired Gustav Klimt.

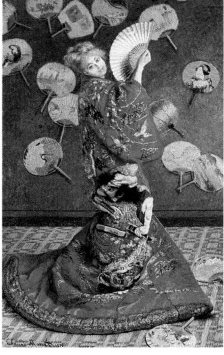

2

Monet's wife, Camille, is dressed here in a Japanese robe to be found on sale in Paris. Other Japanese features are the fans scattered over the wall and strewn on the mat on the floor. This large portrait shows how prevalent was the fashion for things Japanese in Paris.

Japanese prints in Klimt's studio

Frieze. From 1910 Klimt included Japanese figures in the background of his portraits of women. He thus moved away in his portraits from backgrounds that were either neutral or sparsely decorated with the odd geometric motif, such as the *Portrait of Emilie Flöge* (1902), or that of *Hermine Gallia* (1904); instead, his backgrounds became packed with ornamentation.

1 *Le Père Tanguy*, c. 1887. Vincent van Gogh
Oil on canvas, 92 x 73 cm
Musée Rodin, Paris (Photo Bruno Jarret)

2 *La Japonaise*, 1876. Monet
Oil on canvas, 231.6 x 142.3 cm
Museum of Fine Arts (Purchase Fund), Boston

4 *The Dancer*, 1916-18
Oil on canvas, 180 x 90 cm
Private collection, Paris

4

Japanese motifs and flowers fill the decorative backcloth to this painting of a dancer. The geometric motif of the carpet strikes a dissonant note in the picture, in which some find a suggestion of Cubism.

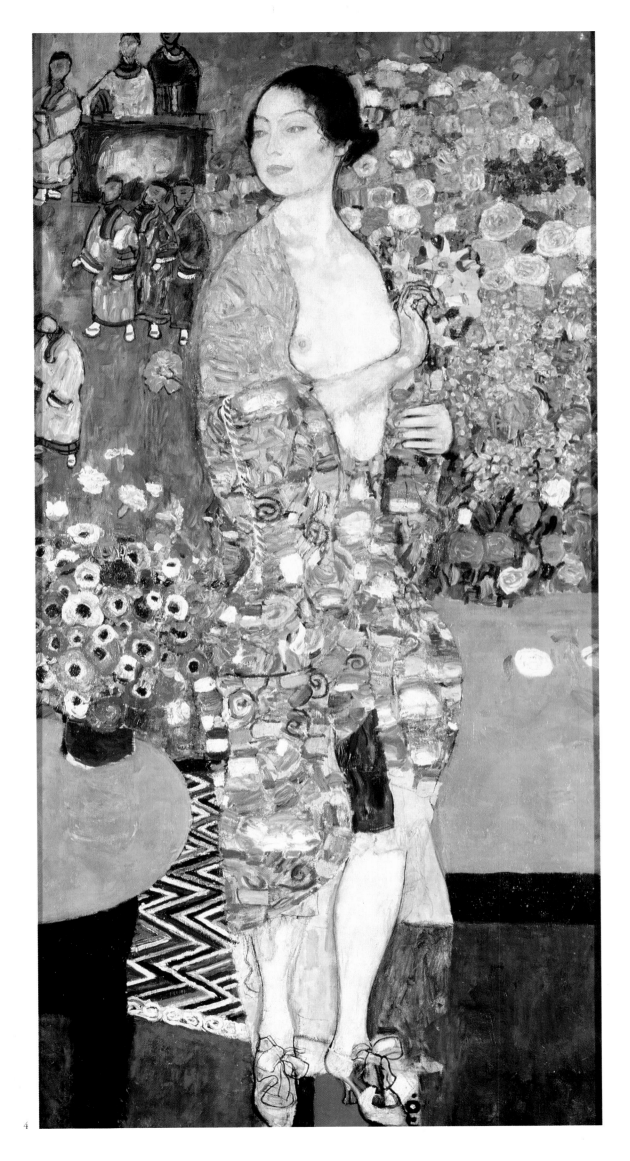

4

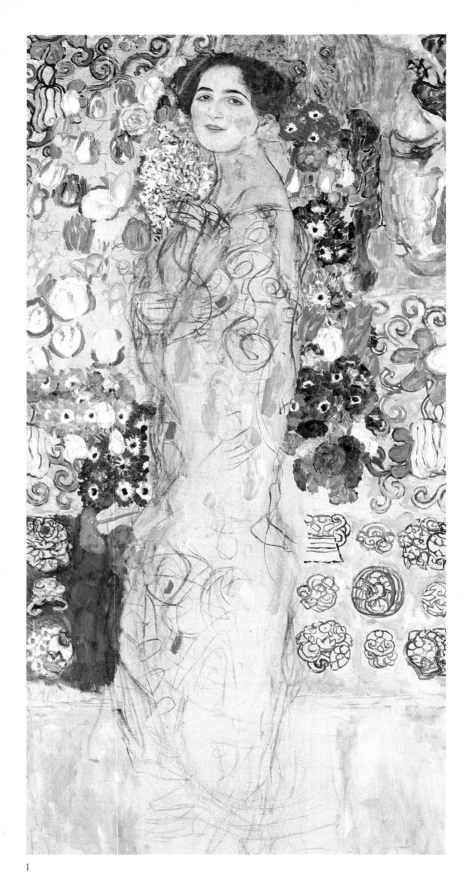

1

1
This unfinished portrait, striking in the extreme realism of the face, shows the profusion of floral decoration envisaged by the artist.

2
In *Friends*, a subject already painted in *Water-Snakes I/II*, the strong oriental décor becomes almost dominant.

Following pages : 3
This portrait (*c.* 1912) is the first in which Klimt adds Japanese motifs to his habitual, isolated flowers. Comparison with the first portrait of Adele Bloch-Bauer, the finest example of Klimt's 'Golden Period', reveals the development of the artist's style.

Following pages: 4
Friedericke Maria Beer sometimes modelled at La Casa Piccola, wearing the designs of Emilie Flöge. She sat for Klimt in her fur coat, but wore it inside out so he could make the most of the decorative lining. Her dress was made by the Wiener Werkstätte. Klimt added oriental figures in the background to accentuate the 'sumptuous' character of the portrait.

1 *Portrait of a Lady (Maria Munch?)*, 1917-18
Oil on canvas, 180 x 190 cm
Wolfgang Gurlitt Museum, Linz

2 *Friends*, 1916-17
Oil on canvas, 99 x 99 (?) cm
Destroyed at Schloss Immendorf in 1945

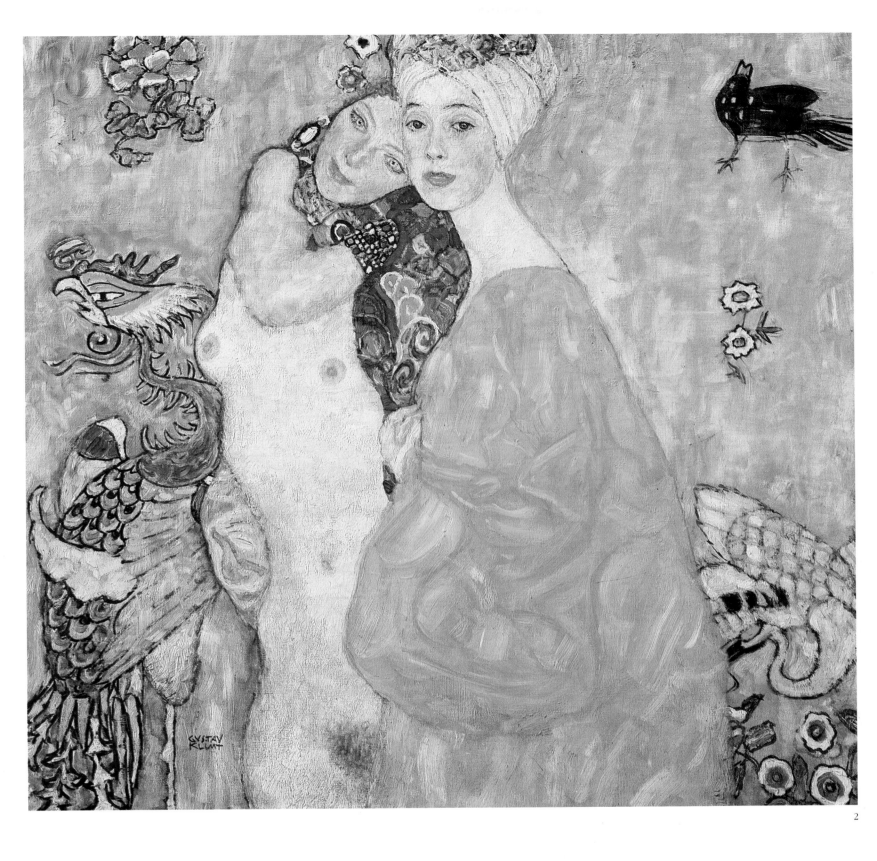

2

Following pages:
3 *Portrait of Adele Bloch-Bauer II*, c. 1912
Oil on canvas, 190 x 120 cm
Österreichische Galerie, Vienna

4 *Portrait of Friedericke Maria Beer*, 1916
Oil on canvas, 168 x 130 cm
Private collection, New York

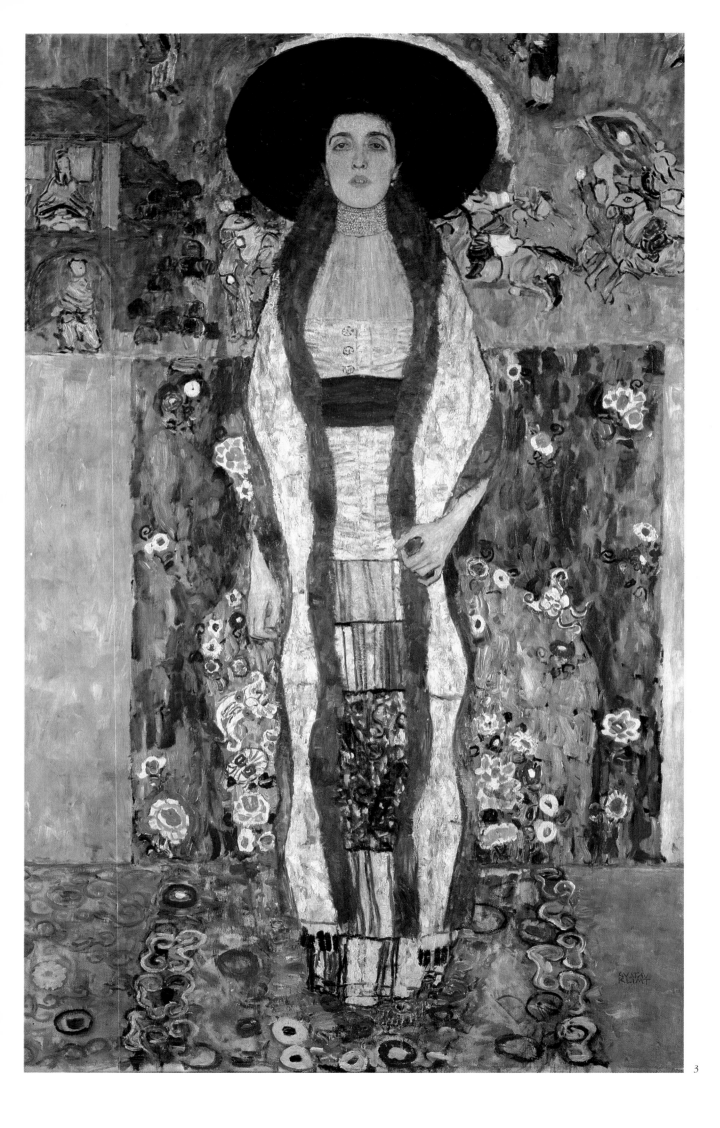

3

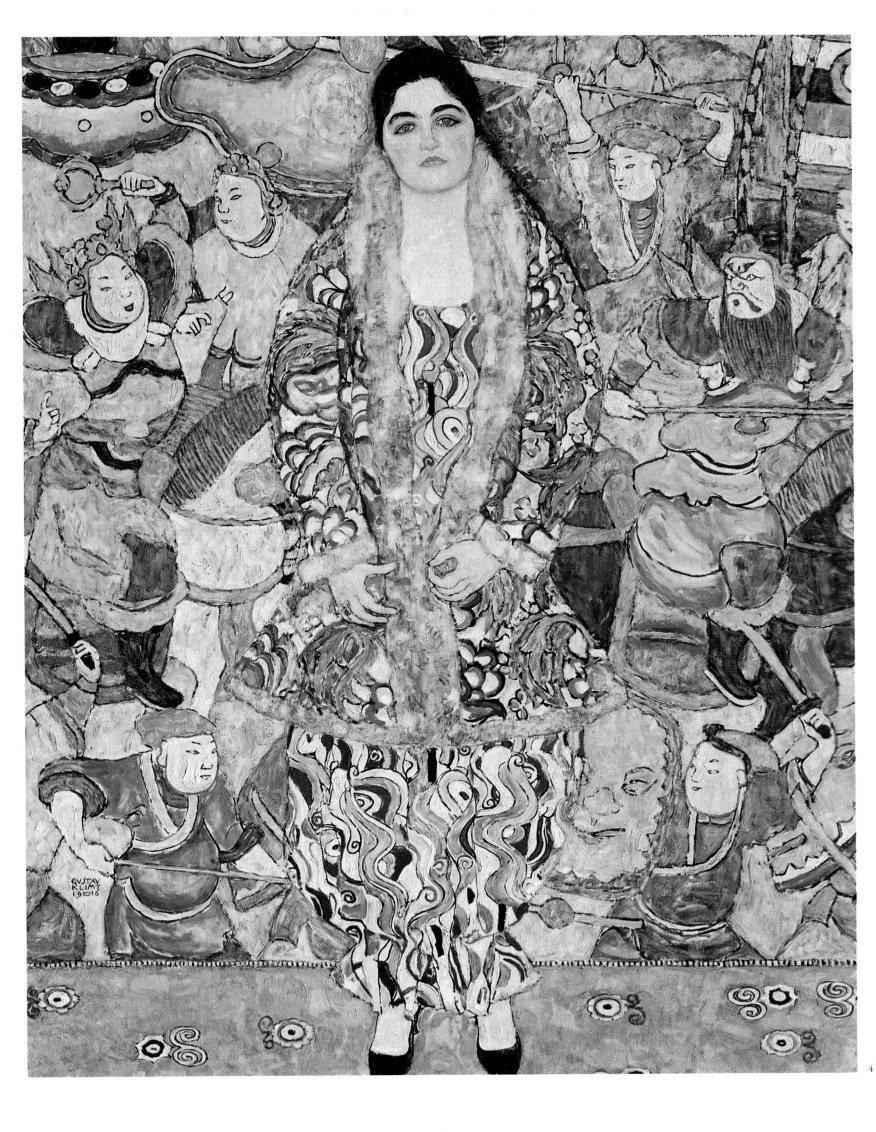

Klimt's love of gardens and cats is well known. The little neglected garden in front of his studio, almost gone wild (as is apparent from the photograph), bears no relation to the gardens he chose to paint. The latter luxuriate in flowers, laid out in intricate arrangements as if recreated by the artist's eye. Each bloom stands out as morphologically distinct, the largest often composing the apex of the composition (sunflowers, peonies). His favourite gardens are the rambling gardens in the countryside, planted with fruit trees, or fields full of wild flowers such as *Field of Poppies* (1907).

1

Klimt's last studio (1914-18)

2

Klimt in the garden of his studio in Josefstädterstrasse, Vienna (photograph by M. Nähr, 1910)

3 *Garden in Flower*, c. 1905-6
Oil on canvas, 110 x 110 cm
Österreichische Galerie, Vienna

3

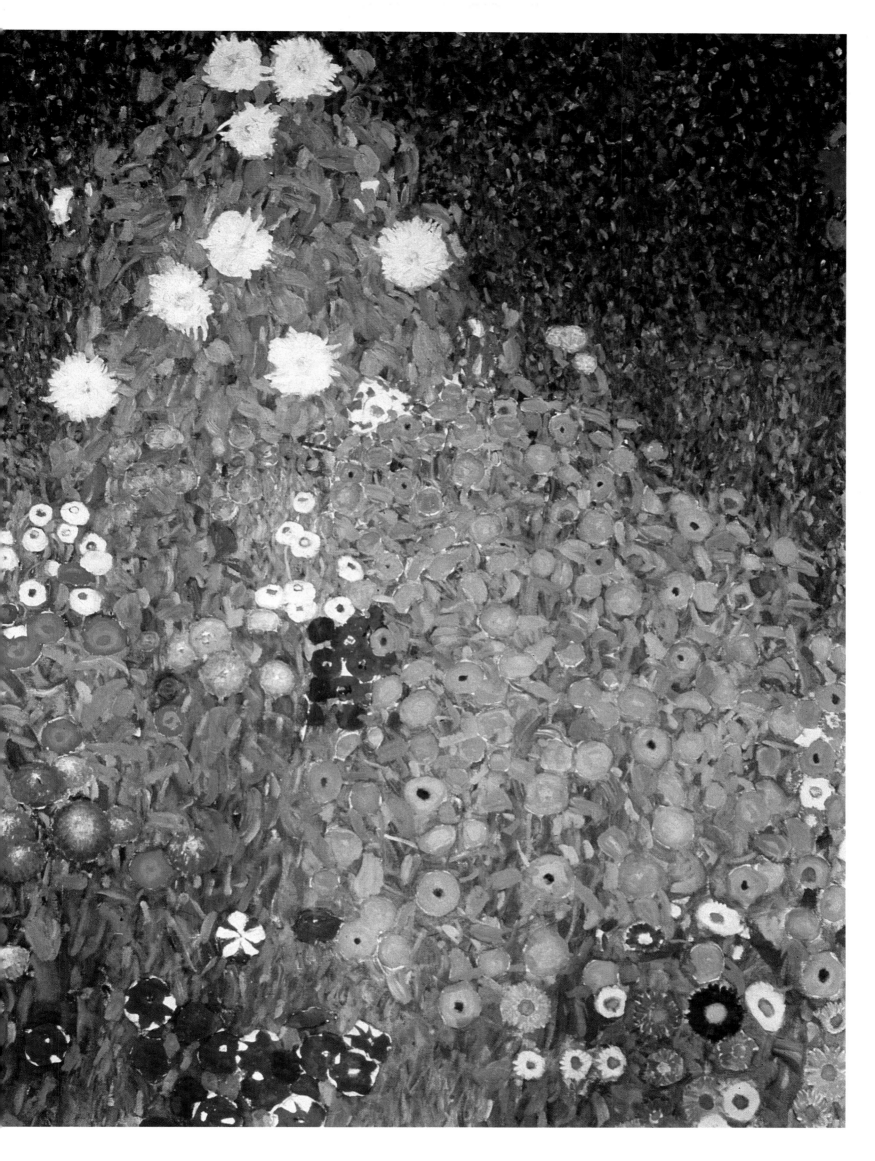

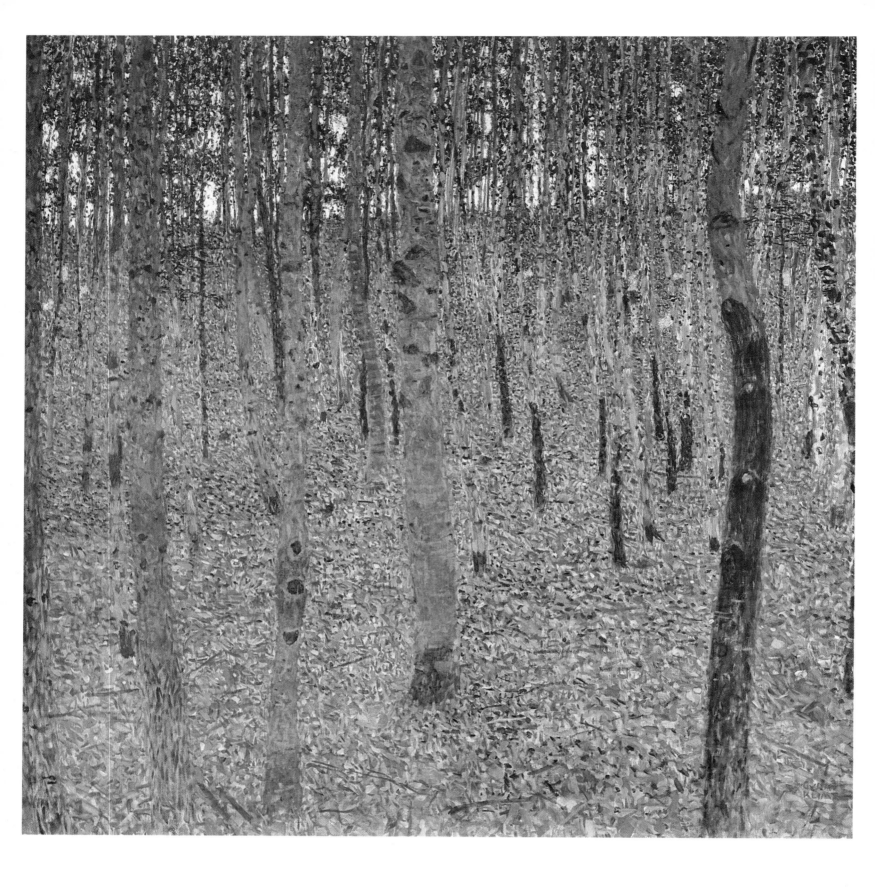

Klimt renders the essential nature
of his forest trees with the same
meticulous care found in his
flower and garden paintings. He
views the forest from an original
angle, focusing on the ground and
the base of the tree-trunks, a
possible echo of Edward
Steichen's photographs of forests
in 1898. These landscapes, marked
by an absence of sky, and the
measured spacing of the thin tree-
trunks, also show a parallel with
Whistler's art.

1 *Beech Forest I*, c 1901-2
Oil on canvas, 100 x 100 cm
Staatlische Kunstsammlungen, Gemäldegalerie
Neue Meister, Dresden

2 *Birch Wood*, 1903
Oil on canvas, 110 x 110 cm
Wolfgang Gurlitt Museum, Linz

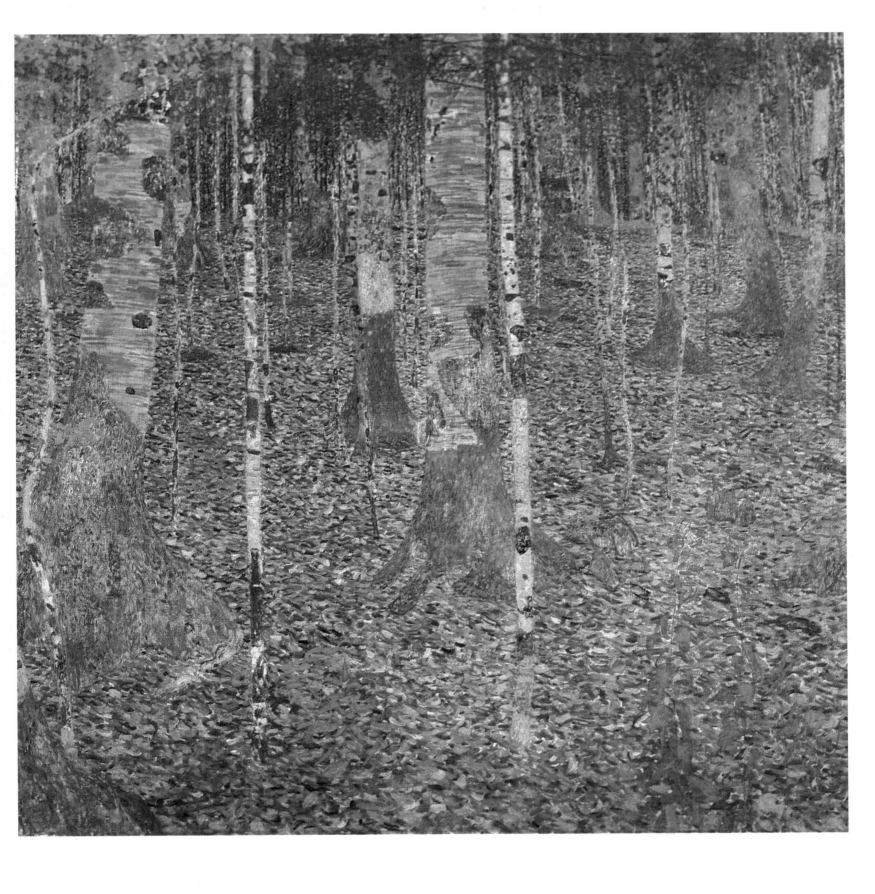

Garden at the top of the Hill, painted a year before Klimt's death, is notable in the way it breaks down the flowers, bushes, fruits represented. All the different elements are outlined in black, assuming little round or ovoid forms. Colour predominates over subject-matter; however, it is possible, given the absence of a signature, that the picture is unfinished. Curious marks, bearing a resemblance to Chinese lettering, are visible in the top left corner, in what one might take to be the sky.

Garden at the top of the Hill, 1917
Oil on canvas, 110 x 110 cm
Private collection

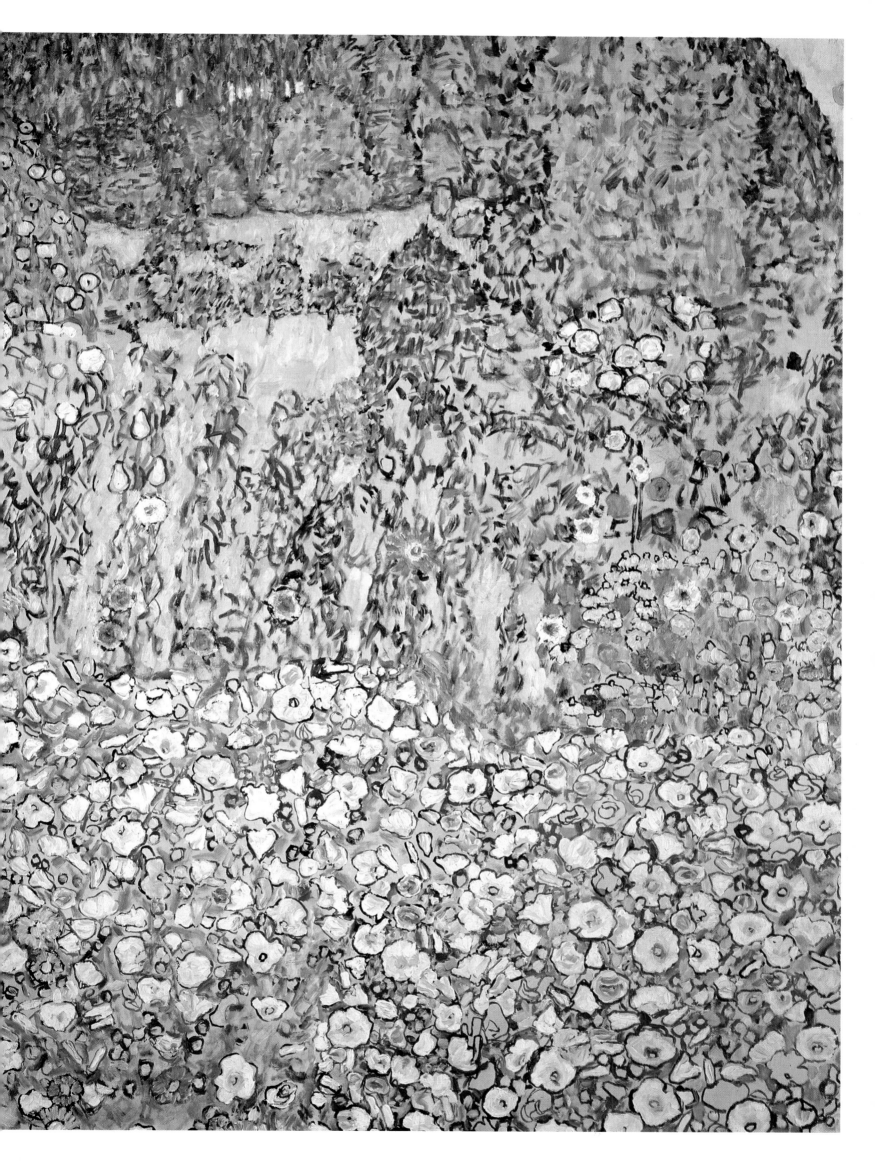

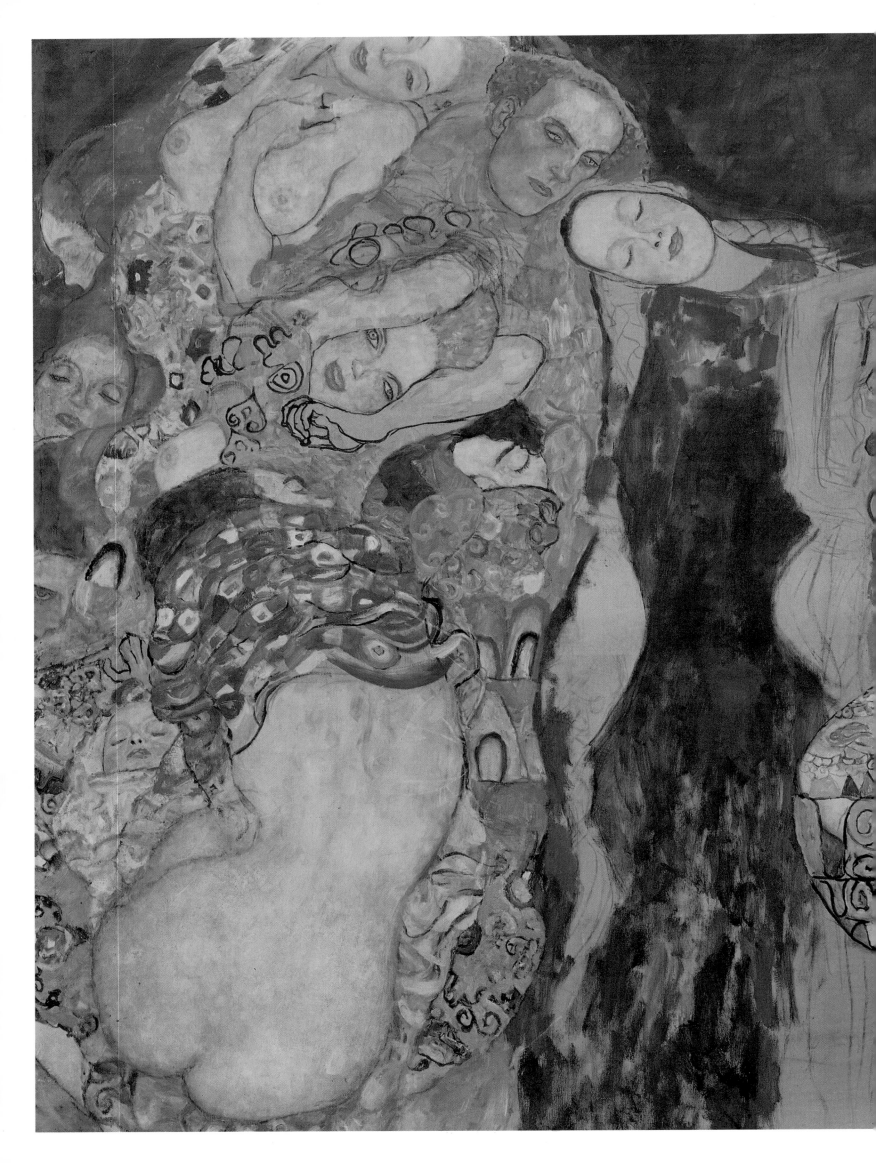

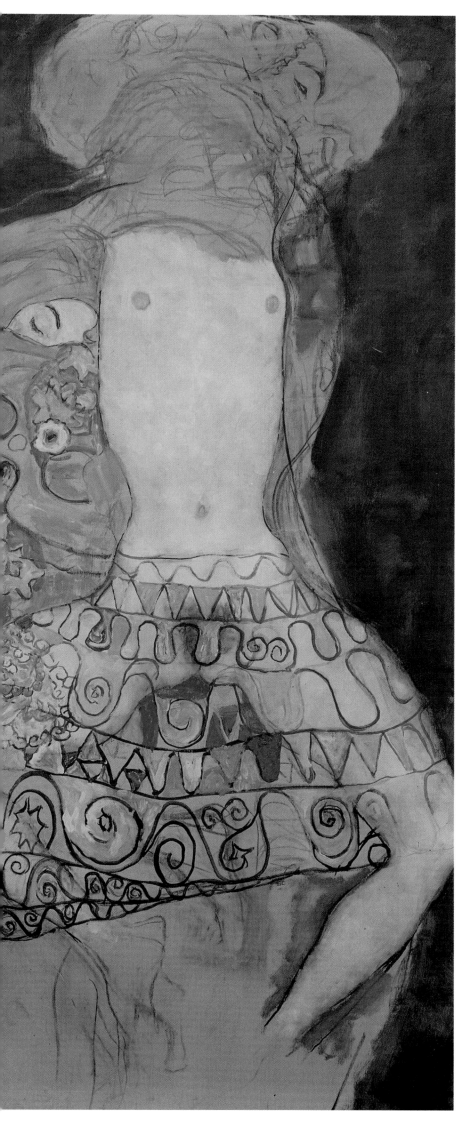

1

2

2
Queue in front of the Soup Kitchen bears witness to the desperate poverty suffered in Vienna at the end of the First World War

3
The day after the Armistice, the Emperor Charles I abdicated and the German Republic of Austria was declared.

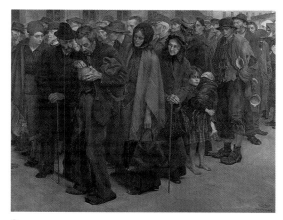

3

1
The Bride, an unfinished painting, reveals the artist's manner of working. He first drew a naked figure on the canvas, then 'dressed' it in a complicated weaving of motifs.

1 *The Bride*, 1917-18
Oil on canvas, 166 x 190 cm
Private collection
On loan to Österreichische Galerie, Vienna

2 *Queue in front of the Soup Kitchen*,
1918. Josef Engelhart
Oil on canvas, 148 x 191 cm
Historisches Museum der Stadt, Vienna

On 11 January 1918 Klimt suffered a stroke which left him partially paralysed and unable to speak. He spent some time at the Fürth sanatorium. Klimt died on 6 February 1918, at the age of fifty-six. Egon Schiele did a drawing of Klimt on his death-bed, before he himself succumbed to a flu epidemic the night of 31 October. Thus the two most representative figures of the Viennese art world died in the same year. Gustav Klimt was buried at the Heitzinger cemetery where a simple plaque marks his grave. The Klimt family refused the grand tomb that the parish of Vienna offered to provide. Klimt did not live to see the end of the First World War nor the proclamation of the Republic on 12 November 1918.

1 Photograph of Klimt's studio with his last painting, *The Bride*, and *Lady with a Fan*, Feldmühlgasse 13
Bildarchiv, Österreichische Nationalbibliothek

2 *Klimt on his Death-bed*, 1918. Egon Schiele
Klimt Archives, Albertina, Vienna

Catalogue of other principal works

1 *Painting for the Municipal Theatre of Liberec*, 1882-3
Curtain. Signed F. Matsch, G. Klimt, E. Klimt
Liberec, Czechoslovakia

2 *Two Winged Genii, c.* 1883
Oil on cardboard, 19 x 39.5 cm
Private collection, Vienna

3 *Portrait of Clara Klimt*, 1883
Oil on canvas, 29 x 20.5 cm
Private collection, Vienna

4 *Academy Figure, Male*, 1883
Oil on canvas, 46.5 x 37.2 cm
Present whereabouts unknown

5 *Academy Figure, Male*, 1883
Oil on canvas, 75 x 48.5 cm
Present whereabouts unknown

6 *Academy Figure, Female*, 1883
Oil on canvas, 42.5 x 68.5 cm
Private collection, Vienna

7 *Head of Girl, c.* 1883
Oil on canvas, 43 x 30 cm
Private collection, Winnipeg

8 *Head of Girl in Profile, c.* 1884
Oil on canvas, 42 x 33 cm
Private collection, Vienna

9 *Head of Old Man Crowned in Ivy*, 1883-5
Oil on cardboard, 27.8 x 21.8 cm
Present whereabouts unknown

10 *Study of Head of Girl from Hanna*, 1883-5
Oil on panel, 25 x 22 cm
Present whereabouts unknown

11 *Idyll*, 1884
Oil on canvas, 49.5 x 73.5 cm
Historisches Museum, Vienna

12 *The Poet and the Muse, c.* 1884
Oil on cardboard, 31.5 x 30 cm
Private collection, Lugano

13 Sketch for *The Organ Player*, 1885
Oil on canvas, 38 x 50 cm
Österreichische Galerie, Vienna

14 *Genie Offering a Crown of Ivy to a Singer*, 1885
Ceiling painting, Bucharest Theatre. Destroyed

15 *The Organ Player*, 1885
Ceiling painting, Bucharest Theatre. Destroyed

16 Fragment of *The Bedroom*, 1885
Ceiling decoration
Villa Hermes, Lainz

17 Fragment of *Salon*, 1885
Ceiling decoration
Villa Hermes, Lainz

18 Fragment of *Study*, 1885
Ceiling decoration
Villa Hermes, Lainz

19 *The Pleasures of the Table*, 1886
Ceiling painting
Karlovy-Vary Theatre, Carlsbad

20 *The Dance*, 1886
Ceiling painting
Karlovy-Vary Theatre, Carlsbad

21 *Study for a Curtain* (Karlovy-Vary Theatre), 1886
Oil on canvas, 149 x 165.1 cm
Present whereabouts unknown

22 Sketch for *The Theatre in Taormina* (Burgtheater), 1886
Oil on canvas, 86 x 71 cm
Present whereabouts unknown

23 *The Thespian Cart* 1886-8
Oil on stucco, 280 x 400 cm
Ceiling of Burgtheater, Vienna

24 *Hans Wurst Playing in the Open Air*, 1886-92
Oil on stucco, 450 x 400 cm
Burgtheater, Vienna

25 *Lady with a Purple Scarf*, 1888
Oil on canvas, 67 x 41 cm
Private collection, Vienna

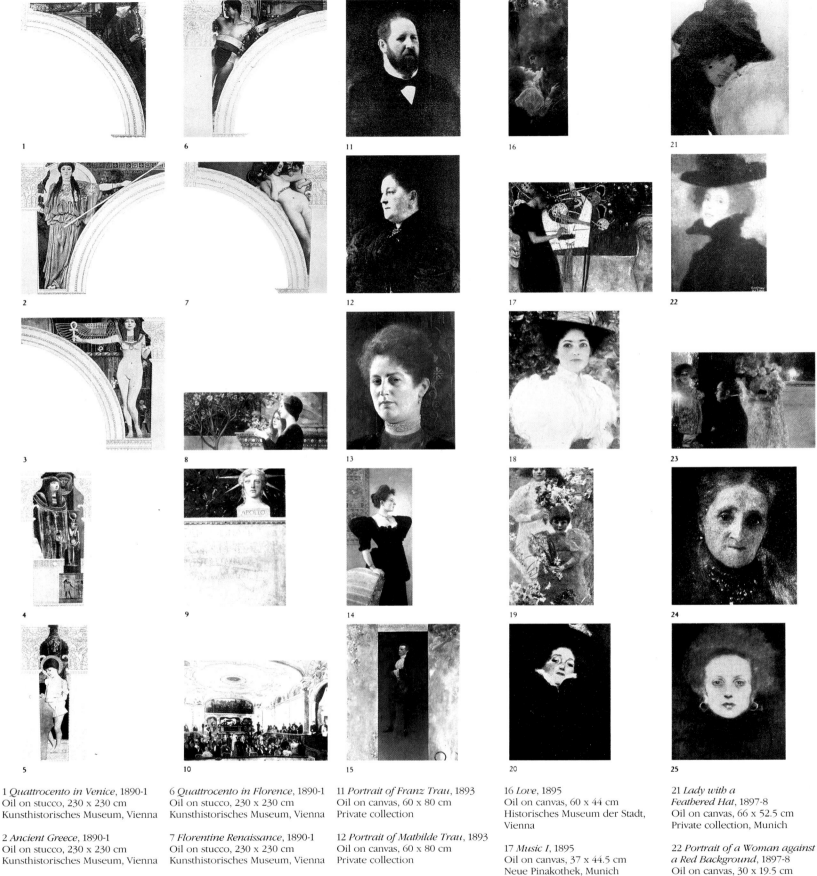

1 *Quattrocento in Venice*, 1890-1
Oil on stucco, 230 x 230 cm
Kunsthistorisches Museum, Vienna

2 *Ancient Greece*, 1890-1
Oil on stucco, 230 x 230 cm
Kunsthistorisches Museum, Vienna

3 *Egyptian Art*, 1890-1
Oil on stucco, 230 x 230 cm
Kunsthistorisches Museum, Vienna

4 *Egyptian Art*, 1890-1
Oil on stucco, 230 x 80 cm
Kunsthistorisches Museum, Vienna

5 *Italian Renaissance*, 1891
Oil on stucco, 230 x 40 cm
Kunsthistorisches Museum, Vienna

6 *Quattrocento in Florence*, 1890-1
Oil on stucco, 230 x 230 cm
Kunsthistorisches Museum, Vienna

7 *Florentine Renaissance*, 1890-1
Oil on stucco, 230 x 230 cm
Kunsthistorisches Museum, Vienna

8 *Girls with Oleander*, 1890-2
Oil on canvas, 55 x 128.5 cm
Private collection, New York

9 *Head of Apollo*, 1892
Oil on canvas, 84 x 56 cm
Historisches Museum, Vienna

10 *Interior of Theatre of
Esterhazy Palace at Totis*, 1893
Present whereabouts unknown

11 *Portrait of Franz Trau*, 1893
Oil on canvas, 60 x 80 cm
Private collection

12 *Portrait of Mathilde Trau*, 1893
Oil on canvas, 60 x 80 cm
Private collection

13 *Portrait of a Lady*, 1894
Oil on panel, 30 x 23 cm
Historisches Museum, Vienna

14 *Portrait of Marie Breunig*, 1894
Oil on canvas, 155 x 75 cm
Private collection, Vienna

15 *Portrait of the Actor Joseph
Lewinsky in the role of Carlos*,
1895.
Oil on canvas, 64 x 44 cm
Österreichische Galerie, Vienna

16 *Love*, 1895
Oil on canvas, 60 x 44 cm
Historisches Museum der Stadt,
Vienna

17 *Music I*, 1895
Oil on canvas, 37 x 44.5 cm
Neue Pinakothek, Munich

18 *Portrait of a Girl*, 1896
Oil on canvas, 32.4 x 24 cm
Private collection, Vienna

19 *Children with Flowers*, 1896
Oil on canvas?
Other details unknown

20 *Portrait of a Lady*, 1897-8
Oil on canvas?
Other details unknown

21 *Lady with a
Feathered Hat*, 1897-8
Oil on canvas, 66 x 52.5 cm
Private collection, Munich

22 *Portrait of a Woman against
a Red Background*, 1897-8
Oil on canvas, 30 x 19.5 cm
Private collection

23 *Schubert at the Piano*, 1898-9
Oil on canvas, 150 x 200 cm
Destroyed at Immendorf, 1945

24 *Portrait of Anna Klimt*, 1898
Oil on canvas, 130 x 70 cm
Lost in Second World War

25 *Head of a Young Lady*, 1898
Oil on canvas?
Other details unknown

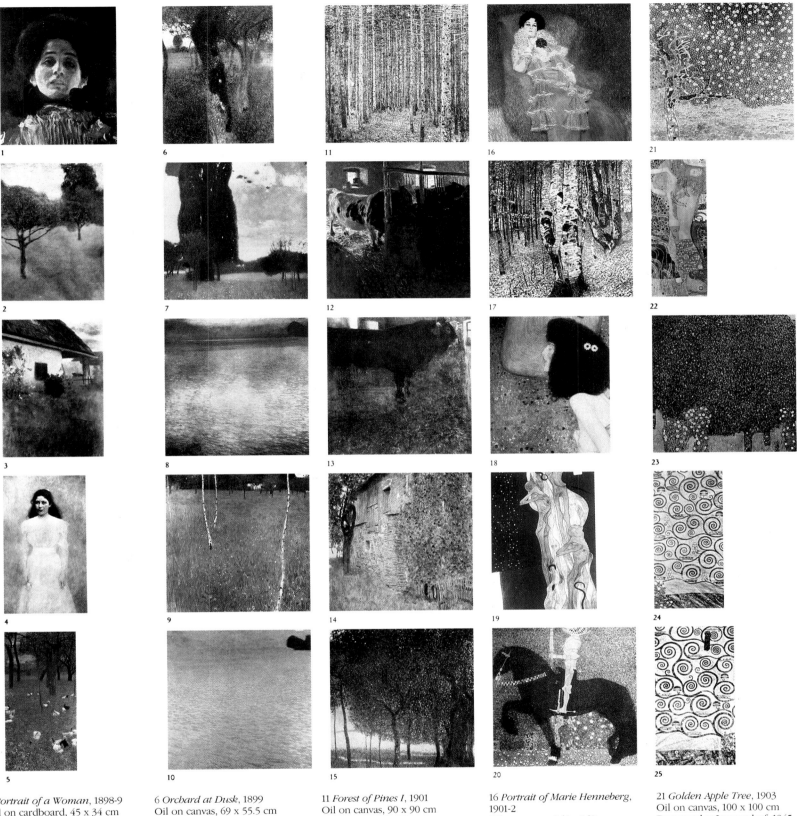

1 *Portrait of a Woman*, 1898-9
Oil on cardboard, 45 x 34 cm
Österreichische Galerie, Vienna

2 *The Orchard*, 1898
Oil on cardboard, 39 x 28 cm
Private collection, Vienna

3 *Farmhouse with Wild Rose*, 1898
Oil on cardboard, 60 x 40 cm
Present whereabouts unknown

4 *Portrait of Trude Steiner*, 1898-9
Oil on canvas, 140 x 80 cm
Present whereabouts unknown

5 *Garden with Chickens
after the Rain*, 1899
Oil on canvas, 80.3 x 40 cm
Österreichische Galerie, Vienna

6 *Orchard at Dusk*, 1899
Oil on canvas, 69 x 55.5 cm
Private collection

7 *The Tall Poplars I*, 1900
Oil on canvas, 80 x 80 cm
Present whereabouts unknown

8 *On the Attersee I*, 1900
Oil on panel
Other details unknown

9 *Farmhouse with Birches*, 1900
Oil on canvas, 80 x 80 cm
Österreichische Galerie, Vienna

10 *On the Attersee II*, 1901
Oil on canvas, 83 x 83 cm
Private collection, Vienna

11 *Forest of Pines I*, 1901
Oil on canvas, 90 x 90 cm
Galerie Würthle, Vienna

12 *Cows in the Barn*, 1900-1
Oil on canvas, 75 x 76.5 cm
Wolfgang-Gurlitt Museum, Linz

13 *The Black Bull*, 1900-1
Oil on canvas, 80 x 80 cm
Private collection

14 *Farmhouse at Kammer
on the Attersee*, 1901
Oil on canvas, 88 x 88 cm
Present whereabouts unknown

15 *Orchard*, 1901
Oil on canvas, 90 x 90 cm
Private collection

16 *Portrait of Marie Henneberg*,
1901-2
Oil on canvas, 140 x 140 cm
Present whereabouts unknown

17 *Beech Forest II*, 1903
Oil on canvas, 100 x 100 cm
Österreichische Galerie, Vienna

18 *Girl in a Blue Veil*, 1902-3
Oil on canvas, 67 x 55 cm
Private collection

19 *Procession of the Dead*,
1903
Oil on canvas, 48 x 63 cm
Destroyed at Immendorf, 1945

20 *Life is a Struggle*, 1903
Oil on canvas, 100 x 100 cm
Present whereabouts unknown

21 *Golden Apple Tree*, 1903
Oil on canvas, 100 x 100 cm
Destroyed at Immendorf, 1945

22 *Water-Snakes I*, 1904-7
Distemper, water-colour on
parchment, 50 x 20 cm
Österreichische Galerie, Vienna

23 *Roses under Trees*, 1905
Oil on canvas, 110 x 110 cm
Musée d'Orsay, Paris

24 *Tree of Life*, 1905-9
Various techniques, 197.8 x 115 cm
Österreichische Museum, Vienna

25 *Tree of Life* (left), 1905-9
Various techniques,
197.7 x 105.4 cm
Österreichische Museum, Vienna

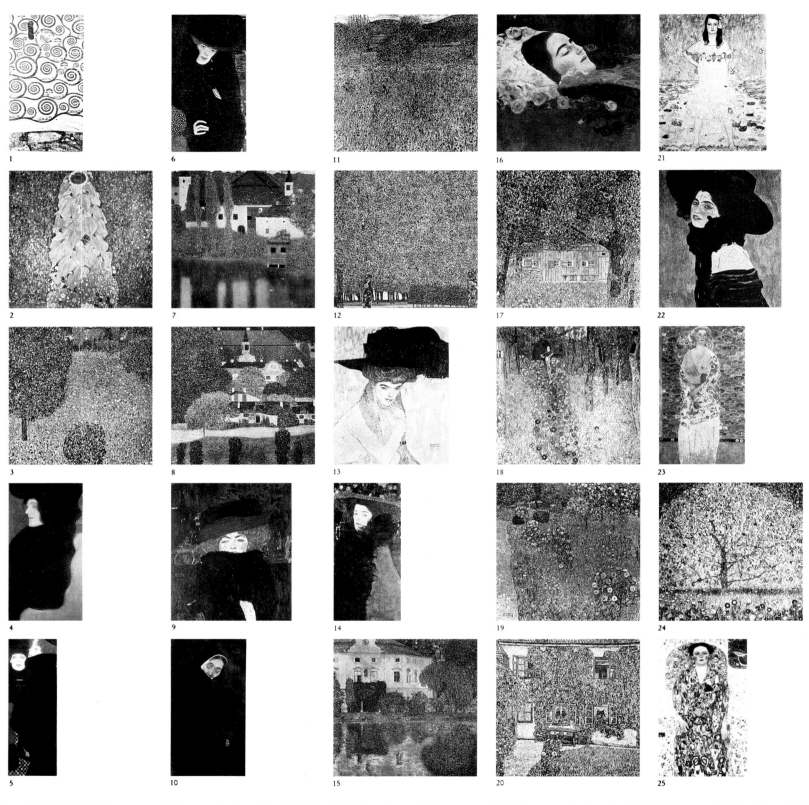

1 *Tree of Life* (right), 1905-9
Various materials, 198 x 103.6 cm
Österreichische Museum, Vienna

2 *Sunflower* 1906-8
Oil on canvas, 110 x 110 cm
Private collection, Vienna

3 *Meadow in Flower*, 1906
Oil on canvas, 110 x 110 cm
Private collection, Vienna

4 *Pale Face*, 1907-8
Oil on canvas, 80 x 40 cm
Museum of Art,
University of Oklahoma

5 *The Sisters*, 1907-8
Oil on canvas, 125 x 42 cm
Private collection, Vienna

6 *Woman in Red and Black*, 1907-8
Oil on canvas, 96 x 47 cm
Private collection, Vienna

7 *Schloss Kammer, Attersee I*, 1908
Oil on canvas, 110 x 110 cm
Národní Gallery, Prague

8 *Schloss Kammer, Attersee II*,
1909-10
Oil on canvas, 110 x 110 cm
Private collection, USA

9 *Woman with Hat
& Feather Boa*, 1909
Oil on canvas, 69 x 55 cm
Österreichische Galerie, Vienna

10 *Old Woman*, 1909
Oil on canvas
Private collection, Paris

11 *Field in Flower*, 1909
Distemper. Oil on canvas,
100.5 x 100.5 cm
Carnegie Institute, Pittsburgh

12 *The Park*, 1909-10
Oil on canvas, 110.5 x 110.5 cm
Museum of Modern Art,
New York

13 *The Black Feather Hat*, 1910
Oil on canvas, 79 x 63 cm
Private collection, Graz

14 *Hat with Roses*, 1910
Oil on canvas, 96 x 46 cm
Present whereabouts unknown

15 *Schloss Kammer, Attersee IV*,
1910
Oil on canvas, 110 x 110 cm
Private collection, Vienna

16 *Ria Munk on her Deathbed*, 1910
Oil on canvas, 50 x 50.5 cm
Present whereabouts unknown

17 *Farmhouse in Austria*, 1911-12
Oil on canvas, 110 x 110 cm
Österreichische Galerie, Vienna

18 *The Crucifix*, 1911-12
Oil on canvas, 110 x 110 cm
Destroyed at Immendorf, 1945

19 *Orchard with Rose Bushes*,
1911-12
Oil on canvas, 110 x 110 cm
Private collection, Austria

20 *Forester's House at Weissenbach
am Attersee*, 1912
Oil on canvas, 110 x 220 cm
Private collection, USA

21 *Portrait of Mäda Primavesi*, 1912
Oil on canvas, 150 x 110 cm
Private collection, New York

22 *Portrait of Girl*, 1912
Oil on canvas
Other details unknown

23 *Portrait of Paula
Zuckerkandl*, 1912
Oil on canvas, 190 x 120 cm
Present whereabouts unknown

24 *The Apple Tree I*, 1912
Oil on canvas, 110 x 110 cm
Österreichische Galerie, Vienna

25 *Portrait of Eugenia
Primavesi*, 1913-14
Oil on canvas, 140 x 84 cm
Present whereabouts unknown

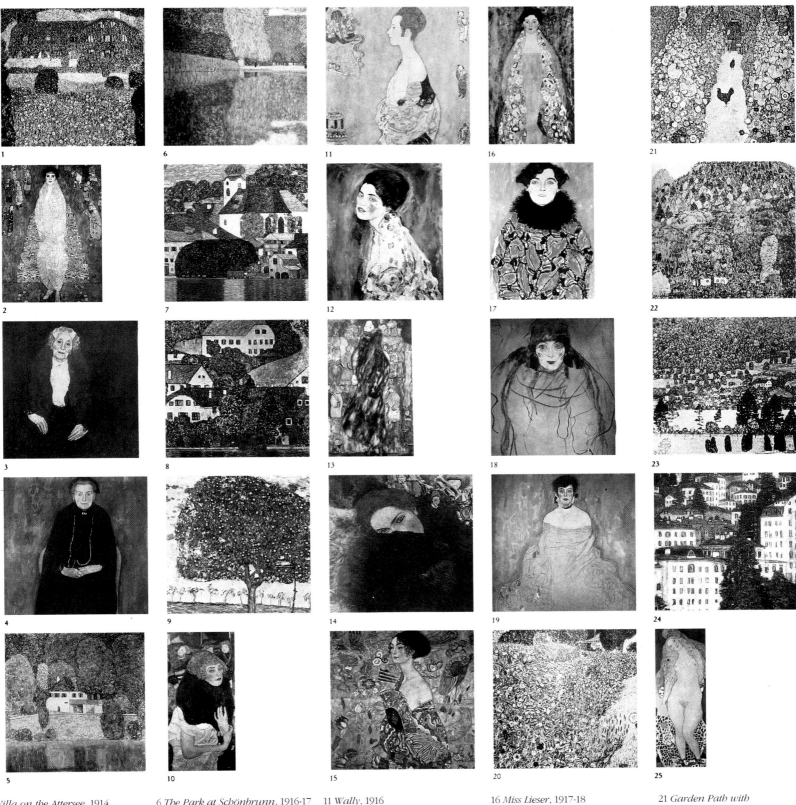

1 *Villa on the Attersee*, 1914
Oil on canvas, 110 x 110 cm
Private collection, Vienna

2 *Baroness Elisabeth Bachofen-Echt*, 1914-16
Oil on canvas, 180 x 128 cm
Private collection at
Kunstmuseum, Basle

3 *Portrait of Charlotte Pulitzer*, 1915
Oil on canvas, 98 x 98 cm
Lost in 1945

4 *Portrait of Barbara Flöge*, 1915
Oil on canvas, 110 x 110 cm
Private collection, Vienna

5 *Inn on the Attersee*, 1915-16
Oil on canvas, 110 x 110 cm
Private collection

6 *The Park at Schönbrunn*, 1916-17
Oil on canvas, 110 x 110 cm
Private collection, Graz

7 *The Church at Unterach
am Attersee*, 1916
Oil on canvas, 110 x 110 cm
Private collection, Graz

8 *House at Unterach
am Attersee*, 1916
Oil on canvas, 110 x 110 cm
Österreichische Galerie, Vienna

9 *Apple Tree II*, 1916?
Oil on canvas, 80 x 80 cm
Österreichische Galerie, Vienna

10 *Fur Stole*, 1916
Oil on canvas, 94 x 46 cm
Present whereabouts unknown

11 *Wally*, 1916
Oil on canvas, 110 x 110 cm
Destroyed in 1945

12 *Portrait of a Lady*, 1916-17
Oil on canvas, 60 x 51 cm
Galleria Ricci-Oddi, Plaisance

13 *The Fur Coat*, 1916-18
Oil on canvas, 100 x 57 cm
Selected Artists Galleries, NY

14 *Lady with a Muff*, 1916-18
Oil on canvas
Other details unknown

15 *Lady with a Fan*, 1917-18
Oil on canvas, 100 x 100 cm
Private collection, Vienna

16 *Miss Lieser*, 1917-18
Oil on canvas
Other details unknown

17 *Portrait of Johanna Staude*,
1917-18
Oil on canvas, 70 x 50 cm
Österreichische Galerie, Vienna

18 *Portrait of Woman from front*,
1917-18
Oil on canvas, 67 x 56 cm
Wolfgang-Gurlitt Museum, Linz

19 *Amelie Zuckerkandl*, 1917-18
Oil on canvas, 128 x 128 cm
Private collection, Vienna

20 *Italian Garden*, 1917
Oil on canvas, 110 x 110 cm
Private collection

21 *Garden Path with
Chickens*, 1917
Oil on canvas, 110 x 110 cm
Destroyed at Immendorf, 1945

22 *Mill on the Attersee*, 1917
Oil on canvas, 110 x 110 cm
Priv. coll., Netherlands

23 *Forest on a slope at Unterach
am Attersee*, 1917
Oil on canvas, 110 x 110 cm
Present whereabouts unknown

24 *Gastein*, 1917
Oil on canvas, 70 x 70 cm
Destroyed at Immendorf, 1945

25 *Adam and Eve*, 1917-18
Oil on canvas, 175 x 60 cm
Österreichische Galerie, Vienna

155

Life of Klimt	Principal Works
1862 14 July, birth of Gustav Klimt at Baumgarten, Vienna; second child of Ernst (gold engraver) and Anna Klimt.	
1876 Gustav Klimt attends Vienna School of Arts & Crafts: pupil of Ferdinand Laufberger and Victor Berger till 1883.	
1877 Ernst Klimt joins Gustav at School of Arts and Crafts.	Gustav and Ernst draw portraits from photographs and sell them for 6 guilders apiece.
1879	Gustav, Ernst and Matsch decorate courtyard of Kunsthistorisches, using Laufberger's designs, for silver wedding of Imperial couple.
1880 Gustav, Ernst and Matsch work together, obtain first commissions.	Four allegories (ceiling of Sturany's house, Vienna); ceiling of thermal establishment, Carlsbad (Czechoslovakia).
1881 Klimt begins to illustrate *Allegories and Emblems* published by Martin Gerlach.	Paintings in collaboration with Ernst and Matsch for Zierer's house in Vienna, using J.V. Berger's designs.
1882 Ernst, Gustav and Matsch work on theatre décors; first real collaboration with architects Fellner & Helmer.	Ceiling paintings and theatre curtain for municipal theatre of Liberec (Reichenberg), Czechoslovakia.
1883 The two brothers and Matsch set up first communal studio in Vienna; travel in Romania, then Alps in Transylvania.	Family portraits for royal palace of Pelesh (Romania); *The Fairy Tale*; *Portrait of Clara Klimt*.
1884 Commission to decorate ceiling of Carlsbad Theatre.	*Idyll*; *The Poet and the Muse*.
1885 With Ernst and Matsch (using Makart's designs), decorates Villa Hermes, favourite retreat of Empress Elisabeth.	Works for National Theatre (Bucharest); ceiling of Villa Hermes at Linz (Vienna); decoration of theatre of Rijka, Fiume.
1886 Klimt begins to differ in style from Ernst and Matsch; at Burgtheater each artist works independently.	Decoration of theatre at Carlsbad (ceiling and curtain); decoration of two staircases at Burgtheater in Vienna (until 1888).
1888 The Emperor awards Klimt the Gold Cross for artistic merit.	*Sappho*; auditorium of old Burgtheater in Vienna.
1889 Travels in Europe: Trieste, Venice and Munich.	*Woman with Purple Scarf*.
1890 Wins Emperor's prize (400 guilders) for *Auditorium of old Burgtheater*; moves away from academic style.	Decoration of great staircase of Kunsthistorisches Museum in Vienna (until 1891); *Portrait of Pianist Joseph Pembauer*.
1891 Enrols in Association of Viennese Painters; Ministry of Education commissions designs for Great Hall, Vienna University.	*Girls with Oleander*.
1892 The three artists move to new studio in Vienna; Klimt's father dies of apoplexy on 9 December, followed by Ernst.	*Head of Apollo*.
1893 F. Matsch and G. Klimt study arrangement of paintings for spandrels and ceiling of Great Hall, Vienna University.	Auditorium of theatre of Esterhazy Palace at Totis in Hungary. *Portrait of Franz Tau*; *Portrait of Mathilde Trau*.
1894 Acceptance of F. Matsch and Klimt's project for Great Hall, Vienna University.	*Portrait of Marie Breunig*; *Portrait of a Woman*.
1895 Klimt wins prize in Antwerp for auditorium of Esterhazy Palace at Totis.	*Portrait of the Actor Joseph Lewinsky*; *Love*; *Music*.
1896 Klimt meets Josef Hoffmann at the 'Club of Seven'.	*Studies of a Man's Head* (old man); *Portrait of Count Traun*; *Portrait of a Young Woman*.
1897 Klimt, founder member, is elected president of Secession; spends summer in Kammer and environs of Attersee.	Sketches for *Jurisprudence* and *Philosophy*; *The Feathered Hat*; *Woman by a Fireplace*.

Artistic Life	History
Hugo: *Les Misérables*; Great Exhibition at London includes section on Japanese art; birth of Debussy.	Bismarck appointed Prime Minister; French expedition to Mexico; War of Mexico; Garibaldi defeated at Aspromonte.
Opening of Festspielhause with tetralogy, by Wagner; death of Diaz and Georges Sand; construction of Sacré-Coeur at Montmartre.	Victoria Empress of India; end of first Internationale of workers; four-stroke engine perfected in Germany.
Manet: *Nana*; Keller: *Nouvelles zürichoises;* Zola: *L'Assommoir*; death of Courbet.	Attempts on life of German Emperor; Russian-Turkish-Romanian war; rebellion of samurais in Japan; Britain annexes the Transvaal.
Exhibition of French art in Munich; Dostoevsky: *The Brothers Karamazov*; death of Daumier, birth of Picabia and Klee.	Austro-German alliance; foundation of workers' party in France; Pasteur: principle of vaccination; birth of Einstein and Stalin.
Van Gogh is in the Borinage; Zola: *Nana*; death of Flaubert and Offenbach; birth of Derain and Apollinaire.	14 July becomes a national holiday in France; first Boer war in South Africa; Siemens: first electric lift in New York.
Puvis de Chavannes: *Le Pauvre Pêcheur*; Nietzsche: *Morgenrote*; death of F. Laufberger; birth of Picasso, Léger and Bartok.	Assassination of Tsar Alexander II; French protectorate in Tunisia; Jules Ferry's law in France: education to be compulsory and free.
Mahler: *Songs of Youth*; Wagner: *Parsifal*; Taine: *Philosophy of Art*; birth of Joyce, Virginia Woolf and Braque.	Austrian-Italian-German alliance; University founded in Prague; British occupy Cairo; birth of Roosevelt.
Construction of Metropolitan Opera; exhibition of French Impressionists in Berlin; death of Wagner and Manet; birth of Kafka.	Plekhanov founds the Russian socialist party; Krebs: diphtheria bacillus; death of Marx; birth of Mussolini.
Liebermann settles in Berlin; M. Twain: *The Adventures of Huckleberry Finn*; death of Hans Makart; birth of Modigliani.	Construction of Reichstag in Berlin by Wallot; discovery of gold in the Transvaal, Chardonnet: artificial silk; Mergenthaller: linotype.
Zola: *Germinal*; Freud studies under Charcot at the Salpétrière; death of Victor Hugo; birth of Sonia Delaunay.	Berlin conference on colonisation; independence of the Congo; French protectorate in Madagascar; Pasteur's vaccination against rabies.
First Impressionist exhibition in the USA by Durand-Ruel; Statue of Liberty in New York; death of Liszt; birth of Kokoschka.	Death of Louis II of Bavaria; French in Laos; British in Burma; Hertz: electromagnetic waves.
Van Gogh leaves for Arles; construction of Eiffel Tower, birth of de Chirico.	Accession of William II; internationalisation of Suez canal; Dunlop: pneumatic tyres; foundation of Pasteur Institute.
Gauguin: *Le Christ Jaune*; Munch: *The Frieze of Life*; World Exhibition in Paris; death of Romaco in Vienna; birth of Charlie Chaplin.	Suicide of Rodolphe and Marie Vetsera at Mayerling; dockers' strike in London; first constitution in Japan; birth of Hitler.
Wedekin: scandal of *The Awakening of Spring* in Germany; *Olympia* enters the Luxembourg Museum; birth of Egon Schiele.	Resignation of Bismarck; 1 May: workers' holiday; Clément Ader: first flight in his plane *Eolé*; birth of Charles de Gaulle.
Gauguin leaves for Tahiti; Hofmannsthal: *Gerstern*; L. Corinth settles in Munich; death of Rimbaud, Seurat, van de Velde and Jongkind.	Suicide of General Boulanger in Brussels; troubles on 1 May; Ivan Pavlov: conditioned reflexes.
F. von Stuck founds the Munich Secession; international music festival in Vienna; founding of Group of XI in Berlin.	Scandal in Panama; Ravachol guillotined, Jaurès regulates work by women and children; Lorentz and Perrin: electrons.
Otto Wagner develops his plan for Vienna; first Secession exhibition in Munich; Hermann settles in Berlin; Munch: *The Scream*.	Vaillant bombs Chamber of Deputies; foundation of colliery cartels in Ruhr; birth of Mao Zedong.
Exhibition of Association of Viennese Painters (Ferdinand Khnopff receives gold medal); Kipling: *The Jungle Book*.	Sadi Carnot assassinated; Nicholas II Tsar; Sino-Japanese war; Reynaud: first animated cartoon.
O. Wagner: *Modern Architecture; Pan* review in Germany; death of Berthe Morisot; birth of Hindemith.	Foundation of CGT in France; first film of Lumière brothers; China cedes Formosa to Japan; Taylorism in USA; Röntgen: X-rays.
Kandinsky in Munich; Adolph Loos declares 'ornament is a crime'; Munich review: *Simplizissimus*; death of Anton Bruckner.	Austro-Russian agreement on Balkans; Turkish massacre of Armenia and Crete; first modern Olympic games in Athens.
Establishment of Vienna Secession and journal *Ver Sacrum*; Toscanini director of La Scala in Milan, Mahler of the Venice Opera.	Tirpitz forms German fleet; disturbance in Italy; Greek-Turkish war; Marconi: Wireless Telegraph Co.

Life of Klimt	Principal Works
1898 Heavily involved in Secession's activities until 1900; strongly criticised for *Jurisprudence, Philosophy, Medicine*.	Posters for first Secession exhibition; *Portrait of Sonja Knips; Music; Schubert at the Piano; Pallas Athena; Portrait of Helene Klimt*.
1899 Works on *Philosophy* in studio in Josephstädterstrasse; finishes decoration of Dumba Villa (destroyed).	*Nuda Veritas; Portrait of Serena Lederer; Pond at Schloss Kammer Park.*
1900 *Philosophy* criticised by professors at Secession exhibition; wins gold medal at Exposition Universelle in Paris.	*After the Rain; The Pond; The Tall Poplars; Medicine* (1900-7).
1901 Press criticism of *Medicine* at Secession exhibition; questions raised in Parliament.	*Judith and Holofernes; Cows in the Barn; Attersee I/II; Pine Forest I/II; Beech Forest.*
1902 Meets Rodin in Vienna on 7 June; Rodin admires *Beethoven Frieze*, but much argument about it ensues in press.	*Goldfish; Beethoven Frieze; Portrait of Emilie Flöge.*
1903 Visits Venice, Ravenna, Florence; University paintings put in Österreichisches Galerie; Klimt reclaims them by letter.	*Hope I; Procession of the Dead; Young Women with Blue Veil; Golden Apple Tree; The Pear Tree; The Tall Poplars; Birch Trees.*
1904 Cartoons for mural mosiac in dining room of Palais Stoclet in Brussels, to be executed by Wiener Werkstätte.	*Portrait of Hermine Gallia; Water-Snakes I/II.*
1905 Buys University paintings from Ministry of Education: 'I want to get away from these shameful attacks, I want to regain my freedom.'	*The Three Ages of Woman; Portrait of Margaret Stonborough-Wittgenstein; Roses under Trees.*
1906 Leads new group, including Hoffmann and O. Wagner; goes to London and Brussels for work on Palais Stoclet.	*Portrait of Fritza Riedler; Garden with Sunflowers.*
1907 Alters University paintings for last time; first meeting with the young Egon Schiele.	*The Sunflower; Portrait of Adele Bloch-Bauer I; The Kiss; Danaë; Hope I.*
1908 Sixteen canvases in Kunstschau; Galeria d'Arte Moderna buys *The Three Ages of Woman*; Österreichische Galerie *The Kiss*.	*The Sisters (Friends III); Death and Life; Schloss Kammer on the Attersee.*
1909 Exhibits at second Kunstschau, as does E. Schiele; starts Stoclet Frieze for Wiener Werkstätte; visits Prague, Paris, Madrid.	Decoration of Palais Stoclet; *Judith II; Old Woman; The Family.*
1910 Klimt exhibits successfully at ninth biennale in Venice.	*Landscape with Garden; The Black-Feathered Hat; Park; Schloss Kammer on the Attersee II.*
1911 *Death and Life* awarded first prize at exhibition in Rome; visits Florence, Rome, Brussels, London, Madrid; moves to new studio.	*Farm in Austria; Garden with Crucifix* (destroyed)
1912 Klimt substitutes a blue background, in the style of Matisse, for gold background of *Death and Life*.	*Portrait of Paula Zuckerkandl; Portrait of Mäda Primavesi; Portrait of Adele Bloch-Bauer; The Apple Tree I.*
1913 Attends exhibition, Assoc. of Austrian Artists, Budapest; summer at Lake Garda; admits Schiele to Bund Österreichischer Künstler.	*The Virgin; Church of Cassone on Lake Garda; Malcesine on Lake Garda.*
1914 Attends exhibition of Deutsch-Bömische Künstlerbund in Prague; Expressionist thinking already critical of his work.	*Portrait of Eugenia and Mäda Primavesi; Portrait of Baroness Elisabeth Bachofen-Echt; Villa on Attersee.*
1915 Visits and works in Györ (Hungary).	*Portrait of Barbara Flöge; Portrait of Charlotte Pulitzer; Unterach am Attersee.*
1916 Participates with Egon Schiele, Kokoschka and Faistauer at exhibition of Bund Österreichischer Künstler at Berlin Secession.	*Portrait of Friedericke Maria Beer; Park of Schönbrunn; Wally; Friends; Church at Unterrach am Attersee.*
1917 Visits north Moravia; summer at Mayrhofen; elected hon. member of Academy of Fine Arts of Vienna and Munich; visits Romania.	*Leda* (destroyed); *Portrait of a Woman; Portrait of Johanna Staude; The Dancer; Portrait of a Woman in White.*
1918 Suffers stroke, 11 January, dies 6 February, buried at Heitzinger cemetery; Schiele paints his portrait on death-bed in hospital.	*Baby* or *Cradle* (unfinished); *The Bride* (unfinished); *Adam and Eve* (unfinished).

Artistic Life	History
Foundation of Berlin Secession; Post-Impressionist exhibition in Germany; death of G. Moreau. Puvis de Chavannes and Garnier.	Assassination of Empress Elisabeth; Lenin: Socialist Workers Party; Dreyfus affair; Zola: *J'Accuse*; Pierre and Marie Curie: radium.
Otto Wagner joines Viennese Secession; artists' colony at Darmstadt; Rilke: *Die Weise von Liebe und Tod des Cornets*.	War in Transvaal; Emile Loubet French president; review of Dreyfus case; Meliès' film about Dreyfus; Marconi: wireless telegraphy.
Japanese exhibition at Secession; Laloux: la gare d'Orsay; Puccini: *Tosca*; death of Nietzsche and O. Wilde; birth of Kurt Weill.	Von Bülow chancellor, doubles German fleet; Métro opened in Paris; Victor Emanuel II king of Italy; Boxer revolt in China.
Olbrich and Behrens: Mathildenhöhe at Darmstadt; *Ver Sacrum* issue on Toorop; death of Verdi, Bocklin and Toulouse-Lautrec.	Death of Queen Victoria, accession of Edward VII; Roosevelt president; International Labour Office founded; Russians in Manchuria.
Secession exhibition based on Max Klinger's statue of *Beethoven*; Stieglitz founds 'photo secession'; death of Zola.	Anglo-Japanese Alliance; accession of Alfonso XIII in Spain; Underground trains in Berlin; Trans-Siberian railway completed.
Cézanne exhibits seven paintings at Secession; *Ver Sacrum* closes down; Wiener Werkstätte established; death of Gauguin.	Republic of Panama; Pius X, Pope; P. Karagjorgjevic King of Serbia; Wright brothers: first flight in motor-powered plane; Ford: first car.
Cézanne exhihition; Josef Hoffmann: Palais Stoclet; O. Wagner: St. Leopold sanatorium; Mayer: stained glass windows commissioned: *Paradise*.	Russo-Japanese war; break between Vatican and France; publication of *L'Humanité*.
Split in Secession; O. Wagner: Vienna Post Office Savings Bank; Strauss: *Salome*.	Separation of Church and State; William II in Tangiers; Russian Revolution; Potemkin; Einstein: Theory of Relativity.
Great exhibition of van Gogh at Galerie Miethke, Vienna; death of Cézanne; birth of Beckett, Billy Wilder, L. Sedar Senghor.	Mining disaster at Courrières; Fallières President in France; Clémenceau in office; Dreyfus rehabilitated; Roosevelt: Nobel peace prize.
Picasso: *Les Demoiselles d'Avignon*; Rejana directs his own theatre; death of Huysmans; birth of Moravia, Guillevic and René Char.	The Hague: failure of peace conference; Imperial ratification of universal, secret ballot; Lumière: colour photographs.
Exhibition by artists who left Secession in 1905; Kokoschka: poster for Kunstschau; death of Olbrich; birth of Lévi-Strauss.	Austria annexes Bosnia and Herzegovina; Franco-German incidents at Casablanca; Bulgaria independent of Ottoman empire.
Van Gogh, Munch, Toorop, Gauguin, Bonnard and Matisse exhibit at Kunstschau; Faisteur and Schiele found Neukunstgruppe.	Franco-German convention on Morocco; Briand in office; Albert I King of Belgium; Blériot crosses Channel in airplane.
Birth of Anouilh, J.L. Barrault and Jean Genêt.	Railway strike; Socialist progress in parliamentary elections; George V King of Britain; Japan annexes Korea; floods in Paris.
Rouault: *Faubourg des Longues Peines*; Rodin: Statue of *Gustav Mahler*; Claudel: *L'Otage*; death of Mahler and Legros.	France occupies Fez; new Franco-German convention on Morocco; Caillaux in office; Marie Curie: Nobel prize for chemistry.
Hoffman founds Österreichische Werbund; Schiele: *The Cardinal and the Nun*, Expressionist rendering of Klimt's *The Kiss*.	France in Marrakesh; Jaurès declares: 'La guerre à la guerre'; first Balkan War.
Man Ray: *The Village*; Proust: *Du côté de chez Swann*; Nijinsky in scandal of *Sacre du Printemps*; birth of Camus.	Poincaré President in France; second Balkan War; Roland Garros crosses Mediterranean in airplane; Wilson US President.
Claudel's *L'Échange* directed by Copeau; Gide: *Les Caves du Vatican*; birth of Marguerite Duras.	Caillaux affair; Archduke Franz-Ferdinand assassinated at Sarajevo; Austro-Hungarian declaration of war on Serbia; Jaurès assassinated.
Sarah Bernhardt has a leg amputated; closure of theatres; birth of Arthur Miller.	First use of gas by Germans; *Lusitania* torpedoed; Allied landings at Salonica; Italy joins war against Austro-Hungarian empire.
Death of Henry James, Odilon Redon and Jack London.	Death of Emperor Franz-Joseph two years before disintegration of his empire; accession of Charles I; Battle of Verdun.
Rouault: *Le Vieux Clown*; Diaghilev's Ballets Russes; Cocteau/Satie/Picasso scandal over *Parade*; death of Degas.	American landings at St Nazaire; October revolution, Lenin in power in Russia; Russo-German armistice of Brest-Litovsk.
Death of Otto Wagner, Hodler, Koloman Moser, Egon Schiele and Apollinaire; birth of Obaldia, Maurice Druon and Althusser.	Paris bombed; Armistice of 11 November; birth of Austrian State and six others from former Empire.

List of works by Klimt

Selected Bibliography

Acht Jahre Secession (March 1897-June 1905), Ludwig Hevesi. Vienna, 1906.

Altkunst-Neukunst: Vienna 1894-1908, Ludwig Hevesi. Vienna, 1909.

Gustav Klimt, Max Eisler. Vienna, 1920.

Gustav Klimt, An Aftermath, Max Eisler. Translated from English by B.W. Tucker, Vienna, 1931.

Souvenirs d'un Monde Disparu – Autriche 1878-1938, Bertha Szeps Zuckerkandl. Translated from German by Maurice Rémon. Paris, 1939.

Gustav Klimt, Fritz Novotny & Johannes Dobai. Galerie Welz, Salzburg, 1967.

Moderne Malerie in Österreich, Werner Hoffmann. Vienna, 1965.

Gustav Klimt: Eine Dokumentation, Edited by Christian M. Nebehay. Vienna, 1969.

Gustav Klimt und die Wiener Jahrhundertwende, Werner Hoffmann. Salzburg, 1970.

Gustav Klimt, Werner Hoffmann, 1st edn. in German, 1971; London, 1972.

The Sacred Spring: The Arts in Vienna 1898-1918, N. Powell. London, 1974.

Art in Vienna 1898-1918, Peter Vergo. Phaidon, London, 1975.

Gustav Klimt, Alessandra Comini. Thames & Hudson, London; Braziller, New York, 1975, 1981.

Art Nouveau, Robert Schmutzler. London, 1977.

Le Symbolisme, Robert L. Delevoy. Skira, Geneva, 1977, 1982.

Wittgenstein et la Modernité Viennoise, Allan Janick. Paris, 1978.

Gustav Klimt: Der Beethovenfries, Marian Bisanz-Prakken, Salzburg, 1980.

Fin de Siècle Vienna: Politics and Culture, Carl E. Schorske. Knopf, New York, 1980.

Die Zeichnungen von Gustav Klimt, catalogue raisonné of drawings (3 vols), Alice Strobl. Galerie Welz, Salzburg, 1980, 1982, 1984.

Gustav Klimt Landscapes, Johannes Dobai, Salzburg, 1981. Weidenfeld & Nicolson Ltd, London, 1988.

Tout l'Oeuvre Peint de Gustav Klimt, Introduction by René Passeron, documentation by Sergio Coradeschi. Paris, 1983.

Vienna 1890-1920, general editor Robert Waissenberger. Translated from German, Fribourg, 1984.

Exhibition catalogue *Le Arti à Vienna – Dalla Secessione alla Caduta dell'Impero Asburgico.* Venice Biennale, 20 May-16 Sept. 1984.

Vienna 1900 – Architecture and Painting, Christian M. Nebehay. Translated from German by Renée Nebehay King, Vienna, 1984.

Vienna 1900. une Identité Blessée, Michael Pollak, Paris, 1984.

L'Esprit Viennois (Une histoire intellectuelle et sociale 1848-1938), William Johnston. Translated from English by P.E. Dauzat, Paris, 1985.

Vienne Architecture 1900, Franco Bori & Ezio Godoli. Translated from Italian by J.M. van der Meerschen & H. Lafont, Paris, 1985.

Journal de l'Art Nouveau 1870-1914, Jean Paul Bouillon. Geneva, 1985.

L'Art Graphique à Vienne autour de 1900, Michael Pabst. Translated from German by Pierre Rusch. Paris, 1985.

Exhibition catalogue *Vienna 1880-1938: L'Apocalypse Joyeuse,* general editor Jean Clair. Pompidou Centre, Paris 1986.

Klimt: Beethoven, Jean-Paul Bouillon. Skira, Geneva, 1986.

Exhibition catalogue *Gustav Klimt* (Europalia), Serge Sabarsky, Musées Royaux des Beaux-Arts de Belgique, Brussels, 1987.

Gustav Klimt, Ilona Sármány-Parsons. Bonfini, Naefels, Switzerland, 1987.

Gustav Klimt und Emilie Flöge, Wolfgang Georg Fischer. Vienna, 1987.

Exhibition catalogue *Egon Schiele und Seine Zeit – Österreichische Malerei und Zeichnung von 1900 bis 1930 aus der Sammlung Leopold,* Munich and Vienna, 1988 and 1989.

Der Beethovenfries von Gustav Klimt, Gerbert Frodl. Galerie Welz, Salzburg, 1989.

Photographic Credits:

Henry Holt books are available at special discounts for bulk purchases for sales promotions, premiums, fund-raising, or educational use. Special editions or book excerpts can also be created to specification.
For details contact: Special Sales Director, Henry Holt and Company, Inc., 115 West 18th Street, New York, New York 10011.

First American Edition—1992

Printed in France
Recognizing the importance of preserving the written word, Henry Holt and Company, Inc., by policy, prints all of Its first editions on acid-free paper.

10 9 8 7 6 5 4 3 2 1